M.

Sporting Art

Sporting Art

England 1700-1900

Stella A Walker

Studio Vista London

For my granddaughters, Sophie and Catherine

The front of the jacket shows a detail from James Seymour A Kill at Ashdown
Park (*pl. 20*) *by courtesy of the Tate Gallery, London. On the back is Thomas
Rowlandson* Dr Syntax Setting Out (*pl. 99*). *The woodcuts throughout the text
are all by Thomas Bewick.*

© 1972 Stella A.Walker

Designed by Keith Kail
First published in Great Britain 1972 by Studio Vista
Blue Star House, Highgate Hill, London N19
Set in Bembo 12 on 13 pt
Printed in Great Britain
by Richard Clay (The Chaucer Press), Ltd, Bungay, Suffolk

ISBN 0 289 70076 0

Contents

Acknowledgements

I would like to thank the many owners who have so generously allowed their pictures to be reproduced in this book, and in particular Her Majesty the Queen and Mr and Mrs Paul Mellon from whose collection so many illustrations have been taken. I must also acknowledge my indebtedness to: His Grace the Duke of Abercorn; The Director of the Agricultural Economics Research Institute, Oxford; The Ashmolean Museum, Oxford; His Grace the Duke of Beaufort KG; The British Museum; J.Peter W.Cochrane Esq.; Mrs J.Colvin; Musée Condé de Chantilly; J.N.Drummond Esq.; The Syndics of the Fitzwilliam Museum, Cambridge; Captain Jack Gilbey; The Glasgow Art Gallery and Museum; Sir Richard Bellingham Graham; The Trustees of Goodwood House; Lord Hesketh; Lord Irwin; The Stewards of the Jockey Club; H.J.Joel Esq.; Helena Lady Kintore; The Leicester Museums and Art Gallery; Major Sir Reginald and Lady Macdonald-Buchanan; The National Trust; The City of Norwich Museums; The Earl of Pembroke; National Museum of Racing Saratoga Inc.; The Director of the Rothamsted Experimental Station; His Grace the Duke of Rutland; The National Gallery of South Africa; N.C.Selway Esq.; The Earl Spencer; The Tate Gallery; The late Sir Humphrey de Trafford Bart. MC; Victoria and Albert Museum; The Walker Art Gallery, Liverpool; J.F.S.Watson Esq.; Josiah Wedgwood & Sons Ltd; S.C.Whitbread Esq.; and other owners of private collections. To all of them I record my sincere appreciation.

Photographs and transparencies have also been kindly supplied by: *The British Racehorse*; The Witt Library, The Courtauld Institute of Art; *The Field*; Messrs Frost & Reed; The Richard Green Gallery; The Moorland Gallery; Messrs Charles Hammond; Messrs Oscar & Peter Johnson; Messrs M.Newman; Paul Mellon Centre for Studies in British Art (London) Ltd; The Radio Times Hulton Picture Library; and the Tryon Gallery. In this connection special appreciation is given to the Directors of Messrs Arthur Ackermann and Son and Mr David Fuller for most generous co-operation, and to Messrs Fores and Mr Stephen Ling for advising on the Sporting Prints chapter. I also wish to thank Messrs Macmillan (London & Basingstoke) for permission to quote from *Samuel Whitbread 1764–1815. A Study in Opposition* by Roger Fulford. In some cases it has been impossible to trace owners of copyright and to these I offer my apologies.

Some small amount of material in the book has been used in different form in articles in *Country Life*, *The British Racehorse*, *Riding Cavalcade* (J.A.Allen & Co.), *The Horseman's Year* (Collins, Publishers) and *The Chronicle of the Horse* (USA) and I am grateful for copyright permission. Thanks are also due to Miss Mary Dougal for reading the MS and especially to my secretary, Miss Dorothy Dutch, for diligent and patient work.

S.A.W.

1 Introduction

One of the Englishman's greatest joys is in field sports—
they are all quite mad about them.

François de la Rochefoucauld, 1613–80
A Frenchman's England

The school of British sporting art is unique. From all the early animal, hawking and hunting pictures by continental artists no traditional treatment of the sporting subject emerged as it did in England, where hunting, racing and the development of the Thoroughbred horse not only encouraged but in fact instigated a national school of sporting art.

A devotion to animals and nature had always remained a basic quality of the Englishman whether it was the noble lord following hounds on his wide estate or the villager illicitly snaring a rabbit or a pheasant in the woods at night. It has been said that Walpole invariably opened the letters from his gamekeeper and huntsman before those of his sovereign, and in England this age-old love of sport could be considered a peculiar national trait that was not confined, as on the continent, almost solely to royalty and the court. The Englishman's home was not a castle but a country house where he could keep horses and hounds, and try to breed them faster and finer than his neighbour.

Though the aristocracy took precedence, only second in standing was the English country gentleman, for a rural property was the foundation of dignity and respect. Fortunes produced by commerce were astutely invested in country estates. By the nineteenth century every man of standing in Europe had adopted the English riding dress, not to indicate he was a horseman but that he was a *country* gentleman. This essential quality the British sporting artist has recorded for posterity in pictures, which

also provide a vivid documentary of the changing face of the English countryside between 1700 and 1900, when agriculture was emerging as the principal industry and sporting customs were being transformed to meet the new conditions.

This task required a many-sided talent, for not only were artistic facility and vision necessary, but also detailed knowledge of both human and animal anatomy allied to an understanding of the esoteric intricacies and traditions of field sports. A good likeness was not enough for the dedicated sportsman: every detail of horse and hound, every bit and breastplate, every shotgun and rod, had to be correct. Hardship of travel was also a perennial handicap to the artist; good health and endurance were required for frequent journeys by coach from Newmarket to Scotland, from Melton Mowbray to Yorkshire, in winter storms and summer heat. With these demands and conditions no wonder artistic standards were uneven; it is something of a miracle that these men so often produced pleasing and important pictures of the English country way of life and occasionally, for our delight today, paintings that are minor masterpieces by any artistic criterion.

Much has been written in the past of the school of British sporting art. Sir Walter Gilbey, Frank Siltzer, Guy Paget, Basil Taylor and that giant of them all, Walter Shaw Sparrow, have left few artistic facets unexplored. Today, this writer's reason for joining in a modest way that illustrious band of authors is to emphasize the fact that in the school of British sporting art there is a unique national heritage of immense importance; for here can be traced not only the history of field sports but of a complete way of life. The time has surely arrived to appreciate these pictures at their true worth and to encourage their more generous inclusion in the permanent collections of public art galleries.

Such sports as cricket, pugilism, foot racing, bull baiting and other typical English recreations have been omitted, and horse and hound have possibly played too large a part, but in the field sports of the British these two characters must inevitably fill the leading roles.

The works of certain artists may appear to have received undue emphasis. Stubbs obviously merits a chapter to himself. Sawrey Gilpin and James Ward, artists of lesser calibre, have also absorbed much space but, as innovators of a new romantic and emotional approach to sporting art, not undeservedly in the opinion of the writer. In contrast such giants of the sporting scene as Ben Marshall, John Ferneley Senr and John F. Herring Senr and many minor contemporaries have been considered more impersonally, for by their day sporting art had become an established school and it was the popularity and management of the different sports and not the aesthetic mood of the artist that dictated the type of picture. Though the book concentrates principally on the two hundred years 1700–1900 it has not seemed inappropriate to include the work of Joseph Crawhall, Robert Bevan, Lionel Edwards and Alfred Munnings whose painting in the early twentieth century linked the old traditions with the new. *Sporting Art* should, therefore, be considered as something of a personal miscellany, assembled to illustrate the quiet beauty and rich diversion of English country life during the eighteenth and nineteenth centuries.

2 Continental background

The history of Art is the history of revivals.

Samuel Butler, 1835–1902
Elementary Morality

The roots of British sporting art lie in the work of such seventeenth-century artists of the Low Countries as Jan Fyt, Jan Weenix, Melchior de Hondekoeter and Philips Wouwerman and go back even further, for Jan Fyt who died in 1700 was the pupil of Frans Snyders (b. 1579), painter of animals in works of Rubens. Even more important was the direct influence of Abraham Hondius, Jan Wyck and the Bohemian-born Wenceslaus Hollar, for these continental artists lived and worked in England at the same time as Francis Barlow, who was to become England's first native-born sporting artist.

Dutch and Flemish painters, however, cannot be considered consciously to have found their métier in the actual world of sport: animals and nature simply held all that age and its artists in fascinated curiosity, horse and hound, stag and game birds providing constant and stimulating inspiration. This fact when allied to the inherent English predilection for field sports provided fertile soil for the creation of a school of British animal painters.

An important link with the continental arts was provided by the young English nobleman of Stuart times who terminated his formal education by foreign travel, most often in France and Italy, with Paris, Venice and Padua as his goals. Part of the tour often lay through the Low Countries and Germany, and here inevitably the young man would admire both the works of contemporary painters and those of an earlier epoch, such as the hunting studies of Stradanus for the classic *Venationes* and the detailed

sporting prints of Hans Bol. Many splendid collections of England's stately homes owe their beginnings to the taste and prescience of these travellers.

Any young tourist of standing would almost inevitably have studied *haute école* at one of the schools of equitation which had spread across Europe from the teachings of the famous Italian *écuyers*, Federico Grisone and Giovanni-Battista Pignatelli. He would also have read the works of William Cavendish, First Duke of Newcastle, one of the great stud owners of the time who numbered Charles I, Prince Henry and James I among his riding pupils and was Governor to Charles II as a boy. His classic book on equitation, *A New Method and Extraordinary Invention to Dress Horses*, first published in 1658 in Antwerp in a French translation, engagingly directs correct mien in the saddle: 'You must look a little gay and Pleasantly but not laughing'. Even more important than the text are the enlightening engravings by Abraham van Diepenbeck, born in 1599, who came to live in England during the reign of Charles I. These illustrations demonstrate clearly the expertise required for such different 'airs' as the *courbette* (pl. 1), the *capriolle* and the *croupade* (skills, incidentally, which Johann Ridinger in the eighteenth century was also to record for the aspiring equestrian). The positions were frequently copied by portrait painters, for it was imperative in that day and age that gentlemen should show to the world at large their effortless efficiency and grace in the saddle. Apart from his engravings, van Diepenbeck also painted several huge portraits of horses for the Duke of Newcastle at Welbeck Abbey, precursors of the immense equestrian studies of John Wootton.

Many sporting pictures by foreign artists found their way to England as a result of these continental tours, including several pictures by Jan Weenix, many of them still-lives of game, painted life size. But his most important work (measuring some 11 × 8 ft) of dead stag, hares and boar, with a distant hunt in progress, decorated the hall of his patron, the Elector John William of the Palatinate, in his castle at Bensberg near Cologne. It is possible that news of this achievement may have led John Wootton to his huge creations at Longleat and Althorp. Weenix's nephew, Hondekoeter, was another artist working in England during this period, painting hunting scenes, animals and birds. Jan Fyt's studies of hounds also provided rich background for the hunting man, and in his own day his work was much esteemed and high priced in England. *The Hunting Party* (pl. 2) in rich sepias and bronzes, with the hawk and his master as the central focal point accompanied by a spotted hound—a type which appeared frequently in contemporary pictures—reminds us that in the late seventeenth century hawking was still known as 'The Sport of Kings', a title later appropriated by racing.

Philips Wouwerman (1619–68) in his country scenes and such pictures as *The Horse Market* shows another Dutch mood of the time, combining the elegant horses of the gentry and plebeian cobs of the peasantry with picturesque landscape effects to create romantic pictures. This quality James Ward, Thomas Gooch and, above all, George Morland were to inherit; and the tranquillity of paintings by such artists of the Low Countries as Aelbert Cuyp and Paulus Potter was also to be reflected in the works of many English sporting artists, with perhaps only Stubbs capturing that same quiet integrity of animal demeanour.

At the end of the seventeenth century hunting was organized in France with particular formality and magnificence. The stately ritual based on ceremony and precedence, many details of which exist to this day, was recorded in works by François Desportes, born in 1661, a pupil of the Flemish artist Nicasius. Though initially a portrait painter

he became official artist of the chase to Louis XIV and every opportunity to witness the sporting scene at first hand was made available to him. He accompanied the royal hunting parties and in such pictures as *The Wolf Hunt*, subsequently engraved by François Joullain, nobility and savagery are suggested with impressive emphasis.

The ceremonies of grand venery were also a favourite subject of Jean-Baptiste Oudry (1686–1755), a French artist of uneven talent, much influenced by Desportes. He was appointed Court Painter to Louis XV and designs from his works were used from 1736 by the Gobelins weavers. Most important of these were for the tapestry set 'Les Chasses du Louis XV', which includes formalities of sport with stag, boar and wolfhounds; certain groups from these designs were also painted in oils and greatly increased his reputation, copies occurring in unexpected places. Oudry's *The Stag Hunt*, for instance, engraved by N-C Silvestre, decorated the front of a chest of drawers made by J-L Grand-jean, now at Waddesdon Manor in Buckinghamshire. Many of his other designs made apt decoration on swords and fine sporting guns of the Napoleonic period and part of *Le Hallali du Renard* (pl. 3) can be seen engraved on a silver mount of the butt plate of a gun in the Wallace Collection, London. Such vivid scenes of the kill may possibly have influenced Sawrey Gilpin in *The Death of the Fox* (pl. 44) which was to create such an impression in 1793 at the Royal Academy Exhibition. The rich realism and romantic savagery of the style of both Oudry and Desportes remained entirely Gallic, though the latter artist visited England briefly and painted pictures there; nevertheless both provided a certain inspiration for such future English artists as James Ward and Edwin Landseer.

The continental art of hunting with its full ritual and ceremony owed little to the excitement of the chase; the skill of hounds and huntsman was purely incidental, for it was the grand ceremonial of the kill that provided the moment of truth for those few eligible by birth and position to participate. The brilliance of this epoch was eventually dimmed by the ruthless onset of the Revolution, and though hunting the wild boar and the stag eventually continued among the reinstated landed gentry it became, as it always had been, an activity for the privileged few, leaving a negligible legacy of sporting art.

In contrast, the simplicity of sport in England, especially in the seventeenth and early eighteenth centuries, where the English landowner, whether nobleman or squire, took out his own hounds and invited friends and neighbours to hunt the stag or even hare, seems far removed from the magnificent occasions on the continent. However, it was the early emigrés to this country who set the scene for Francis Barlow, artists such as the extrovert Abraham Hondius, a Dutch painter and etcher who spent much of his working life in England. His direct and realistic pictures in which bear baiting and wild boar hunts were frequent subjects won great popularity. It must be remembered that bear baiting, though banned by the Puritans who closed and destroyed the bear pits, was still being advertised in Queen Anne's reign. Most of Hondius's work, however, was still continental rather than English in emphasis, in contrast to the style of Hollar who had arrived in the country earlier.

It was the Earl of Arundel in Cologne on ambassadorial duties for Charles I in 1633 who had recognized the unique talent of the established etcher and topographer, Wenceslaus Hollar, and had persuaded the young artist to join his service and return home with him, where Hollar not only fell in love with England but married the Countess's personal maid. Hollar was to work for several London printers and book-sellers; his drawings and etchings covered almost every facet of English life. As a

dedicated anglophile and supporter of the Royalist cause Hollar was to share exile with the Earl of Arundel in Antwerp and after the Restoration he was appointed His Majesty's Scenographer and Designer of Prospects. Although his views of London before the Great Fire are justly famous, he is also well known for his numerous engravings of sporting activities and animals after Francis Barlow (pls. 4 and 5). Though prolific and hardworking, fortune never came his way and he died penniless in 1677; nevertheless, without Hollar the creation of the British school of sporting art might have been long delayed.

Francis Barlow's background is obscure, his birth in Lincolnshire being only tentatively dated *c.* 1626. Though mainly self-taught, it is known that at one time he lived in Drury Lane and studied with William Sheppard, a portrait painter—tuition not entirely wasted as his human figures are always depicted with assurance. Though he called himself a Londoner the country way of life was Barlow's speciality. Today he is remembered primarily as an etcher and engraver, and as early as 1652 he had etched with Hollar illustrations to Edward Benlowes' *Theophila or Love's Sacrifice*; but in his own period it was his work as a painter that brought him the greater acclaim. Thomas Rawlinson, the Stuart bibliophile, referred to Barlow as a happy painter of birds and beasts; John Evelyn the diarist records on 19 February 1656 that he went with Dr Wilkins, who was to become Bishop of Chester, to see Barlow 'ye famous painter of fowls, birds and beasts'. Here we have direct reference to an established English animal artist, the first one of native birth, who was to be referred to by W.Shaw Sparrow as 'The Father of English Sporting Art'.

Barlow had hoped in his early days for the direct patronage of John Evelyn, but the relationship between the two never came to fruition for various involved reasons, possibly from over-insistence by the artist. It was, however, for Evelyn's friend, Denzil Onslow of Pyrford in Surrey, that Barlow painted half a dozen of his most important works in oils. Today these can be seen near Guildford at Clandon Park. Barlow has been denigrated as a painter, largely because of George Vertue's belittlement of his colour sense and composition, but these huge pictures possess striking decorative qualities evoking the splendours of Snyders and Fyt. Most important perhaps is *The Decoy at Pyrford with Waterfowl at Sunset startled by a Bird of Prey*, measuring 159 in. × 110 in., which presents a kaleidoscope of activity and colour perceptively observed. Of equally high quality is the beautiful picture, *At Sunset after a Day's Fishing*, dated 1667.

Of outstanding interest to historians of the hound, the almost 12 ft long canvas *Southern-mouthed Hounds* (pl. 14), provides some unique detail of the type of polyglot hunting packs used towards the end of the seventeenth century. Big, heavy and slow, with a hint of the modern bloodhound, one hound is flecked with Dalmatian markings but of pointer conformation – a forerunner of Wootton's study of a similarly marked hound nearly seventy years later (pl. 7). In soft, muted colours the effect of this long frieze of hounds is both decorative and lifelike, and the introduction of a sprightly hare suggests this pack was used as both harriers and foxhounds. The tree-topped knoll emphasizes the woodland nature of their hunting country, with hounds carefully working out the line. Southern-mouthed hounds are described in 1686 by Richard Blome in *The Gentleman's Recreation* as 'thick skinn'd and slow footed'; they are 'most proper for such as delight to follow them on foot, as stop-hunting as some call it, but by most it is termed Hunting under the Pole'. Hunting under the pole meant that the hounds were

controlled and held up by the flourish of a stout stave by the unmounted huntsman. A hundred years later in 1807 foxhounds are described by the Rev. William B.Daniel in his *Rural Sports* (Vol. 1, p. 58) as 'deep-tongued, thick-lipped, broad and long-hung Southern hounds', qualities that had come over with realism in Barlow's immense picture. The artist's study, *Coursing* (pl. 6), of a greyhound of the day in pursuit of a mammoth hare is also informative as well as pictorially pleasing.

Demanding attention in the central hall at Clandon Park are two other oblong paintings by Barlow, one of an ostrich and the other of a cassowary, both painted three-quarters of their life size. One would have imagined both these birds were far removed from actual life study in Stuart England, but the constant portrayal of romantic and rare creatures is a feature of British animal painting. Menageries had in fact formed a part of the background of the national life from an early date and strange animals were certainly on view in London and other European centres. The famous rhinoceros that travelled far and wide over Europe was finally installed in the Amphitheatre at Verona, and an elephant exhibited at the White Horse Inn by Salisbury Court in Fleet Street in 1675 had been shipped from East India for Lord Berkeley at a cost of £2000. Contemporary artists could hardly have failed to satisfy their curiosity about these fabulous beasts.

Francis Barlow's illustrations for books on sport and nature contain many of his most animated drawings of rural life. Six books with plates by Barlow appeared, many of them engraved by Hollar who shared his skill and expertise with the young English artist. His work was associated with several other engravers, including his friend William Faithorne, and Francis Place, Richard Gaywood and Richard Cooper.

In the British Museum can be seen the 'Original Drawings Designed and Executed by Francis Barlow' from which Barlow etched the prints for his *Aesop's Fables*. Published at his own expense in the ill-fated year 1666, more than half the copies of the book were destroyed in the Great Fire of London, so it remains something of a rarity. In the 112 etchings, lions, hares, cocks and foxes are all drawn with great verve, and the familiar animals of the English scene share a sureness of touch with beasts of prey.

Of paramount interest are Barlow's drawings for his own book, *Severall Wayes of Hunting, Hawking and Fishing according to the English Manner*, published in 1671 and etched by Hollar, probably in collaboration with one of his pupils. Studies of stag, fox and otter hunting, rabbit catching, buck hunting with greyhounds, and different forms of hawking after heron, partridges and pheasants are effectively and vigorously composed, with animals and men drawn with skill and perception. As an artist Barlow understood animal form—anatomy, in fact, had been taught in schools in England even as early as the sixteenth century—and though there is often uncertainty in the conformation of his barebacked horses (pl. 4), his more confident drawings of the contemporary ridden hunter used in field sports show a docked horse with strong quarters, short head and wide-set eyes, that possesses some Neapolitan quality allied to the blood of weight carriers from the Low Countries.

In this set of plates and in the illustrations Barlow designed for Richard Blome's *The Gentleman's Recreation*, published in 1686, important and changing fashions in style and equipment are minutely chronicled, not always with absolute accuracy, for Blome's high opinion of hare-hunting was a relic of past tradition when the chase of timid 'puss' still held some prestige, later completely superseded by stag-hunting. In a plate published in 1671 Barlow shows 'the princely stag' pursued by the heavy slowhounds of the day and pulled down to his death in a scene artistically suggestive of later Oudry

tapestries. With perceptive eye he depicts the stag being hunted by greyhounds, the mounted followers riding with stirrup leathers already a couple of inches shorter than in Diepenbeck's straight-legged studies of *haute école*; riders were still, however, impeded in the field by ceremonial swords.

Barlow presents foxhunting in two traditional ways, the prey being either bolted from his hole or hunted by scent. As Blome says, 'There are few Dogs but will hunt the Fox with all imaginable eagerness'. Hounds are depicted by Barlow as big and heavy, accompanied by a huntsman on foot with stave in hand followed by mounted gentry on strong horses with flowing manes (pl. 5). Hern (heron) hunting with its accompanying bevy of spaniels must have required extraordinary skill, and Barlow's drawing shows attractive animation with the graceful birds forming a frieze overhead. Angling scenes of quiet fishermen wielding long rods emphasize that Francis Barlow's gifts were not merely those of the chronicler; his artistic approach to sport possessed both sensitivity and observation. Of specialized interest is one of the earliest British prints, *Shooting on the Wing*, and it says much for the docility of the contemporary sporting horse that mounted sportsmen with long-barrelled shot guns ever hit their mark—in this case partridge.

Another drawing depicts the popular sporting camouflage of the day, the stalking horse—in Barlow's version a bare back common cob—behind which the fowler on foot approaches unseen a covey of partridges. This was also recorded by Ridinger and the method itself was used in infinite variation for nearly another two hundred years. It appears again in James Ward's *The Deer Stealer* (pl. 45).

Francis Barlow seems to have had few English-born competitors, but his costly schemes of book production from The Golden Eagle, the shop started by him on New Street near Shoe Lane, rarely prospered and kept him impecunious. The only English contemporary animal artist to receive even minor mention was Somerset-born Marmaduke Cradock (1660–1717). His studies of birds and animals, highly praised by George Vertue, possess some genuine appeal and ability.

Francis Barlow died *c.* 1702 at the start of the eighteenth century when the mode and tempo of English country life were ideally suited to his successors. As he was esteemed more for his etchings than for his paintings, it is curious to find in the middle 1760s that his designs, so typically English in feeling, were used by Rococo carvers and reappeared as a theme for samplers. Though he founded no school nor initiated any original style, nevertheless he gave a native touch to the contemporary continental influence. His considerable talent for recording the animals and birds of the English countryside, for presenting the manners and customs of its field sports in pictures both informative and delightful, makes his the first important name in the long and varied roll of British sporting artists.

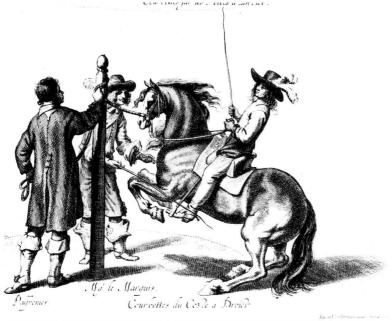

1 Abraham van Diepenbeck *Courbettes du Coste a Droict*
　　1658
　　Engraving
　　From The Duke of Newcastle's *La Nouvelle Methode et
　　Invention Extraordinaire de Dresser les Chevaux* Ant-
　　werp 1658
　　British Museum

2 Jan Fyt *The Hunting Party*
　　Oil on canvas 30 × 92 in. (76·2 × 233·7 cm.)
　　Tryon Gallery, London

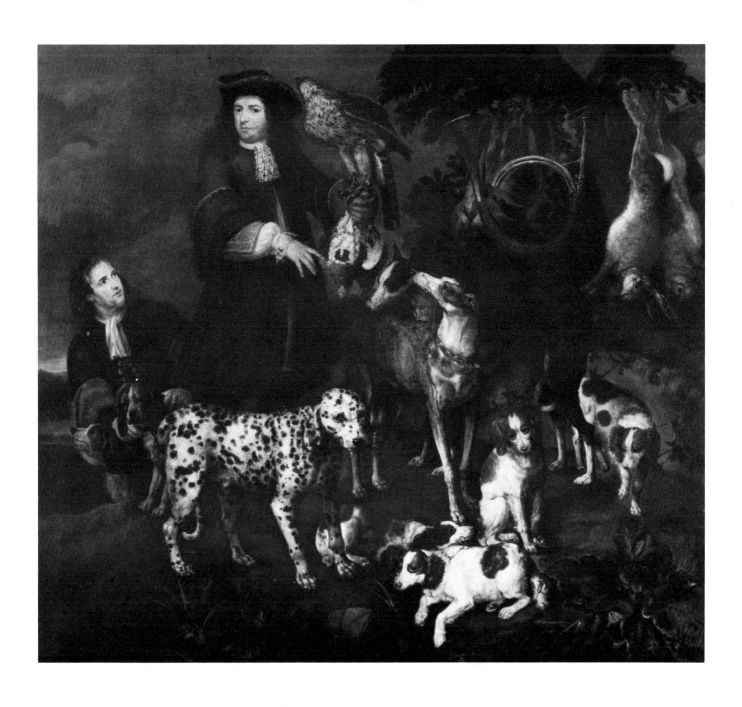

4 Wenceslaus Hollar, after Francis Barlow *Horse* 1671
 Etching 6 × 5 in. (15·2 × 12·7 cm.)
 British Museum

5 Wenceslaus Hollar, after Francis Barlow *Foxhunting* 1671
 Etching 6⅝ × 8⅞ in. (16·8 × 22·5 cm.)
 Reproduced by permission of the Syndics of the Fitzwilliam Museum, Cambridge

3 Jean-Baptiste Oudry *Le Hallali du Renard*
 Oil on canvas 68⅞ × 61 in. (175 × 155 cm.)
 Musée Condé de Chantilly, photo Giraudon

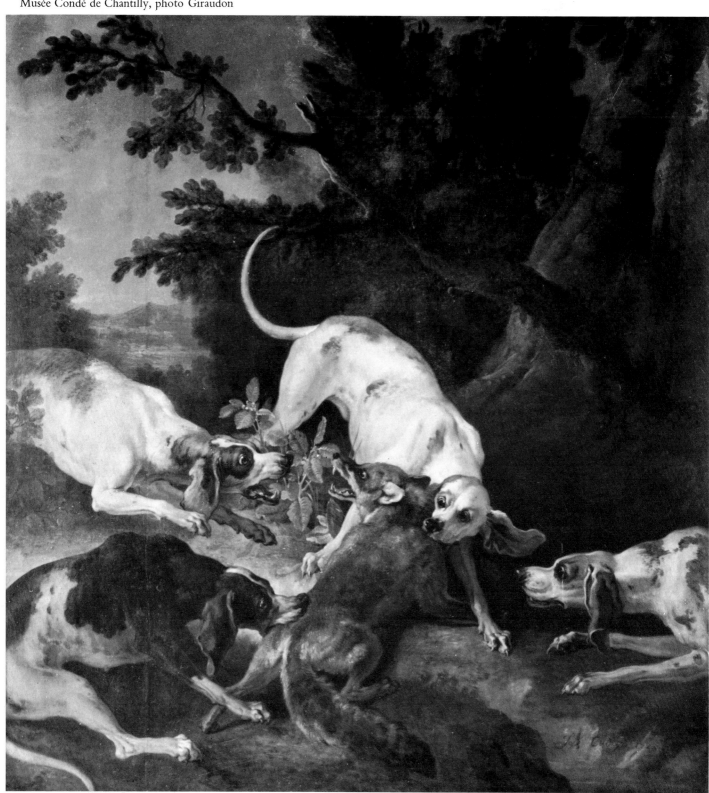

4

5

. FOX HVNTING .

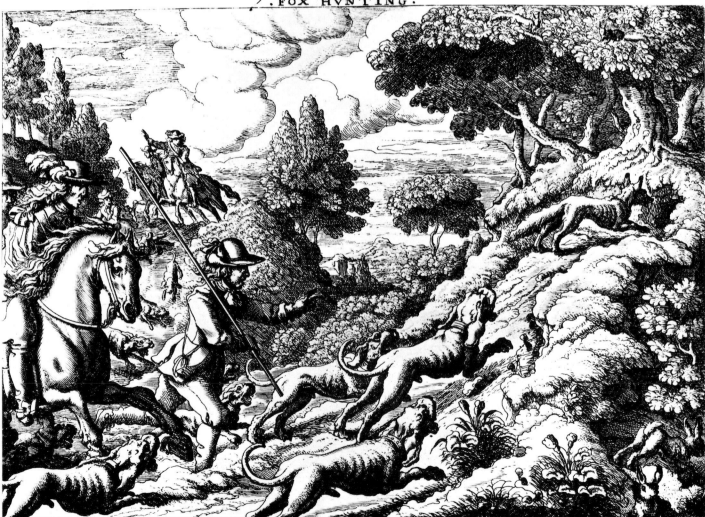

With Eger Hounds, the Fox is hard pursu'd . | Theire noble chase, and shew'd them Princely Sport.
Till him they Earth, whose Subtile shifts renew'd | Whose Death the Cuntrey pleases as the Court .

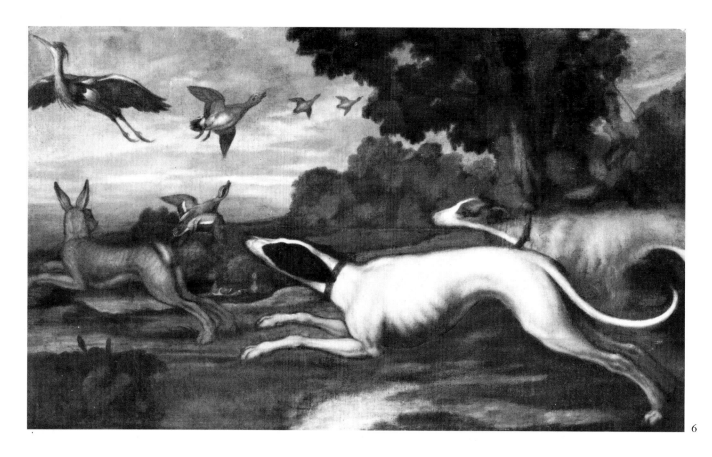

6

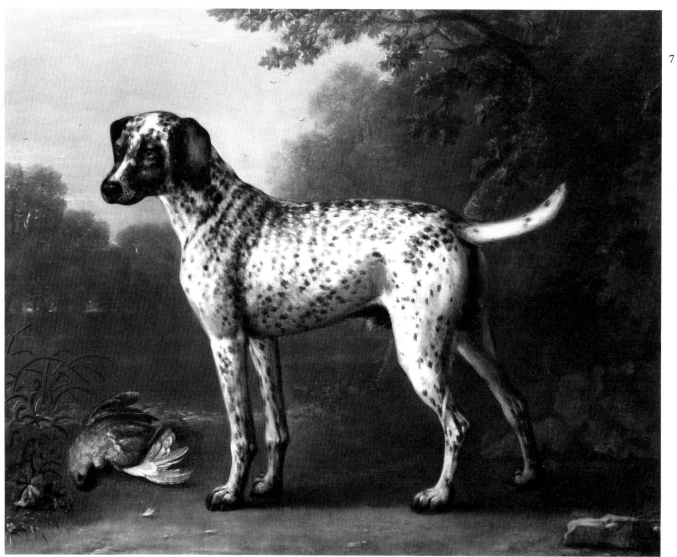

7

opposite

6 Francis Barlow *Coursing*
 Oil on canvas 43 × 72 in. (109·2 × 182·9 cm.)
 By permission of The Earl of Pembroke

7 John Wootton *A Grey Spotted Hound* 1738 (?)
 Oil on canvas 40 × 50 in. (101·6 × 127 cm.)
 From the collection of Mr and Mrs Paul Mellon, Upperville, Virginia, USA

8 Pieter Tillemans *Horse-racing at Newmarket: A Scene at the Start*
 Oil on canvas 34½ × 39¼ in. (87 × 99·75 cm.)
 From the collection of Mr and Mrs Paul Mellon, Upperville, Virginia, USA

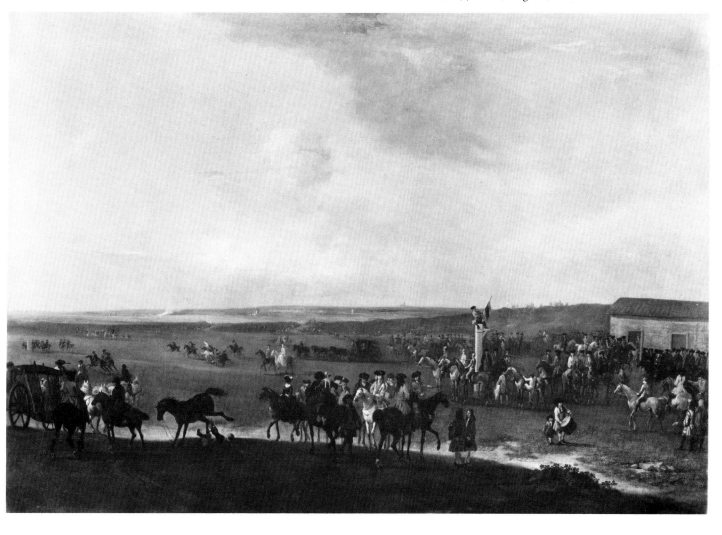

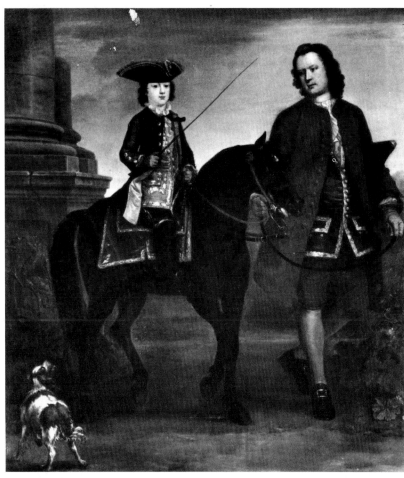

opposite

11 After John Wootton
The Byerley Turk
Engraving
Messrs Fores, London

12 After John Wootton
The Darley Arabian
Engraving
Messrs Fores, London

9 John Wootton *Fifth Duke of Beaufort*
Oil on canvas 76 × 68 in. (193 × 172·7 cm.)
By permission of The Duke of Beaufort, KG
Photo: Courtauld Institute of Art, London

10 John Wootton *Lady on Horseback with Huntsmen and Hounds* 1748
Oil on canvas 42 × 61¾ in. (106·7 × 156·8 cm.)
From the Collection of Mr and Mrs Paul Mellon, Upperville, Virginia, USA

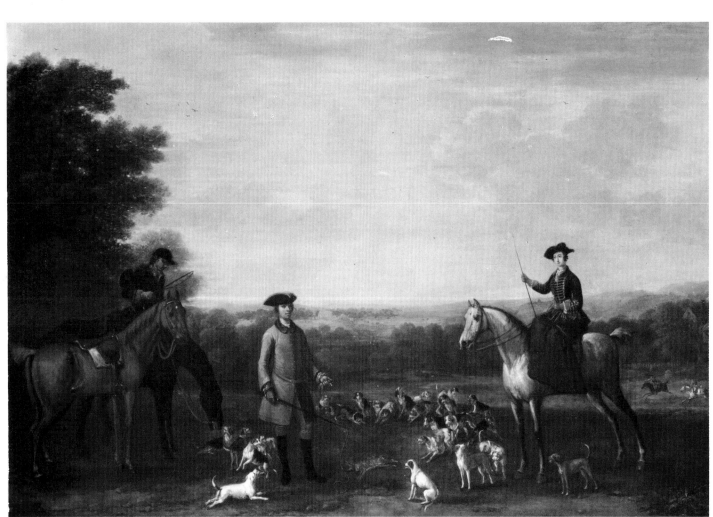

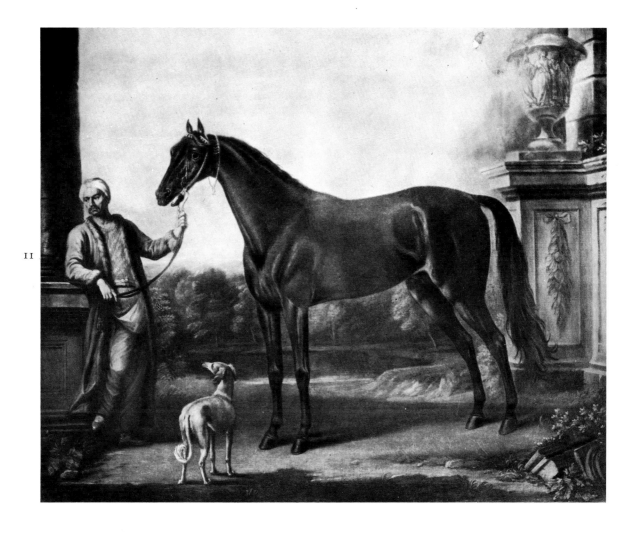

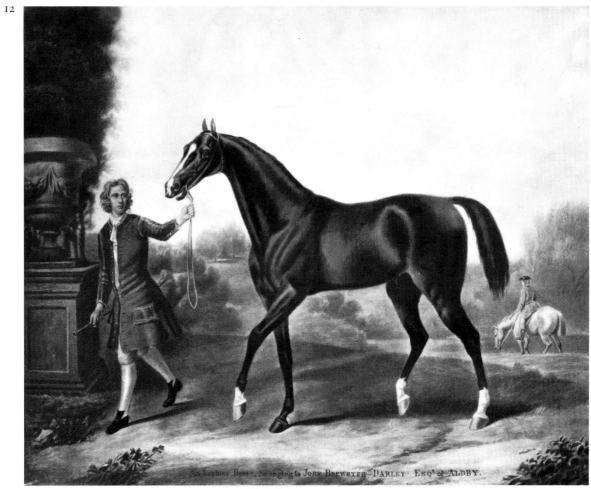

An Arabian Horse, belonging to John Brewster Darley Esq. of Aldby.

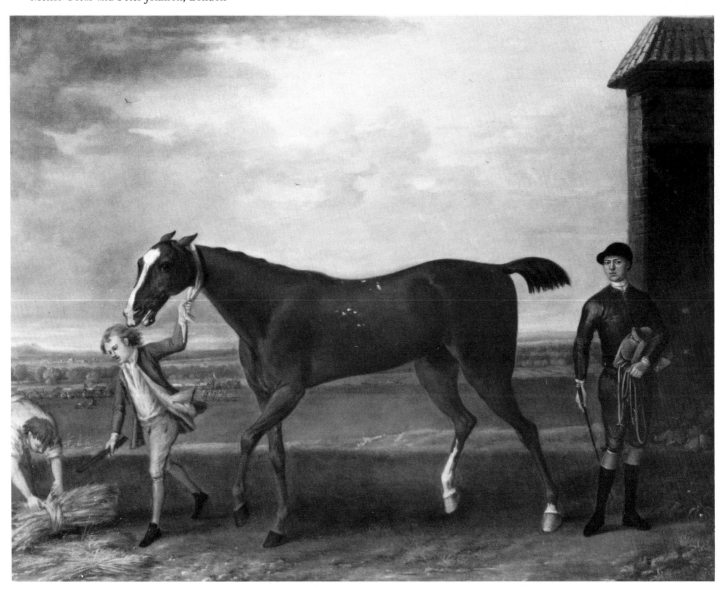

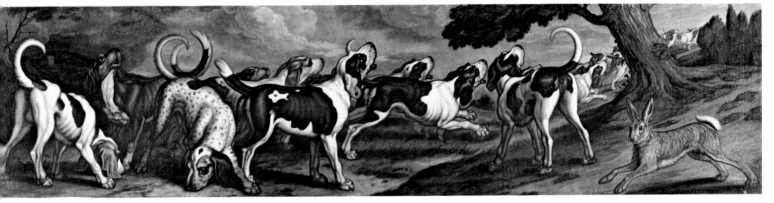

14

15

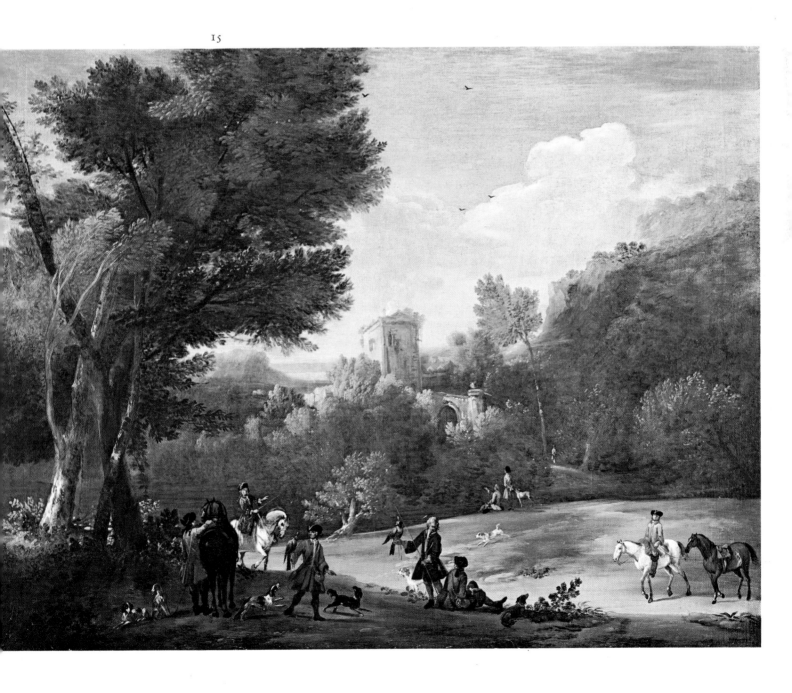

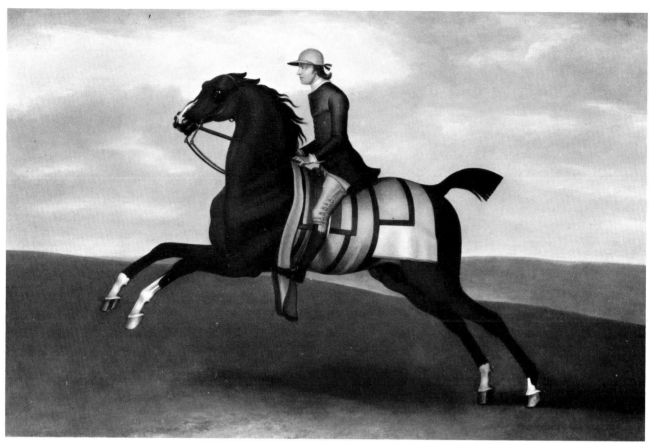

16 James Seymour *The Duke of Devonshire's Flying Childers with a Jockey Up* 1740
 Oil on canvas 35 × 53 in. (88·9 × 134·6 cm.)
 Messrs Arthur Ackermann & Son, London

17 James Seymour *The Chaise Match* 1750
 Oil on canvas 42 × 66 in. (106·7 × 167·6 cm.)
 From the collection of Mr and Mrs Paul Mellon, Upperville, Virginia, USA

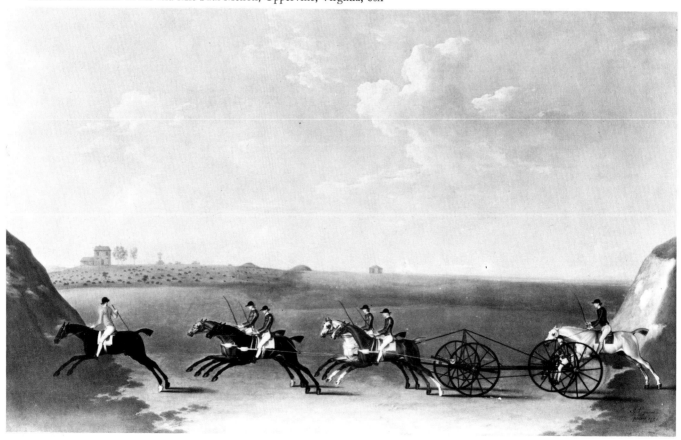

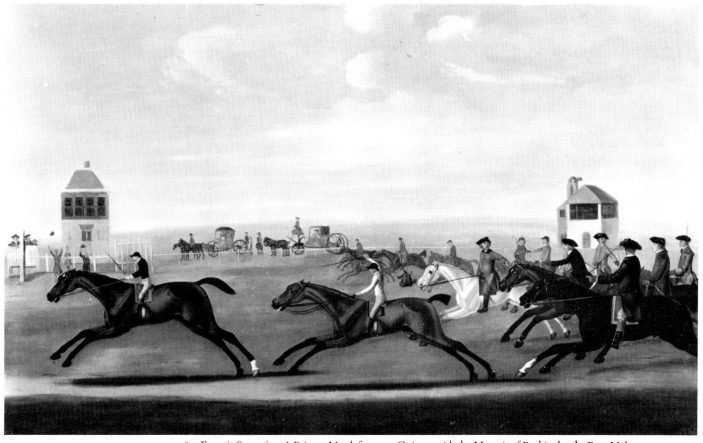

18 Francis Sartorius *A Private Match for 1000 Guineas with the Marquis of Rockingham's Bay Malton beating the Hon. Richard Vernon's Otho at Newmarket, April 21st 1766*
Oil on canvas 29¾ × 48 in. (75·6 × 121·9 cm.)
Messrs Arthur Ackermann & Son, London

19 George Stubbs ARA *The Duke of Richmond, his Brother Lord George Lennox and General Jones Out Hunting* 1759 or 1760
Oil on canvas 53½ × 99½ in. (135·9 × 252·7 cm.)
From Goodwood House, by courtesy of the Trustees

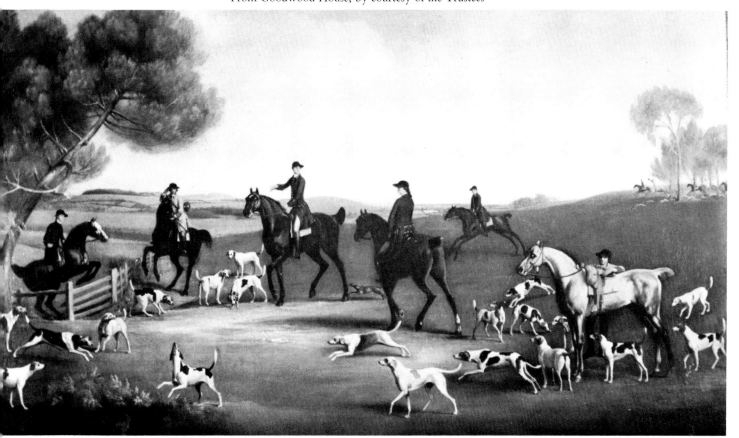

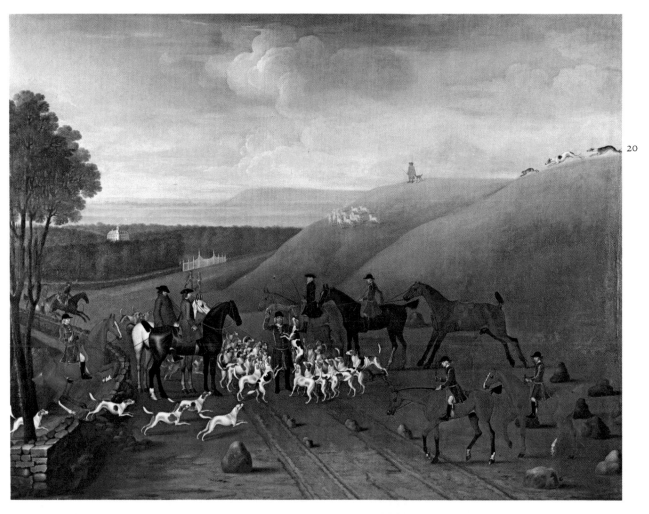

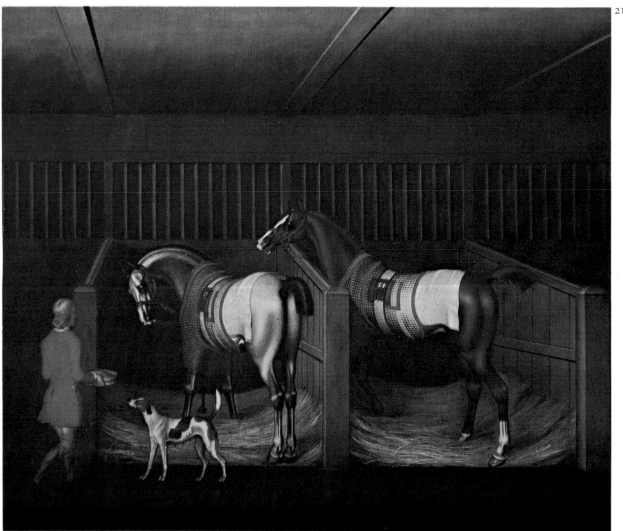

opposite

20 James Seymour *A Kill at Ashdown Park* 1743
 Oil on canvas 71 × 94 in. (180·3 × 238·8 cm.)
 Tate Gallery, London

21 James Seymour *Two Horses and a Groom in a Stable* 1747
 Oil on canvas 24½ × 29¼ in. (62·2 × 74·3 cm.)
 From the collection of Mr and Mrs Paul Mellon, Upperville, Virginia, USA

22 George Stubbs ARA *Lion Attacking a Horse c.* 1760–65
 Oil on canvas 96 × 131 in. (243·8 × 332·7 cm.)
 From the collection of Mr and Mrs Paul Mellon, Upperville, Virginia, USA

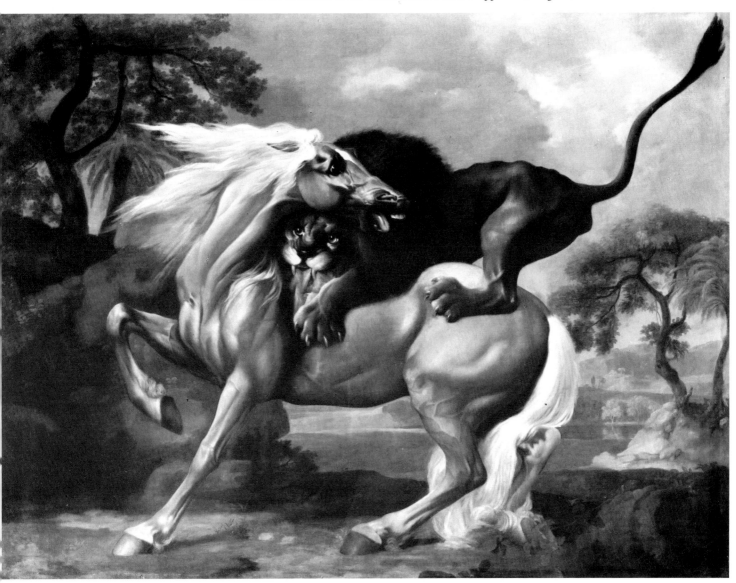

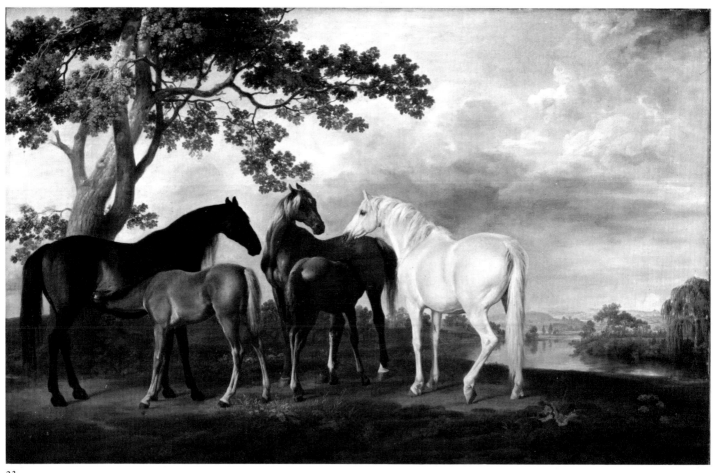

23

24

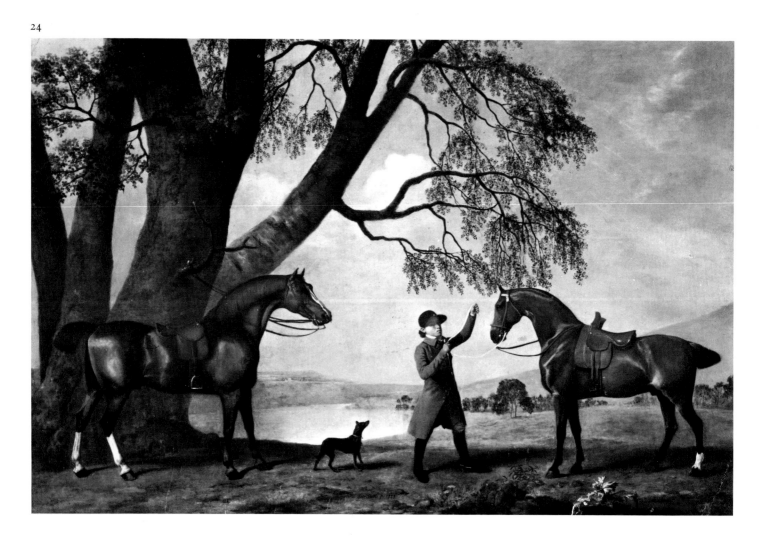

opposite

23 George Stubbs ARA *Mares and Foals in a Landscape c.* 1763–68
 Oil on canvas 39 × 62½ in. (99·1 × 158·8 cm.)
 Tate Gallery, London

24 George Stubbs ARA *Two Horses with a Groom and a Dog* 1779
 Oil on panel 36 × 53½ in. (91·4 × 135·9 cm.)
 Private collection, England

25 George Stubbs ARA *Mambrino* 1779
 Oil on canvas 33 × 44 in. (83·8 × 111·8 cm.)
 By permission of Lord Irwin

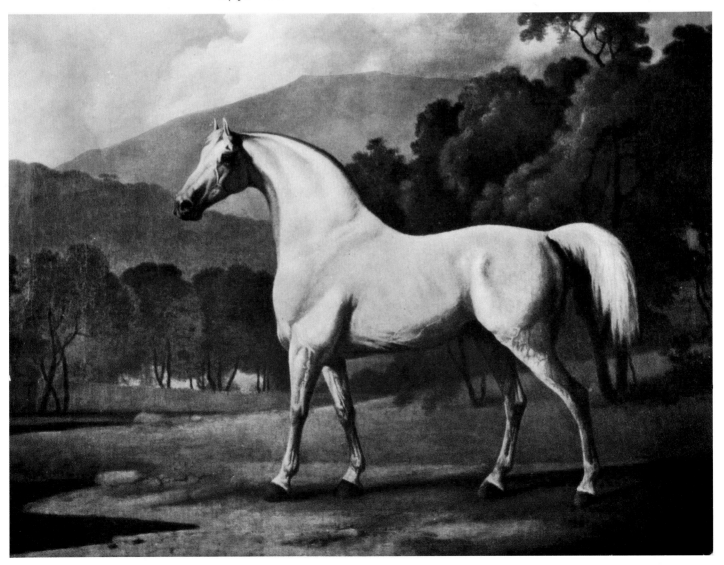

opposite

27　George Stubbs ARA *Laetitia, Lady Lade* 1793
　　Oil on canvas $40\frac{1}{4} \times 50\frac{3}{8}$ in. (102·2 × 128 cm.)
　　By gracious permission of Her Majesty the Queen

28　Sawrey Gilpin RA *Cypron, King Herod's Dam, with Her Brood* 1764
　　Oil on canvas $38\frac{1}{4} \times 61\frac{7}{8}$ in. (97·2 × 157·2 cm.)
　　By gracious permission of Her Majesty the Queen

26　George Stubbs ARA *Josiah Wedgwood and his Family at Etruria Hall* c. 1780
　　Oil on wood panel $47\frac{1}{2} \times 59\frac{1}{2}$ in. (120·7 × 151·1 cm.)
　　Josiah Wedgwood & Sons Ltd

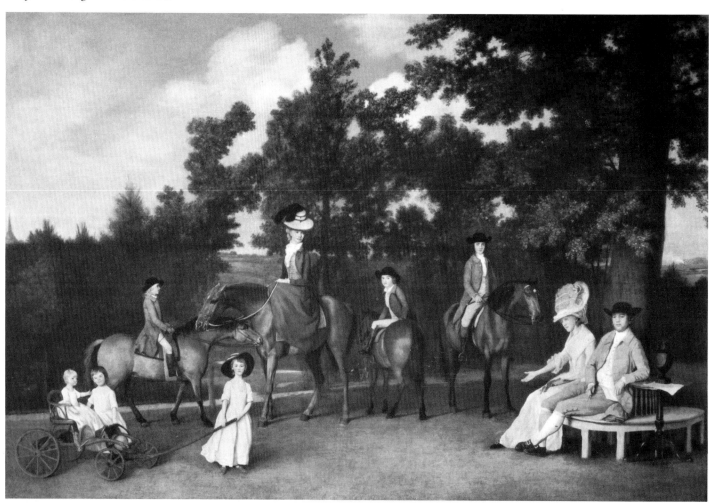

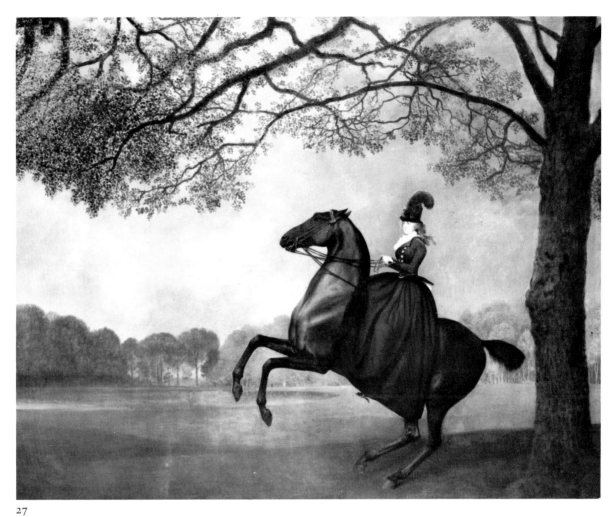

27

28

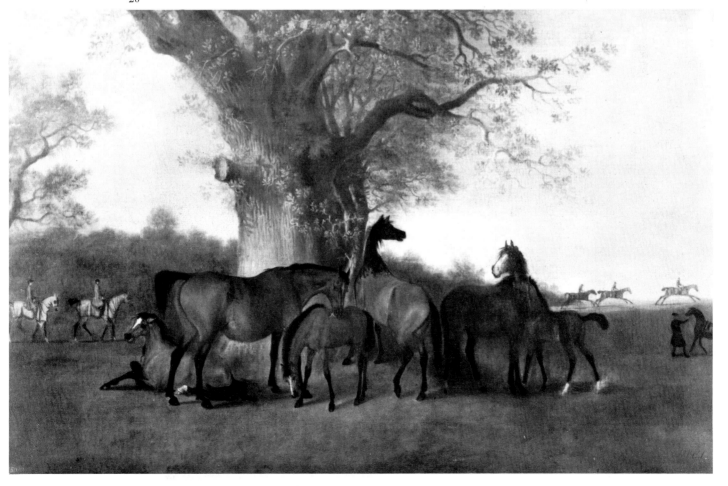

opposite

30 James Ward RA *Eagle, a Stallion* 1809
Oil on canvas 35¾ × 48 in. (90·8 × 121·9 cm.)
From the collection of Mr and Mrs Paul Mellon, Upperville, Virginia, USA

31 James Ward RA *Study for the Bunch of Grapes Tavern c.* 1827
Panel 10½ × 15¼ in. (26·7 × 38·7 cm.)
By permission of Lord Hesketh

29 Sawrey Gilpin RA and William Marlow *William Augustus, Duke of Cumberland, inspecting his Stud c.* 1764
Oil on canvas 41¾ × 55 in. (106 × 139·7 cm.)
By gracious permission of Her Majesty the Queen

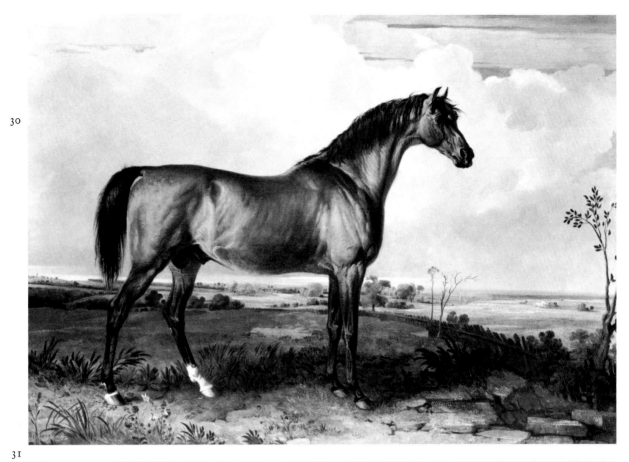

30

31

32 James Ward RA *Huntsmen Drawing a Covert*
 Oil on canvas 34 × 49 in. (86·4 × 124·5 cm.)
 Walker Art Gallery, Liverpool

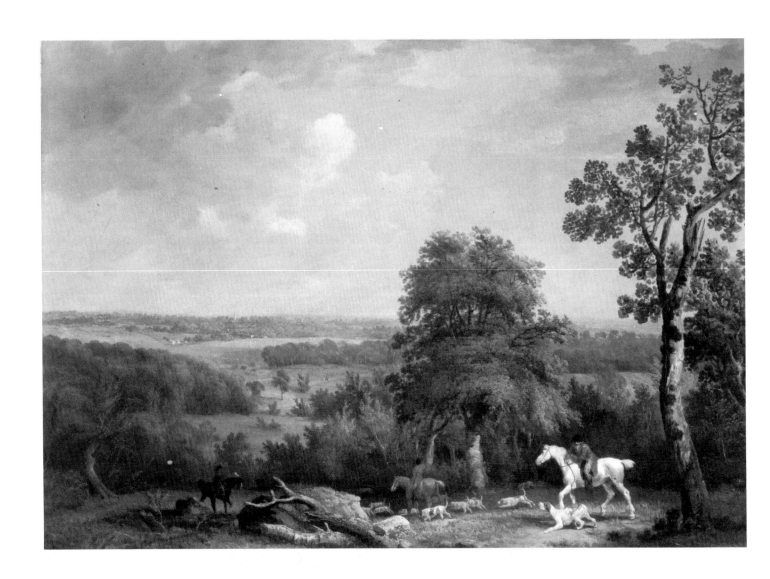

33 George Stubbs ARA *Reapers* 1795
Enamel colours on Wedgwood plaque 30¼ × 40½ in. oval (76·8 × 102·9 cm.)
From the collection of Mr and Mrs Paul Mellon, Upperville, Virginia, USA

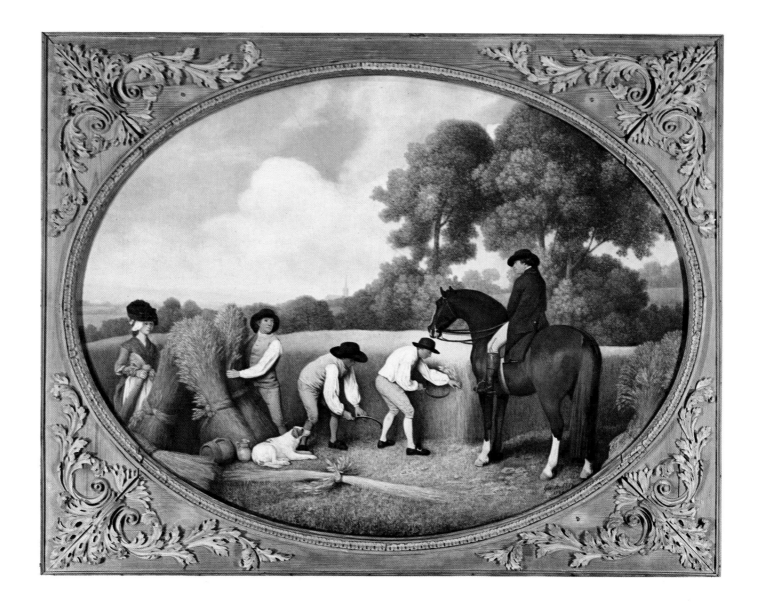

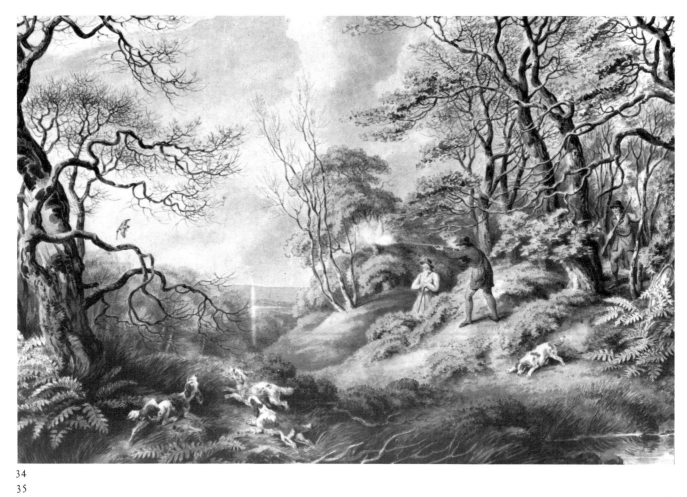

34

35

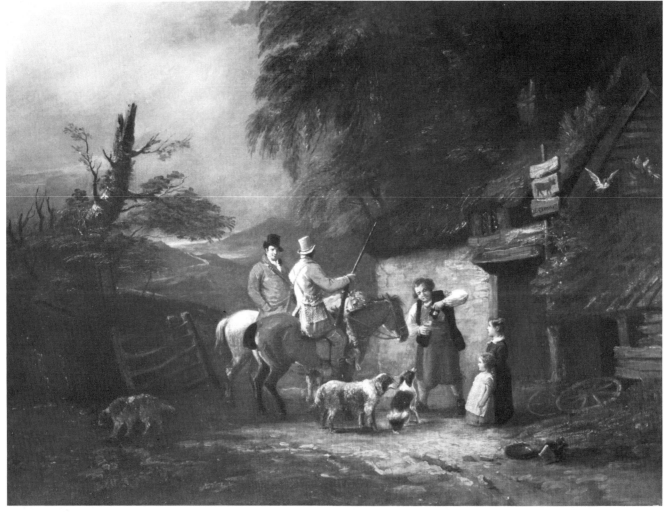

opposite

34 Samuel Howitt *Woodcock Shooting*
 Watercolour, one of a pair 13¾ × 20 in. (34·9 × 50·8 cm.)
 Messrs Frost and Reed, London

35 Luke Clennell *Sportsmen Regaling* exh. 1813
 Oil on canvas 45 × 59½ in. (114·3 × 151·1 cm.)
 By permission of J.F.S.Watson Esq.

36 Benjamin Marshall *Supposed Portrait of the Artist with a Gun and Dogs*
 Oil on canvas 40 × 34 in. (101·6 × 86·4 cm.)
 From the collection of Mr and Mrs Paul Mellon, Upperville, Virginia, USA

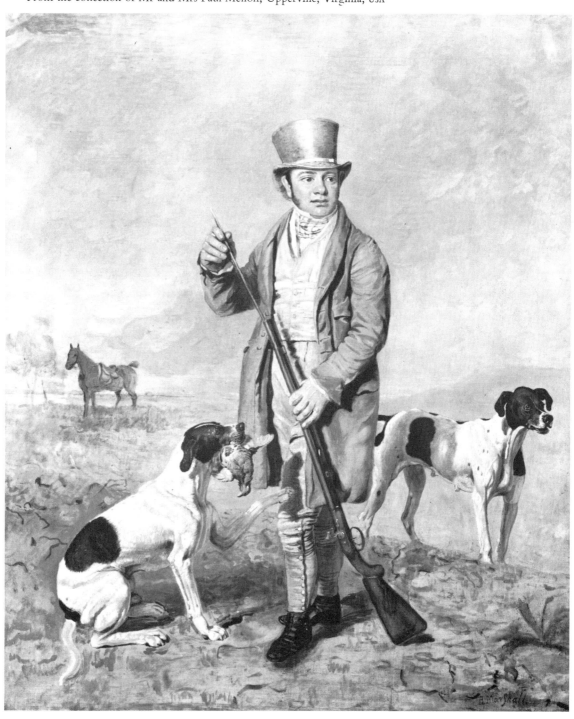

37 George Stubbs ARA *Phaeton with Cream Ponies and Stable Lad* c. 1785
Oil on panel $35\frac{1}{4} \times 53\frac{1}{2}$ in. (89·5 × 135·9 cm.)
From the collection of Mr and Mrs Paul Mellon, Upperville, Virginia, USA

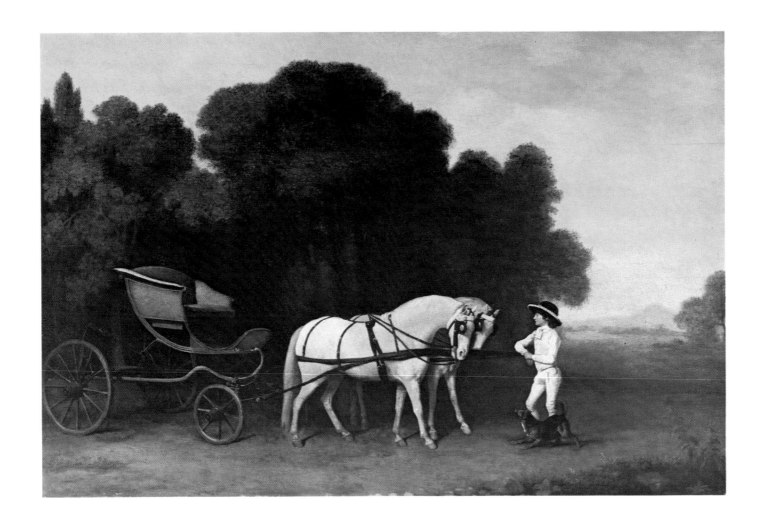

38 George Stubbs ARA *Freeman, Keeper to the Earl of Clarendon* 1800
Oil on canvas 40 × 50 in. (101·6 × 127 cm.)
From the collection of Mr and Mrs Paul Mellon, Upperville, Virginia, USA

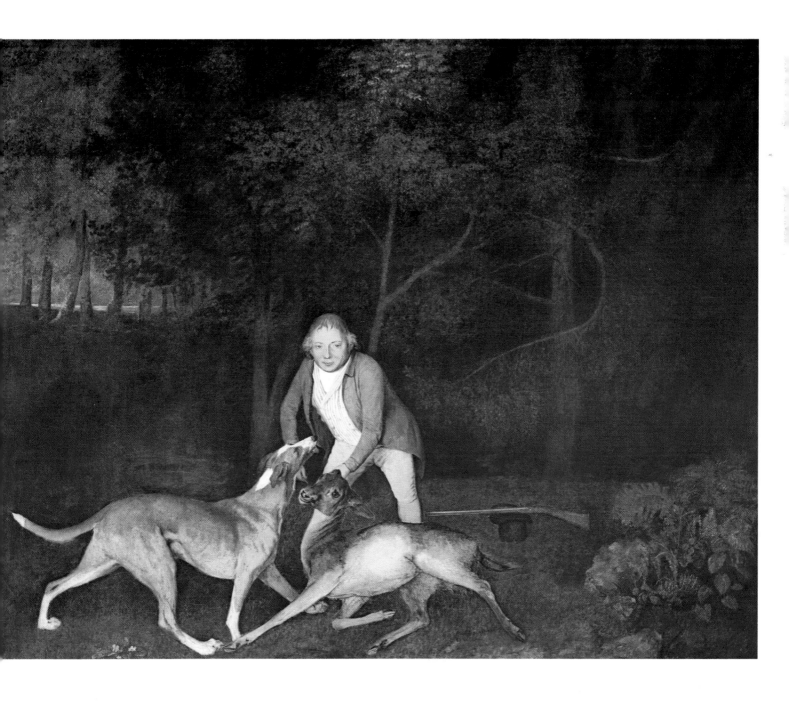

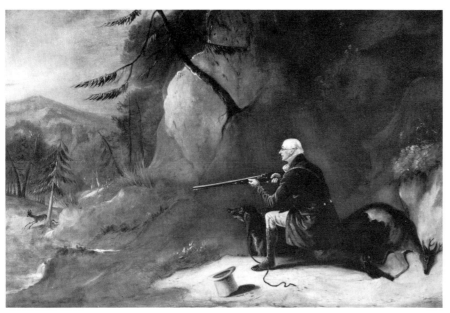

39 John Ferneley Senr *John Henry Bouclitch, Lord Kintore's Old Gamekeeper, Shooting Roe-deer at
 Keith Hall c.* 1824
 Oil on canvas 27 × 39 in. (68·6 × 99·1 cm.)
 Private collection, England

40 John Frederick Lewis RA *Buckshooting in Windsor Great Park* 1825
 Oil on canvas 39 × 54 in. (99·1 × 137·2 cm.)
 Tate Gallery, London

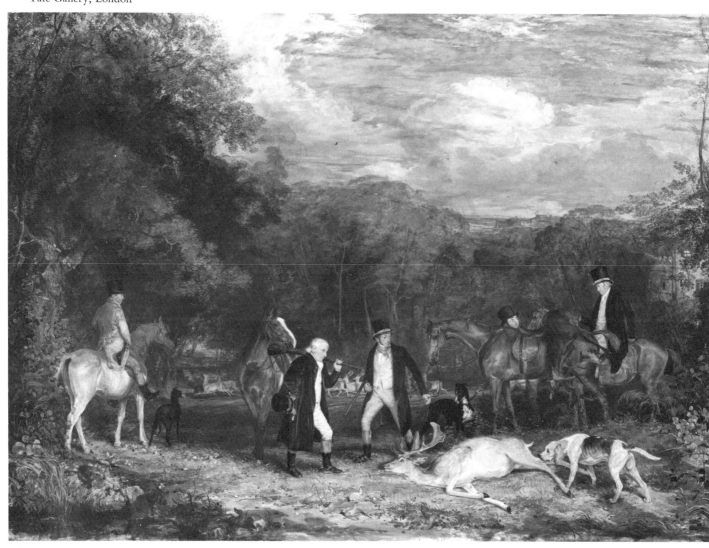

41 George Stubbs ARA *Lord Albermarle and Lord Holland Shooting at Goodwood* c. 1759
Oil on canvas $53\frac{1}{2} \times$ 80 in. (135·9 \times 203·2 cm.)
From Goodwood House, by courtesy of the Trustees

42 John Nost Sartorius *Coursing—Two Gentlemen with Greyhounds* 1806
Oil on canvas 27 \times $43\frac{3}{4}$ in. (68·6 \times 111·1 cm.)
Messrs Arthur Ackermann & Son, London

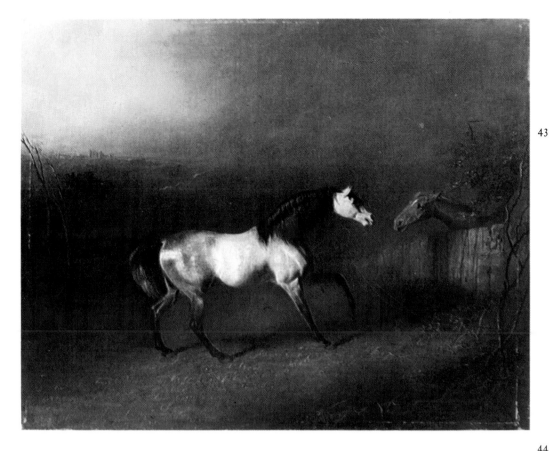

43

44

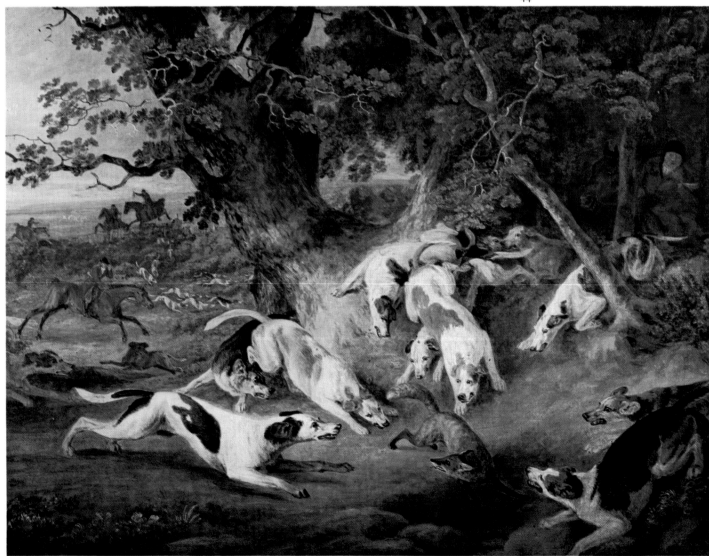

opposite

43 Sawrey Gilpin RA *A Grey Arab Horse*
Oil on canvas 28 × 35⅞ in. (71·1 × 91·2 cm.)
By permission of the Syndics of the Fitzwilliam Museum, Cambridge

44 Sawrey Gilpin RA *The Death of the Fox* 1793
Oil on canvas 146 × 80 in. (370·8 × 208·3 cm.)
By permission of S.C.Whitbread Esq.

45 James Ward RA *The Deerstealer* 1823
Oil on canvas 150 × 90 in. (381 × 228·6 cm.)
Tate Gallery, London

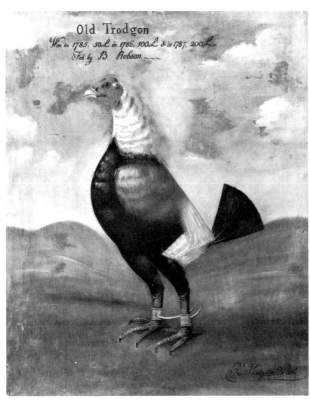

46 Robert Hodgson *Old Trodgon* (op. 1780–7)
 Oil on canvas 30 × 25 in. (76·2 × 63·5 cm.)
 Messrs Oscar and Peter Johnson, London

47 William Jones *Fishing*
 Oil on canvas 20 × 24 in. (50·8 × 61 cm.)
 Messrs Arthur Ackermann & Son, London

48 George Morland *The Angler*
 Oil on wood panel 8 × 5¾ in. (20·3 × 14·6 cm.)
 Moorland Gallery, London

49 James Ward RA *The Rev. T.Levett and his Favourite Dogs, Cockshooting* 1811
Oil on canvas $27\frac{1}{4} \times 36$ in. (69·9 × 152·4 cm.)
Richard Green Gallery, London

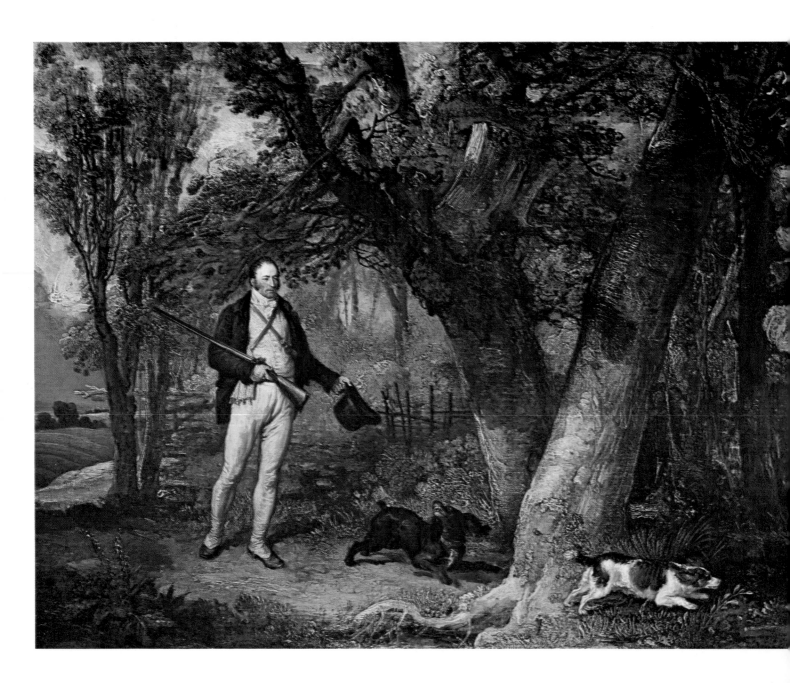

50 Thomas Gooch *Hon. Marcia and Hon. George Pitt Riding in the Park at Stratfield Saye House* 1782
Oil on canvas 27 × 25 in. (68·6 × 63·5 cm.)
From the collection of Mr and Mrs Paul Mellon, Upperville, Virginia, USA

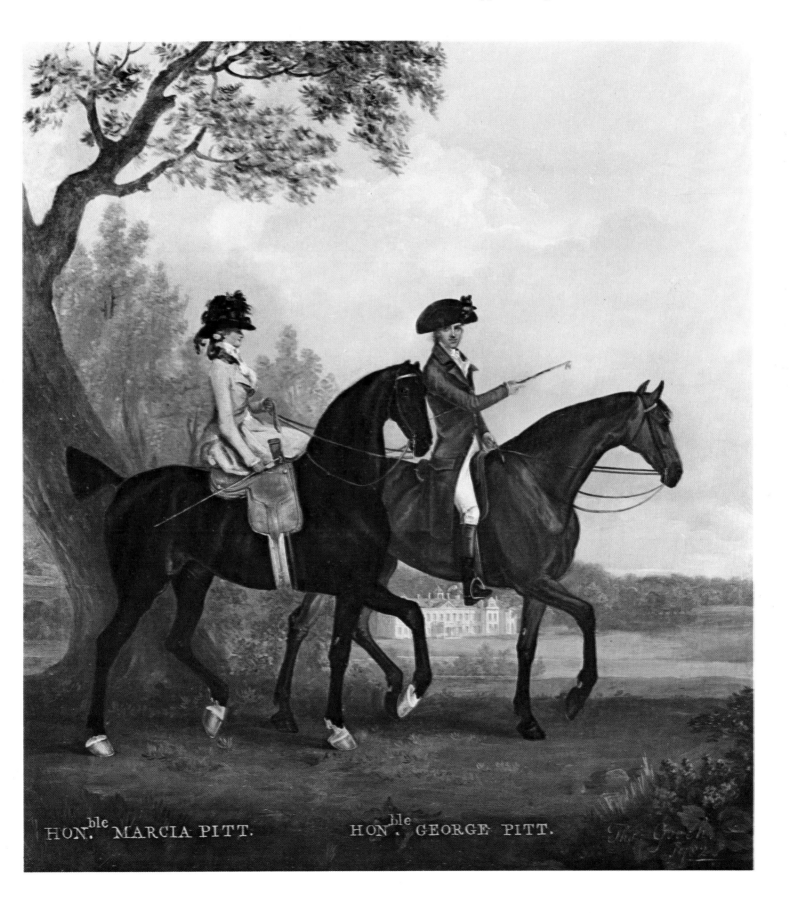

HON.^{ble} MARCIA PITT. HON.^{ble} GEORGE PITT.

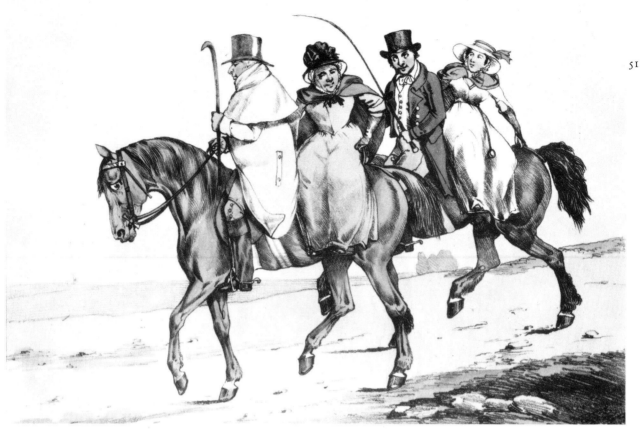

opposite

51 Henry Alken Senr *Yeomanry of England Paying a Visit* 1821
Hand-painted lithograph 6½ × 8¾ in. (16·5 × 22·2 cm.)
From *Humorous Specimens of Riding, etc., etc.* published by Thomas M'Lean 1821
British Museum

52 Henry Alken Senr *Lords View in the Park* 1821
Hand-painted lithograph 6½ × 8¾ in. (16·5 × 22·2 cm.)
From *Humorous Specimens of Riding, etc., etc.*, published by Thomas M'Lean 1821
British Museum

53 John Frederick Herring Senr *John Mytton Esq., of Halston, Salop* 1828
Oil on canvas 24 × 29 in. (61 × 73·7 cm.)
By permission of J.F.S.Watson Esq.

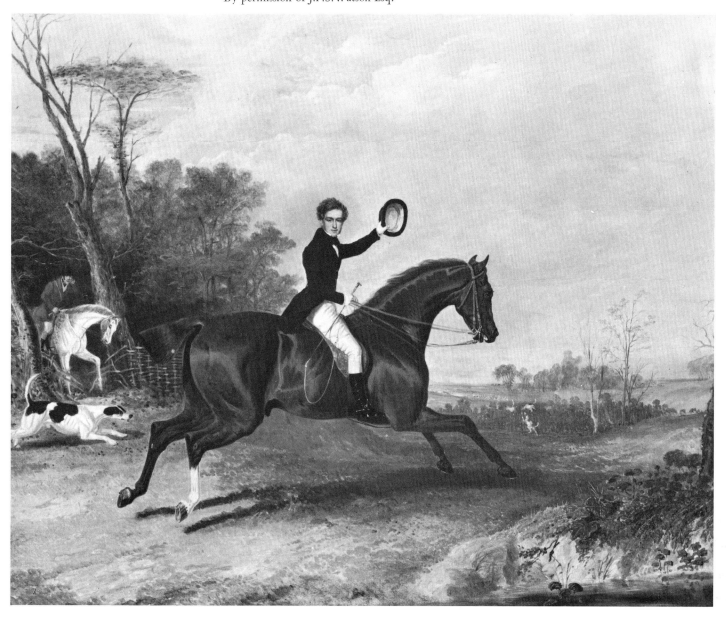

54 John Frederick Herring Senr *Mr. Richard Watt's Memnon with William Scott Up* 1826
Oil on canvas 30 × 40 in. (76·2 × 101·6 cm.)
Messrs Arthur Ackermann & Sons, London

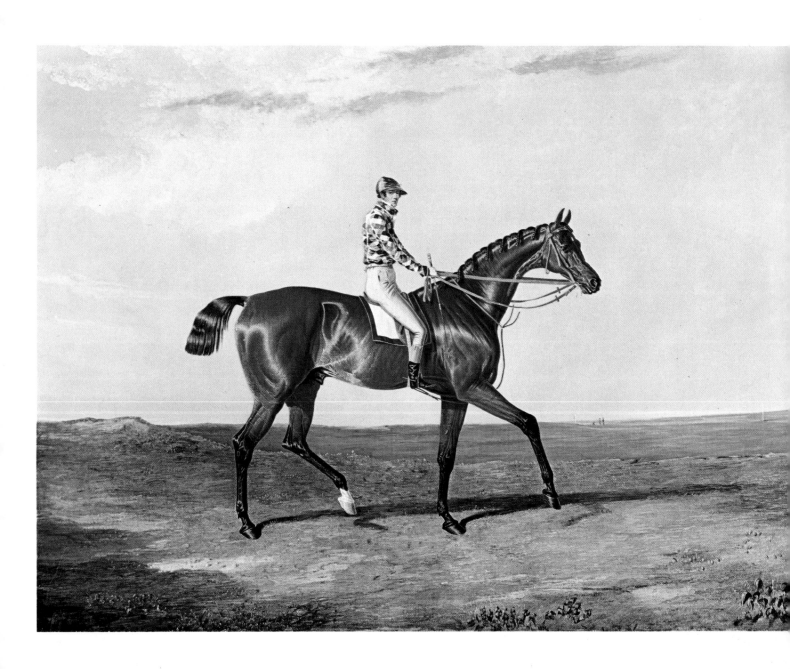

3 The arrival of the British school

Art and life ought to be hurriedly re-married and brought to live together.

Horace Walpole, 1717–97

The beginning of the eighteenth century provided new and golden opportunities in England for the animal painter. The leisurely pursuit of the hare and stag was being superseded by the speedier foxhunt; ahead lay the Enclosure Acts that were to result in the need for horses that could jump the new big fences as well as gallop; and, most important of all, the country way of life was becoming a significant status symbol for nobility and *nouveau riche* alike. Rapidly emerging was a new leisured class with both time and money, prepared to support and enjoy organized and sophisticated sport.

Economic and social conditions are all-important facts in an appraisal of the art of any period. At this time though the total population of England and Wales numbered under 6 million, less than 1·5 million people lived in towns; even the city of London was bordered by open fields. Rural pursuits and interests were a constant element in every-day life. The Puritans, though banning horseracing, had grudgingly approved hawking and hunting as conducive to good health and also as furnishing useful campaigning experience: in chasing beasts men were rehearsed for military manoeuvres. It was merely the enjoyment that had been morally deplored and not the actual exercise, and as Dryden's couplet neatly phrases it, 'Better to hunt in fields for health unbought, Than fee the doctor for a nauseous draught.' However, the restoration of the monarchy resulted in no return to the informal sporting regime of earlier days; it was a case of *autres temps, autres moeurs*. Though there was reaction from former Puritan restraint, under the leadership of Charles II sport became more organized, more decorous and, happily, less cruel.

Under the Stuarts from James I onwards Britain had accumulated national and individual wealth. The affluent built themselves stately homes, for the rich were very rich indeed; in fact the Earls of Newcastle, Shrewsbury and Worcester received annual incomes of £20,000. The eighteenth century witnessed the invasion of former strictly aristocratic preserves by wealthy commoners with fortunes made in cotton, linen, banking, mining and shipping; and many marriages took place between the business community and the county gentry.

Hunting and racing, once the private diversions of the nobility, became important status symbols for a much wider circle, and horseracing which had been a haphazard and local sport was eventually established as a highly organized activity enjoyed by both royalty and commoners, with high stakes the rule among the many heavy gamblers. Before the end of the century the five great classic races had commenced, the Jockey Club had been formed and bloodstock was the prized possession of the day, all factors that contributed to a demand for competent sporting artists.

Remarkable in this sphere was the influence of the new scientific approach to animal breeding, emphasized by the impact of imported oriental stallions, the most dominant being the Byerley Turk, the Godolphin Arabian and the Darley Arabian, which were to found the miracle horse of our age—the Thoroughbred—an unfailing subject for generations of animal painters.

With the onset of the eighteenth century the psychological moment had arrived for the constant employment of the sporting artist. Rich and influential country gentlemen, almost without exception, demanded pictures of their new stately homes, of themselves as masters of hounds, of their winners on the turf, of their pedigree farmstock, of a favourite dog, of their lady wife riding in their park. All these subjects became the priority commissions of the day. Dukes, squires and, of course, royalty were prepared to offer valuable patronage to the painter of talent and a few artists were ready to take advantage of the situation.

Initially the continental tradition remained well defined, but though for a long period many of England's sporting artists were to bear such names as Sartorius, Herring, Alken, Chalon and Barraud, the foreign influence fast disappeared and the character, style and reactions of these sons and grandsons of emigrés became almost aggressively acclimatized to the English way of life.

One of the first arrivals on these shores in the new century, twenty-four-year-old Pieter Tillemans, son of an Antwerp diamond cutter, came to England in 1708 to copy the works of such masters as Teniers and Jacques Courtois for a dealer named Turner, but before long he abandoned battle scenes to find ready patrons among the nobility, all anxious to commission pictures of their homes and horses. Soon he was working at Chatsworth for the Duke of Devonshire, painting scenes of the private race course at Knowsley for the Earl of Derby and acting as art instructor to Lord Byron. Later he completed 500 drawings in Indian ink on the *History and Antiquities of Northamptonshire* for one John Bridges, being rewarded at the rate of a guinea a day plus hospitality from his patron.

This topographical and descriptive element reappears in his many racing pictures. In particular, his later paintings of meetings at Newmarket are unique documentaries of sport at this Mecca of racing. Charles II's lavish patronage after the Restoration led to the little town's rapid growth and improvement. Betting for extravagant stakes ensured its popularity with fashionable sportsmen, and Tillemans, a man of attractive personality, gregarious and presentable, was not slow to make the most of these

opportunities. His wide, narrow canvases, necessitated by the panoramic scope of his compositions, record many important sporting occasions on the Heath and were often engraved by himself and contemporary artists.

His picture, *George I at Newmarket*, one of a set of four, presents fascinating detail of the day and age. Horseflesh varies from the stylish hacks of the nobility and the quality bay of the King, to a detachment of lifeguards with their plebeian troop horses and Tregonwell Frampton, that Father of the British Turf, and his companion on sturdy cobs; the famous Flying Childers leads a string of racehorses in the distance. In another study, *Horseracing at Newmarket: A Scene at the Start* (pl. 8), the central figure on a grey horse is also presumed to be George I and the lady in the carriage Queen Caroline. In both these paintings the details of horses and riders, the distant view of Newmarket town with its spired church and a faraway glimpse of Ely Cathedral, have been painted with clarity and perception. In both, racehorses are depicted at rocking-horse gait, swathed in coloured rugs and headcaps and tightly girthed to induce the excessive sweating at that time considered a vital ingredient of training. Though recording specific events and painted therefore to a difficult formula, these pictures possess a facility of composition that is infinitely agreeable.

Tillemans was buried in East Anglia in 1734 in the churchyard at Stowlangtoft, where the register describes him as 'Peter Tillemans of Richmond in County of Surry [sic]'.

The British school of sporting art includes several artists of versatile and outstanding talents who could assuredly have made their names as painters of landscapes, battle scenes and mythological subjects, as engravers or even as sculptors, if field sports had not claimed first place in their working career. Of these Stubbs, Ward, Sawrey Gilpin, Cooper and Landseer come to mind, and equally John Wootton. Born *c.* 1677, his landscapes in the style of Poussin would alone have made his name, but fortunately the times were propitious for Wootton to turn to the sporting scene. His background is obscure and even George E. Kendall in his assiduous research for his 'Notes on the Life of John Wootton', though he elicited details of Wootton's marriages and the baptisms of his children and a definitive list of his nineteen engraved works, failed to produce any facts about the actual date and place of his birth.

Of vital importance to Wootton's artistic development is his early association with Jan Wyck, a Dutch artist born *c.* 1640, who lived the greater part of his life in England and died at Mortlake in 1702. Wyck became a skilled exponent of hunting subjects in which the sporting ritual and decorative backgrounds, though painted with considerable artistic skill, appear more continental than English in inspiration. A typical example is the study, *Harehunting*, with hounds urged on by a dismounted huntsman and a noble horseman on a fine grey presented *en levade*. Wootton's own talent benefited immeasurably from Wyck's professional tuition; many other British sporting artists were to be self-taught and never entirely surmounted the handicap. Many of Wootton's early pictures were influenced by Wyck's romantic approach, as in *A Hawking Party in a Wooded Landscape* (pl. 15), where an exquisite lady's magnificent grey of the prized Neapolitan blood is contrasted with her retainer's plebeian horse of common head and poor action in the right foreground. Wyck's influence also ensured a lasting appreciation of pictorial effects, of cloud formation and variation of light and shade and Wootton's subtly toned and sensitively composed landscapes were to play an attractive part in his sporting pictures.

Although Wootton also painted seascapes, battles and religious scenes, the demands

of his hunting and racing patrons proved, at least for the first half of his life, irresistible. The Second Duke of Beaufort was Wootton's earliest benefactor; he quickly recognized the young artist's outstanding talent and generously sent him to study in Rome some time during the first decade of the eighteenth century. Such patronage assured Wootton's success and resulted in a flood of work from such influential families as the Beauchamps, the Grevilles, the Thynnes and, of course, the Royal Family. There are important scenes of the Royal Buckhounds by Wootton in Windsor Castle, several of his paintings are at Longleat and Blenheim, and twenty at Welbeck Abbey in Nottinghamshire. Wootton became the fashionable sporting painter of the day, wealthy and popular, and moved from Covent Garden to a well-appointed house in Cavendish Square with behind it 'a large noble painting Room', where, according to George Vertue, 'Mr John Wootton by his assiduous application to the prudent management of his affairs rais'd his reputation and fortune to a great height, being in great vogue and favour with many persons of the highest quality'. (Add MSS 23076 (f. 23b.), British Museum.)

Just consideration of Wootton as a painter of animals presents certain difficulties. Some of his most interesting work is not only of immense size but is framed structurally into the walls of such stately houses as Althorp in Northamptonshire and Longleat in Wiltshire. The pictures at Althorp, however, were not painted *in situ*, for the First Earl of Egmont writes on Sunday, 7 April 1734 'I was called . . . by cousin Ned Southwell to go to Wootton the Painter's to see some noble large hunting pieces made by him for the Earl of Sutherland to be set up at Althorp. He is the best painter of horses in England.' (Historical Manuscripts Commission, MSS of the Earl of Egmont, ii. 78.) These huge paintings presented Wootton with problems unsuited to his talents: a near life-size horse demands an intimate knowledge of equine anatomy and a wide sweeping brush, attributes which Wootton lacked. It is possible that he received assistance from Tillemans and James Seymour in these mammoth compositions, for the sheer area of canvas to be covered may well have daunted any one man; but though time and dust have dimmed the rich greens and sepias, something of the original pastoral beauty and impact of these park scenes, horses, hounds and retainers still remains.

Members of the Beaufort Hunt (Tate Gallery, London) illustrates Wootton's inherent eye for the arcadian scene, a quality emphasized at Longleat in the immense canvases of the Weymouth family and their horses. Other paintings there include a spirited rendering of two fighting stallions which pre-dates similar studies by Stubbs and Ward. There are also individual pictures of hounds, for the artist possessed an adroit brush for canine attitudes, as shown in his other studies of greyhounds, pointers and the popular King Charles spaniels, and never better than in his painting *A Grey Spotted Hound* (pl. 7). This picture bears interesting resemblance to the flecked pointer type in Barlow's *Southern-mouthed Hounds* (pl. 14) and Jan Fyt's *The Hunting Party* (pl. 2). Spotted guard dogs had been bred on the borders of Dalmatia and Croatia from ancient times and travellers appear to have brought home some of these animals. Zuccari and Castaglioni had both painted Dalmatian type dogs resembling pointers. Another important canine commission came from Horace Walpole who wrote 'Patapan [a favourite dog] sits to Wootton tomorrow for his picture. He is to have a triumphal arch at a distance to signify his Roman birth and his having barked at thousands of Frenchmen at the very heart of Paris.' (*The Letters of Horace Walpole, Fourth Earl of Orford*, ed. P. Toynbee, Clarendon Press, Oxford, 1903, i. 343.)

Wootton's pictures at Badminton in Gloucestershire are of more acceptable dimen-

sions and in richly gilded frames from designs by William Kent, who was also responsible for the plaster work and furnishings of the Great Hall; they do not form an integral part of the wall fabric. Here it is possible to comprehend fully the manner of early eighteenth-century hunting. In the seventeenth century hounds hunted deer and fox, and the harriers, of course, hare from Badminton; but from 1761 sport centred solely on foxhunting and has remained so ever since. There is no written record of the early hounds at Badminton, the first actual Hound List starts in 1728 with harriers, but such hunts as the Old Charlton, Bilsdale and Mr Boothby's number themselves among the first to hunt specifically fox from as long ago as the seventeenth century. The harriers are pictured in *Hare-hunting on Salisbury Plain*, accompanied by the Third Duke of Beaufort and his huntsman. This is a delightful picture of a rural meet with a shepherd and sheep in the centre, hounds relaxed, and Tilsbury Hill in the distance.

First-hand evidence of the early eighteenth-century hunter can be obtained from Wootton's pictures of two greys, two chestnuts and two bays, painted for the Second Duke of Richmond at Goodwood House. Five of them are mentioned individually by name in the Old Charlton Hunt letters, and the sixth was known as 'Bay Bolton, got by the Famous Bay Bolton'. With Wootton's eye for a landscape attractive details abound—a glimpse of Old Goodwood House, Chichester Cathedral, the harbour with shipping. Hunt servants, grooms and hounds play their part; the horses are depicted as individuals, though of sensible rather than elegant conformation, and appear eminently suitable for the woodland hunting of Sussex.

Wootton's talents were also in demand as an equestrian portrait painter. He painted George II twice, once on a dark chestnut, whose mane is plaited with blue ribbon, and once on a grey. This second picture was commissioned for Lord Hubbard, and Mr Jarvis, the Court painter, was supposed to put in the face; the result, however, was considered a poor likeness. Wootton's splendid study of Tregonwell Frampton, who had received the title of Keeper of the Running Horses to His Sacred Majesty King William III in 1695 and kept the appointment under Queen Anne and the first two Georges, must rank as a real *tour de force*. He depicts this great character of the contemporary sporting scene in old age, wizened, secretive and crafty, with his favourite greyhound, his trimmed fighting cock at hand and a medallion commemorating his racehorse Dragon in the background. A portrait possessing great charm and painted in large and small versions is that of Henry, Fifth Duke of Beaufort, as a small boy, wearing a blue coat and pink waistcoat (pl. 9). His black pony, with an unusually refined head for the times, is led on the near side by a stalwart man in a russet-brown coat. The confident upright pose of the young rider with long whip held high at the *haute école* angle evokes van Diepenbeck's earlier study of the young Prince Charles (later Charles II).

Women's acceptance in the world of field sports in that age remained anything but universal: child-bearing was still their time-and energy-consuming occupation. But several ladies of quality played a decorative and serious part in equestrian sport, encouraged by such extroverts as Diana Draper who acting as whipper-in to her father William Draper, an early Master of Foxhounds in Yorkshire, was famed for her holloa and reckless riding. In 1723, according to a letter sent to the Harley family, a Mrs Aslibie arranged a flat race for women, nine of them, riding astride and dressed in short breeches, jackets and jockey caps, but it was held to be 'an indecent entertainment'. More decorous are Wootton's equestrian portraits, *Lady Henrietta Harley Hunting the Hare on Orwell Hill*, a work for which he received £53 15s., and another of Lady

Henrietta standing by her dun mare, which was sold for sixty guineas, both considerable sums in those days. Wootton never undervalued his abilities and George II complained, without success, at the prices he demanded. In another portrait, a horsewoman traditionally identified as Lady Mary Churchill, illegitimate daughter of Sir Robert Walpole, but now thought probably to be Princess Amelia, daughter of George II, wears a costume of a Ranger. Here hounds seem light and puny by modern standards and for the horses bang tails have come into fashion, to endure for the next hundred years. (pl. 10.)

It is also to Wootton that the equine historian looks for a pictorial record of the oriental stallions, in particular the Byerley Turk, the Godolphin Arabian and the Darley Arabian, ancestors of the Thoroughbred. Today it is considered that all three were probably of pure Arabian breed, for the terms Arab, Barb or Turk were applied indiscriminately to horses imported from the Near East, depending often only on their port of embarkation or the nationality of the vendor. From the times of the Crusaders pure-bred Arabians had occasionally reached England but at the beginning of the eighteenth century stallions began to arrive in sufficient numbers to exert a real influence on horse-breeding. Because of their outstanding quality and prepotency, in addition to their value as an investment, they became prized possessions and every owner demanded paintings of his Arabian horses.

The Byerley Turk was brought to England from Buda in 1687 by Captain Robert Byerley, when he returned from service against the Turks. It is doubtful whether Wootton's portraits of him were painted from life (pl. 11). The Godolphin Arabian, originally a present from the Emperor of Morocco to Louis XV of France, was allegedly discovered between the shafts of a cart in Paris by Mr Edward Coke and bequeathed by him to the Second Earl of Godolphin. This stallion is always depicted with an abnormally high crest and is often accompanied by the stable cat to which he was devoted. Perhaps of the greatest influence was the Darley Arabian, which had been imported direct from Aleppo by Mr Richard Darley, a Yorkshire squire. His son Thomas had written of the horse in 1703 'his colour bay . . . he is about 15 hands high, of the most esteemed race among the Arabs both by sire and dam . . . I believe he will not be much disliked'. In fact the Darley Arabian was destined to rank as the most famous ancestor of the Thoroughbred. He himself sired the Flying Childers, was the great-great-grandsire of Eclipse and ancestor of numerous Classic winners. Eighty per cent of modern thoroughbreds can be traced back to him. He was painted by Wootton several times, the artist showing the typical small Arabian head and flaunting tail to great effect (pl. 12). Pictures of the three Arabians in different versions continued to be painted by Wootton and a spate of other animal artists, and were subsequently engraved; even Sir Edwin Landseer could not resist a study of the Godolphin Arabian, which was engraved by J.B. Pratt in 1894.

In his pictures of these three horses Wootton, like every other contemporary artist, exaggerated the large oriental eye which is placed extra wide frontally in the breed. This trait is also emphasized in his pictures: *The Bloody Shouldered Arabian*, a portrait of a grey whose dark roan stains were supposedly accounted for pre-natally in an accident to the dam; *The Leedes Arabian;* and *Lord Oxford's Dun Barb*, a stallion sent from Aleppo in 1715 and described as 'the finest horse that ever came over'; and in lesser degree in the magnificent portrait which dominates the Great Hall at Badminton, *The Grey Barb*, imported by Charles II. Proportions are also frequently distorted by Wootton and his contemporaries, for though Arabian stallions rarely measured more than

14·3 h.h., they often tower over their turbanned attendants and their cannon bones appear impossibly long and weak, conformation entirely alien to the breed. But proud new owners, not content with the unique beauty and elegance of the Arabian horse required, perhaps, that extra fillip of a sire bigger than average to impress their friends.

The artist's portraits of racehorses, though individual and dignified, are also marked by these stylistic exaggerations, as can be seen in his various studies of the famous mare Bonny Black shown held only by a stable rubber round her neck, and a similar picture, the Earl of Portmore's *The Bay Racehorse Smiling Ball on Newmarket Heath* (pl. 13). This horse, winner of six plates in 1727 seems to possess in addition a malformed parrot mouth. The grey, Lamprey, with a grotesquely elongated hind leg, also appears of improbable height in his portrait, at a period when Thoroughbred horses were several inches smaller than they are today.

In spite of these problems Wootton was never short of commissions at thirty guineas a time from the Newmarket fraternity. We owe to him not only some very fine compositions evoking the racing scene on the famous Heath but also many descriptive hunting pictures of those early days. All these paintings illustrate the sensitive way in which the artist utilized continental form to suit the English situation. Wootton's talented approach to the sporting scene also combined effectively the customs and accoutrements of sport with the beauties of rural England and in this manner he, more than anyone else, laid the foundations of the school of British sporting art.

Distortion also infected the work of James Seymour, the extrovert son of a well-to-do banker, who only took to art professionally to defray gambling reverses. Vertue wrote: 'Jimmy Seymour . . . from his infancy had a genius to drawing of Horses. This he pursued with great spirit, set out with all sorts of modish extravagances. The darling of his father, he ran through some thousands, lived gay, high and loosely . . . never studied enough to colour or paint well, but his necessities obliged him to work or starve.' Today it seems curious that Seymour's untutored efforts should often have been preferred to Wootton's talented and finished compositions. Though Seymour's work was often amateur and primitive in style he could catch an equine likeness with naive perception and possessed a vigilant eye for details of costume and saddlery on the racecourse and in the hunting field, for he had his own considerable personal experience in the sporting sphere to draw upon. Based strategically at Newmarket, his contacts there brought him lucrative commissions from the racing aristocracy.

In such direct and incisive pictures as *Two Horses and a Groom in a Stable* (pl. 21) Seymour stamped English sporting art with a specific style that was to endure in greater or lesser degree for more than a century. In his painting *The Duke of Devonshire's Flying Childers with a Jockey Up* (pl. 16), despite the fact that the horse is of renowned stamina, never beaten in races of over four to six miles, Seymour characteristically shows a noticeable lack of bone and the same weak length of cannon which makes nonsense of William Pick's statement in the *Turf Register* that the Flying Childers 'was allowed by Sportsmen to be the fleetest horse that ever ran at Newmarket or, as generally believed, that was ever bred in the World'.

His popular picture *The Chaise Match 1750* (pl. 17) brought him wide publicity. It was engraved by J. Scott and others and also painted on silk. Even Sir Joshua Reynolds commissioned Seymour to paint a duplicate version of the event. This wager for 1000 guineas, made by the Third Earl of March and the First Earl of Eglintoun with Colonel Theobald O'Taafe and Andrew Sprole on 29 April 1750, provided that a carriage with four running wheels and four horses and carrying one person could cover

nineteen miles in one hour. A skeleton vehicle was designed by Wright, a coach builder of Long Acre, with harness constructed of thinnest leather covered with silk, and the boxes of the wheels were provided with tins of oil to drip slowly on the axle trees for an hour. Three of the horses had won plates and the fourth was also in training, and though the match was run at seven o'clock in the morning spectators thronged the start. The horses ran away for the first three miles and finished the contest in fifty-three minutes, twenty-seven seconds, checked exactly by three time-keepers. Seymour's stark picture captures little of the pace and tension of the occasion, but serves as a reminder of these curious matches which were such a feature of English sporting life.

James Seymour could produce a good formal hunting picture and among his best is *A Kill at Ashdown Park* (pl. 20), dated 1743. Fulwar, Fourth Lord Craven, and other horsemen on the Berkshire Downs surround the huntsman and hounds who are about to break up their fox. In the background a shepherd watches his flock, greyhounds course a hare, and there is a glimpse of stately Ashdown House. The picture is naive in many ways but full of perceptive detail.

Painting at the same time as Tillemans, Wootton and Seymour was Thomas Spencer, born *c.* 1700, who first made his reputation as a successful portrait painter but later turned to the racehorse as a more lucrative subject. Spencer painted many famous sires of the day, such as Dormouse, Crab and Bay Bolton. Another contemporary, James Roberts, executed forty portraits of renowned racehorses, of which engravings were made by his brother Henry. Twelve of these pictures were of horses foaled in the 1740s and included bloodstock belonging to many influential owners.

In those days commissions were never scarce; it was horse artists that were few. However, there is one advertisement of the 1750s extant in which a minor artist, Thomas Butler, announced he was available 'to go to several parts of the Kingdom to take horses and dogs, Living and Dead Game, Views of Hunts etc. in order to compose sporting pieces for curious furniture in a more elegant and newer taste than has been yet. Any Nobleman's or Gentleman's own fancy will be punctually observed . . .' These 'fancies' may well explain some of the more bizarre portraits of racehorses.

Nevertheless, demand obviously exceeded supply during the first half of the eighteenth century, a fact which probably prompted the Sartorius family to leave Bavaria and come to England. John Sartorius Senr, son of an engraver of Nuremburg, was established in England *c.* 1720 and painted several racehorses in a primitive style for owners such as the Duke of Bolton and the Duke of Kingston; Mr Panton also commissioned him to paint his famous mare Molly. The work of Francis Sartorius, his son, born in 1734, quickly achieved more widespread recognition, but having been taught by his father he inherited many of the same limitations of technique, notice-able in his picture, *A Private Match for 1000 Guineas with the Marquis of Rockingham's Bay Malton beating the Hon. Richard Vernon's Otho at Newmarket, April 21st 1766* (pl. 18). These wagers between influential owners were typical sporting activities of the day, especially with horses of established reputation; Bay Malton, for instance, won eight matches and races between 1764 and 1768, even beating the celebrated Herod and Gimcrack. In Sartorius's painting neither contestant shows signs of real exertion and the jockeys appear ridiculously small. Nevertheless the galloping supporters and the two waiting carriages in the distance all tend to make this a period composition of pictorial as well as social importance.

The sporting tradition was carried on by Francis's son, John Nost Sartorius (1759–1828), the most gifted painter of the family. English records of racing, hunting, coursing

and shooting were considerably enriched by the Sartorius family, for they painted in an idiom free from continental mannerism and absorbed the native approach to sporting art. It is, however, the pictures of Tillemans, Wootton, Seymour and Spencer that record for posterity the first British bloodstock for, as Ernest Hutton, that specialist of early sporting art, wisely pronounced: 'I do not think any genuine portraits of race-horses anterior to 1700 exist'. Many of the pictures of early winners on Newmarket Heath were painted on the spot and, when outdated, left to decay in attic and cellars, a fact deplored even as early as 1790 by Mr Sandown, a Newmarket veterinary surgeon. Nevertheless, much remains from the early years of the century to emphasize that here was the real cradle of sporting art in England.

4 Stubbs the incomparable

All nature is but art.

Alexander Pope, 1688-1744
An Essay on Man

George Stubbs ARA was born in Liverpool on 25 August 1724. The only son of a well-to-do currier, he was expected eventually to take his place in this prosperous trade, but significant and contrary inclinations appeared as early as his eighth year, when he started to sketch anatomical bones and as a boy artist modelled a horse which won him a medal from the city art society. Young Stubbs's interest in leather was minimal and paternal approval of his artistic talent initially deficient. Family tensions therefore mounted, but finally, bowing to the inevitable, Stubbs *père* selected Hamlet Winstanley, a pupil of Kneller, to act as his son's art master. At this point, when Stubbs was about fifteen years old, his father died, and though Stubbs became Winstanley's pupil, quarrels immediately flared up. The pupil wanted to compete with the teacher and selected such complex subjects as *Cupid* by van Dyck and Panini's *Ruins of Rome* to copy from the Knowsley Collection situated close at hand. On being rebuked for this presumption, lessons ceased, and Stubbs decided that 'Henceforward he would look unto Nature for himself, and consult and copy her only'. (Joseph Mayer FSA, *Memoirs of Thomas Dodd, William Upcott and George Stubbs, RA* (sic), p. 7.) This was the limit of his artistic training.

Stubbs appears to have enjoyed a sufficient allowance from his widowed mother to have led a life free from real financial stress from early youth. Artistically this resulted in his late development as a painter, for with no economic pressures he was able to explore such time-consuming ploys as anatomy, engraving and enamelling, which ultimately enriched his talent but delayed its early fruition. In about 1744 Stubbs left the

maternal home and spent some time in Wigan and Leeds, receiving portrait commissions when only twenty years old. He arrived in York with further work and here he remained about six years, becoming so obsessed by the study of anatomy that he lectured on the subject privately before medical students of the hospital. A Dr Atkinson, a surgeon, provided him with his first body for dissection, a woman who had died in childbirth, and his anatomical drawings were of such excellence that Dr John Burton employed him to illustrate *An Essay towards a Complete New System of Midwifery*, published in 1751. For this work Stubbs taught himself to engrave with precision and clarity after only some rudimentary instruction from a local house painter. Stubbs was to become an engraver of outstanding ability, a perfectionist, his own platemaker, printer and publisher, and it should be remembered that for a third of his artistic career Stubbs was in some way involved in this medium.

In 1754 Stubbs visited Rome to reassure himself of the fact that Nature really *was* superior to Art, whether Greek, Roman, Renaissance or contemporary. One feels that Stubbs's mind was already convinced before he ever left England. It was on this trip that he possibly visited North Africa, where at Ceuta he is supposed, according to a report in the *Sporting Magazine* (May 1808, p. 56), to have watched a lion stalk and seize a white Barbary horse, an incident that was to provide him with the obsessive inspiration for nearly twenty versions of the scene.

Was this incident in fact experienced, or are these pictures an echo perhaps of such Old Master studies as Rubens's *Horse Attacked by Lions* in the Louvre or motivated by a Hellenistic carving of the same subject in Rome, to be seen at the time of Stubbs's visit? In the days of the artist's decline and during the Victorian period it was virtually the only theme that won him any acclaim. The first picture appeared at the Society of Artists in 1763 and another, *Lion Attacking a Horse* (pl. 22), was painted for the Second Marquis of Rockingham in the same period, certainly before 1765. Lions, tigers and leopards engrossed Stubbs as subjects and his sketch books abound with studies of wild animals throughout his life. Here was an outlet for his aspirations beyond the horse, and one of his most subtle and sophisticated animal studies, *A Tiger*, painted in the 1760s, is a picture which suggests something of the strange mystery of William Blake's poem 'Tiger, tiger, burning bright'.

Models were not far afield. Menageries such as Lord Shelbourne's at Hounslow Heath and the Royal Menagerie in the Tower of London were popular diversions. The Duke of Cumberland's collection of wild animals kept in semi-free conditions in Windsor Park included not only lions and a tiger, but an elephant and a zebra added by George II. It was from Pidcock's Menagerie in the Strand that late one night Stubbs acquired the body of a dead tiger for dissection, at a price of three guineas. Pidcock's also provided Stubbs with live subjects and in about 1772 he painted *Indian Rhinocerous* for Dr John Hunter, the surgeon and anatomist, and the yak brought to England by Warren Hastings. Other exotic studies had as their subject lemurs, monkeys and a kangaroo but most splendid of all was *A Cheetah and a Stag with Two Indians*, a gift to George III from Lord Pigot, Governor of Madras. This shows the scene as the animal was released in Windsor Park to chase a stag; nonplussed by the large and curious crowd, the cheetah remained static and non-aggressive and, as depicted by Stubbs, strangely proud and withdrawn.

The intensity and dispassionate integrity of all Stubbs's animal studies were the direct result of the eighteen months in 1758–9 that he spent in anatomical research in the artistic wilderness of a lonely farmhouse near Horkstow in Lincolnshire. Here

horses were brought for his dissection, and local gossip may have supplied some of the legendary stories of his feats of strength in manhandling on his own the huge inert carcases and setting them up by means of hooks and a 'teagle' (the Lincolnshire term for tackle) to an iron bar fixed across the ceiling. According to Stubbs's own description the horses were bled to death from the jugular vein, the skin was peeled away, muscles and veins were dissected meticulously in strict order, layer after layer being carefully removed; no part of the animal escaped minute examination. As arteries and blood vessels had been injected with a wax solution, decomposition was delayed in some cases for up to seven weeks. Obviously his childhood background of the currier's trade would have inured him to some of the basic unpleasantness of the operation; nevertheless the dedication of this man who endured the whole gruesome business, the stench and the filth, to work day after day at these drawings is astonishing.

Stubbs's sole companion appears to have been Miss Mary Spencer, a posthumous child of a Captain Spencer who had been murdered by his favourite slave in a ship's mutiny in the Guinea trade. Variously described as Stubbs's niece, his aunt and his mistress, she was still with him whatever her ambivalent position on the day of his death fifty years later; and the artist had a natural son, George Townley Stubbs, the mezzotinter and engraver, who produced nearly forty prints after his father's paintings between 1770 and 1804.

With the drawings completed Stubbs came to London and received a severe blow, for the professional engravers of the day refused to undertake such an unfashionable and complex subject. With characteristic resource he decided to engrave himself the '18 Tables, in Folio, all done from Nature', working only late at night and in the early morning so that time should not be taken from his daytime painting. From 1759 he lived in London where his total involvement in equestrian form inevitably led to his becoming, in spite of his more classical aspirations, a popular horse artist, and commissions came fast and furious. It was not therefore until 1766 that *The Anatomy of the Horse* 'by George Stubbs, Painter, printed by J. Purser for the Author' appeared. Its contemporary impact was considerable, for no comparable treatise on the subject had appeared since Carlo Ruini's *Dell'Anatomia et dell'Infirmità del Cavallo* in 1598. The *Medical Review* of 1767 reported: 'We are at a loss whether most to admire the artist as a dissector or as a painter of animals.' Petrus Camper FRS, the famous Dutch anatomist, wrote in 1772: 'I am amazed to meet in the same person so great an anatomist, so accurate a painter and so excellent an engraver.' (Joseph Mayer, *Memoirs of Thomas Dodd, William Upcott and George Stubbs RA*, p. 15.) The book was in fact an exquisite marriage of art and science.

While immersed in this mammoth task of engraving, Stubbs entered perhaps the most brilliant decade of his artistic career. With the accession of George III in 1760 and with the success of the Thoroughbred horse, racing had entered a new phase. Titled breeders vied with each other to produce faster and finer equine speed machines. Pictures of winning bloodstock provided priority commissions, and George Stubbs's patrons included the most important and illustrious owners in the country, the Duke of Portland, the Duke of Rutland, the Marquis of Rockingham, the Earl of Grosvenor, Earl Spencer, Viscount Torrington, Lord Crewe and many others, introductions having been effected, it is claimed, by Domenico Angelo who ran the fashionable riding school in Soho frequented by animal artists and ambitious horsemen. Instead of making his headquarters at Newmarket, Stubbs based himself in London and travelled to many parts of England to paint pictures at various stately homes. As a result he became not just a

mere portrayer of horses, but a subtle and perceptive interpreter of the eighteenth-century country scene and the way of life of the landed gentry.

He painted three pictures at Goodwood House for Charles, Third Duke of Richmond, a young and cultured nobleman who had made the regulation Grand Tour, was a Fellow of the Royal Society and a founder member of the Society of Artists, and who, in 1758 when he was twenty-three, had opened a sculpture gallery for art students at his London home. The trio of pictures still hang in the white-painted Long Hall at Goodwood House and illustrate Stubbs's skill in composing different elements into a picturesque design and in making the functional trappings of horse and hound part of the decorative scene. In *The Duke of Richmond, His Brother Lord George Lennox and General Jones Out Hunting* (pl. 19), painted in 1759 or 1760, the type of hunter has already developed from the one painted by Wootton only twenty years earlier at Goodwood for the Duke's father; there is now a hint of quality in the head, though long cannon bones are still obvious. Stubbs still uses the conventional corner motif of a horse taking a standing jump over timber that was beloved of Seymour, Wootton and the Sartorius family. The real verve of the picture, however, lies in the varied poses of the hunters, the emphasis on the sunlit grey in the foreground surrounded by ten couple of hounds and the distant glimpse of the rest of the field with more hounds running, a curious fact as a huntsman rarely loses half his pack. The figures of the hunt servants in the bright yellow and scarlet ducal livery appear elongated—a mannerism Stubbs was later to lose—but this impression may be explained by the fact that at that time hunters, as well as racehorses, were several inches smaller than they are today, with the result that riders tend to appear underhorsed.

The second picture at Goodwood, *Racehorses belonging to the Third Duke of Richmond at Exercise*, might be described as a symphony in three movements. The first shows the central riding party with the young Duke and Duchess and his sister-in-law, Lady Louisa Lennox, all three in the dark blue and gilt buttons of the family hunt. In the second group the racehorses gallop almost out of the picture in single file, hooded, rugged and girthed in the bright Goodwood red and yellow; and finally in the right foreground grooms attend a stripped horse. The whole is set against a distant glimpse of the English Channel and Chichester Cathedral. To mould these themes into a related composition required more than mere talent from a self-taught artist.

In quieter and more formal vein, the picture of *Lord Holland and Lord Albemarle Shooting at Goodwood* (pl. 41) shows the dismounted gentlemen advancing slowly with their guns. They both wear buff breeches and one the 'spatter-dashes' of the day—the protective gaiters for feet and legs; an attendant in livery carries two spare guns. The two light-boned quality chestnut horses are far removed from the heavy cobs usually portrayed in shooting scenes and appear unsuited temperamentally to their role with the guns. An important detail is provided by the inclusion in the left foreground of a liver chestnut Arabian horse with an oriental saddle, held by a Negro in the Richmond livery and wearing earrings. Leisure, informality and enjoyment pervade this scene which epitomizes the life of the Georgian country landowner as seen by Stubbs, for he spent nine months at Goodwood painting these pictures.

Early in the decade the artist visited Eaton Hall in Cheshire to fulfil commissions for Richard, First Earl of Grosvenor, one of England's greatest sportsmen. According to Horace Walpole, when the Earl was required to kiss hands on his elevation to the Barony, he went instead to Newmarket to see the trial of a racehorse. Stubbs travelled north to paint the celebrated Bandy, famous both on the turf and as a sire in spite of the

slightly crooked leg which gave him his name. Here he remained several months working on other commissions, though the superb study, *The Grosvenor Hunt*, was completed in London. Stubbs painted few pictures of hunting, but this is an elaborate masterpiece; a twisted tree frames the riders, a luminous vista of the Cheshire hills makes a topographical landscape, the focal point is the scarlet-coated Earl on his favourite Honest John, and each rider, horse and staghound is skilfully portrayed. Today it seems odd that apart from an odd white fetlock here and there, no white socks, stockings, blazes or snips break up the bay and brown colour of the horses.

It was at this period, between 1762 and 1773, that Stubbs started painting his series of mares and foals (pl. 23), five examples being exhibited at the Society of Artists from 1762 to 1768, and one at the Royal Academy in 1776. In all he painted ten versions; five of the pictures appear to have been directly commissioned and acquired by the Duke of Grafton, the Second Marquis of Rockingham, the First Earl Grosvenor and the Second Viscount Bolingbroke. The works are nearly all portraits of specific mares, either with successes on the turf themselves or dams of winners, but these portraits were something more than mere records. Stubbs arranged these maternal forms in mellow, harmonious, horizontal, frieze-like compositions, and always subtly juxtaposed the colours of the bays, roans, greys and chestnuts, often setting them against great oak trees in full leaf; the exception is his striking study of *Mares and Foals without a Background* for the Marquis of Rockingham. It is noticeable that these Thoroughbred mares have already lost the small head and dished profile of their Arabian ancestors and show the accepted Thoroughbred conformation, but in almost every case they still possess the large wide-placed oriental eye.

This also was the epoch of lucrative commissions for portraits of famous racehorses, including Tristram Shandy, Molly Longlegs, Gimcrack, Marske, Eclipse and Whistle-jacket. Several of them, such as Gimcrack and Eclipse, Stubbs painted more than once; but unlike later racehorse specialists, in particular J.F.Herring Senr, Harry Hall and David Dalby, Stubbs was never content to paint merely a satisfactory likeness of a horse: the composition was designed to form a pleasing picture. Vistas of lakes, hills and groups of trees play their part, though sometimes Stubbs's backgrounds to hunters appear to be more classical than English in inspiration.

Stubbs's studies of the Thoroughbred show considerable deviation in conformation. Molly Longlegs and Tristram Shandy, and even little Gimcrack who stood only a quarter-of-an-inch over fourteen hands, again emphasize the long cannon bones which with Stubbs's minute research into equine anatomy one must accept as a feature of the early Thoroughbred racehorse. It is also noticeable that pasterns appear straight, a fault not shown in his anatomical studies, and of course the shallow bodies evident in many of the horses were the result of the contemporary sweating methods of training. Hambletonian, a horse bred about thirty years later, manifests greater substance and stronger bone. These animals on retirement to stud obviously appeared in very different shape when maturity and flesh had furnished their frames. Typical of these adult portraits is the fine picture painted in 1779 of the Earl of Grosvenor's grey, Mambrino (pl. 25), who was exported to America to be sire of the famous Messenger and founder of a dynasty there. Mambrino possesses an impressive front and depth, but he also shows the tiny ears and high set-on tail of his Darley Arabian ancestor, and being in stud and not in racing condition seems far removed from earlier Thoroughbreds painted by the artist. Any horseman, however, will deplore those straight pasterns, but on the other hand find much to praise in *Two Horses with a Groom and a Dog* (pl. 24), painted in the same year.

Here both animals are short-legged, with immense depth through the heart, and the sunlight and shade on sleek summer coats emphasize the fine underlying bone conformation. In spite of the tranquillity of the scene, the alert interest of the horses who are watching the groom holding up the light reins of the bay, lends instant animation. Their making pose is cleverly repeated by the black and tan dog, a superb composition. Bridles and saddles never become mere adjuncts with Stubbs, but fit their horses and form an integral part of the picture, a fact well illustrated by the sidesaddle on the bay which shows an exceptionally good shoulder for the job. A noseband is an unusual contemporary addition and gives a surprisingly modern appearance.

Most of Stubbs's racehorses, though generally static in pose, are not wooden in their portrayal except where the artist depicts the galloping horse. Occasionally he makes a tentative suggestion of a breakaway from the prevalent rocking horse movement and this problem will be more fully discussed in the racing section of this book. It should be remembered also that his portraits of racehorses were commissioned by the finest judges of horseflesh of his day, who, above everything else, required a first-class and possibly a slightly flattering likeness, a fact emphasized in the life-size portrait of Whistlejacket, belonging to Charles, Second Marquis of Rockingham, now at Kenwood, London. Whistlejacket was an animal of uncertain temper. On seeing this picture in the stable yard of Wentworth House, of what appeared to be a rival stallion, he was so enraged that he attempted to savage the painting on its easel. This anecdote has tended to overshadow the fact that Ozias Humphrey suggests the picture was originally intended as a companion to Morier's equestrian portrait of George II; the figure of George III and landscape effects were to be added by other artists. The *levade* position of the horse corroborates this idea of a royal portrait, but Rockingham was too delighted with the unadorned picture by Stubbs to part with it, or maybe the failing Whig fortunes foiled the idea.

Although Stubbs's horse portraits were commanding a fee of a hundred guineas, the artist was unable *c.* 1770 to resist an expensive and time-consuming scientific diversion and, urged by Richard Cosway, the painter of miniatures, he began experimenting with enamels. After two years of chemical trial and error he evolved nineteen satisfactory colours for his first paintings with enamels on copper plates, but these plates were small and, requiring greater scope, he approached the potters, Messrs Wedgwood and Bentley, to investigate the possibilities of large earthenware plaques. A warm friendship was formed between Stubbs and Josiah Wedgwood which resulted *c.* 1780 in the execution of an unusual conversation piece, *Josiah Wedgwood and his Family at Etruria Hall* (pl. 26) which was to serve with other pictures as an amicable *pro contra* arrangement towards the expenditure on special kilns and other equipment. This Wedgwood group typifies the background of many county families of the day, who, their wealth founded on trade, enjoyed the country way of life.

For many years Stubbs produced work in enamels, sometimes repeating in this medium versions of his farming subjects. In these rural scenes there is an intense regard for practical detail in the different implements and methods employed and in the characterization of the country labourers. In *Reapers* (pl. 33), of which he made several versions, a pastoral felicity pervades the scene, but in addition each worker performs meticulously an appointed task, as with the women making the bonds to bind the sheaves.

In 1780 Stubbs became an associate of the Royal Academy and the following year was nominated an Academician elect. For the annual exhibition he sent in several pictures in enamels, brilliantly fresh in colour, which contrasted vividly with some of

the members' own dull and heavy oils. Stubbs's contributions were rather tactlessly 'skied' to his intense chagrin and the disappointment of his patrons. Considering this a direct artistic affront, Stubbs apparently failed to present the picture required for the permanent Academy collection on election to full membership. There were other facets to this complicated situation which resulted in Stubbs's final status never being ratified, though in 1824 the Royal Academy actually printed his name among the list of full Academicians.

In the 1790s, when the artist was already in his late-sixties, he painted several pictures for the Prince of Wales, later George IV. Though His Royal Highness's morals and manners may have been deplorable, he certainly 'encouraged the promotion of every National British Pastime', possessed an unfailing eye for artistic quality in many fields and freely commissioned pictures. These included *John Gascoigne with a Bay Horse*, a portrait of the Prince's Hunting-groom who became Clerk of the Stables and *William Anderson with Two Saddle Horses*. Anderson was Helper and Hack-groom to the Prince between 1788 and 1800. The splendid study of Samuel Thomas, the Body-coachman in *The Prince of Wales's Phaeton*, is a picture of extraordinary intensity, often reproduced and unfailingly effective with its brilliant touches of scarlet. These were not only perceptive paintings of different types of horses, but telling portraits of the men who worked with them. Presumably also specially commissioned, and painted in 1791, the debonair study of *George IV as Prince of Wales Riding in Hyde Park* suggests something of Prinny's legendary charm in his twenties, before corpulence took over. Another portrait of merit is *Laetitia, Lady Lade* (pl. 27); the rider was a notorious adventuress of considerable attraction who married the Prince's sporting companion, Sir John Lade. Immorality and foul language may have been part of her image, but her skill in horsemanship was renowned, a fact indicated by Stubbs in the prancing impetuosity of her horse and the telltale restraining rein for a 'puller' running from bridle to saddle. The cumbersome blue habit falls in decorative folds to give only a glimpse of the platform stirrup.

Other pictures by Stubbs commissioned by the Prince include *A Red Deer Buck and Doe*, a little masterpiece of composure and animal elegance, and *Fino and Tiny*, a vivacious painting of a Pomeranian and a small spaniel. Stubbs's many pictures of dogs always exhibit a clear concept of canine character and type, from the studies of hounds painted for the Duke of Richmond in 1763 to his last exhibit at the Royal Academy thirty years later, *The Duke of York's Newfoundland Dog*. Joseph Mayer's appraisal of Stubbs as an animal artist puts it succinctly: 'He painted what he saw and never showed an immortal soul in a poodle's eye.' (*Memoirs of Thomas Dodd, William Upcott and George Stubbs RA*, p. 37.) Landseer, unfortunately, could rarely resist this challenge.

In 1790 Stubbs had undertaken an ambitious project initiated by the *Turf Review* to paint for the sum of £9000 a series of famous English racehorses starting with the Godolphin Arabian. After they had been exhibited the pictures were to be engraved and eventually published periodically, together with descriptive letterpress of the races, matches and anecdotes concerning each horse. In 1794 sixteen of these pictures were shown at The Turf Gallery, including *Eclipse, Dungannon* and his accompanying sheep, *Gimcrack, Baronet, Mambrino* and *Pumpkin*. Thirteen were engraved by Stubbs's son, George Townley, and these engravings brought Stubbs's work before a much wider public and largely influenced his classification as a horse painter, at that time a category of infinitely lesser consequence than that provided by the fashionable classical and historical themes. But politically fortune was against him, for the year 1793 had seen the execution

of Louis XVI and the outbreak of the war between France and England. Money was scarce, inflation rampant, none of the portraits sold and the enterprise was abandoned. Stubbs's star was in decline. Many of these racehorses he had, of course, painted previously, but these new portraits showed the same concentration and careful observation. Stubbs's method of painting, though firm and confident, was slow and methodical, the figure of the horse being completed first and then the landscape backgrounds and framing trees. After working in enamels his style had undergone a certain change, with the paint applied more thinly and with greater transparency, a fact which some cleaners and restorers have ignored with deleterious effect.

It should not be forgotten that at the time of this commission Stubbs was also heavily involved with pictures for the Prince of Wales, who at one time owed him £2100 but his capacity for work and sheer physical effort was always staggering. In 1795, at the age of seventy-one, he commenced another mammoth and extraordinary scientific project in *A Comparative Anatomical Exposition of the Human Body with that of a Tiger and a Common Fowl*. One hundred and forty-two drawings were completed and some engravings commenced, but the work was still unfinished at his death.

In his seventy-sixth year Stubbs painted, in just over two months, two fine portraits for Sir Henry Vane-Tempest of the famous Hambletonian, descendant of Herod and Eclipse and winner of the 1795 St Leger. One shows the horse beating his foremost rival, Mr Cookson's Diamond, by a short head in a four-mile match at Newmarket; the other, life size, portrays him being rubbed down after the ordeal, with ears laid back and off hind leg ready to lash out—all the signs of a horse tested to his nervous as well as his physical limits.

In the artist's eightieth year he completed competent pictures of hunters Truss and Selim, but commissions were few and far between although his physical energy was unflagging. Missing the coach at Marble Arch he walked the sixteen miles to The Grove at Watford to keep an appointment with his latest patron, the Earl of Clarendon.

In 1806 he suffered a heart attack and died in a few hours. This was possibly a happy release from insoluble financial problems. Though his way of life had always been modest, his constant scientific experiments cost both time and money. Debts had accumulated, his house was mortgaged and only the generosity of Miss Isabella Saltonstall, a family friend of long standing, had kept disaster at bay. Most of his early patrons had died and the public was requiring more specific sporting pictures, which artists such as Sawrey Gilpin, James Ward, Dean Wolstenholme Senr and Ben Marshall were willing to provide. Nothing is so fickle as fashion and nowhere does it veer so quickly as in the realm of art.

Of his contemporaries none approached his merit even in the purely equestrian field; Wootton, who died in 1765, had achieved most of his best work before Stubbs made any real impact on the scene, and Sawrey Gilpin, only nine years Stubbs's junior, as well as Francis Sartorius, were both artists of very different calibre. The hunting and racing pictures of Henry Alken Senr, John Frederick Herring Senr and John Ferneley Senr were not to appear until later in the century; and only James Ward and Ben Marshall, who began his painting career in the 1790s, shared for a few years the same patrons as Stubbs. His studies of wild and domestic animals, his outdoor conversation pieces, his anatomical research and experiments with enamels, all emphasized a versatility that establishes this artist's stature as the giant among the pygmies of his age. But it is remarkable that in his own day, and retrospectively, his qualities aroused only mixed enthusiasm, and it is only recently in this century that his pictures, painted with

69

a unique observation and concentrated vitality, have been accepted as great works of art.

For Stubbs socially the times were propitious, as Tillemans, Wootton and Seymour had not only established the vogue for pictures of field sports, but racing, with the formation of the Jockey Club *c.* 1750, had become an important diversion of the influential and wealthy nobility, and animal portraits also were particularly in demand. Many stately homes and countless less pretentious mansions had been recently built and rich owners, alive with acquisitive instincts, were anxious to collect pictures. It is curious, therefore, that an artist of Stubbs's outstanding scope, while receiving important commissions from patrons who often not only possessed an enthusiasm for the sporting life but were artistically aware, was to receive such mixed contemporary acclaim, and in his old age and posthumously was to be discredited. By 1856 the 'Druid', Henry Hall Dixon, actually wrote 'His [Stubbs] chief failing was a lack of anatomical knowledge'. (*Post and Paddock*, p. 132.) The most significant reason is provided by the artist's own virtuosity which led him away from the purely sporting scene; also, patrons began to demand a descriptive type of picture with a wealth of accurate sporting detail, features which Stubbs was neither willing nor equipped to supply. Unlike his predecessors Seymour and Wootton, and such later artists as Alken, Ferneley and Marshall, Stubbs was not a hunting nor a racing man; scientific interests, which were to endure until his death, not sport, absorbed his energies away from the easel. Of course Stubbs rode, there is his own *Portrait of the Artist on a Grey Horse* dated 1782, but any man of standing in that age was of necessity a horseman. We never, however, find him, like Marshall, hurrying to witness an important race nor, like Ferneley, painting a portrait of himself following hounds. Stubbs's interest in anatomy, engraving and ceramics provided more serious and absorbing diversions.

Though Sir Joshua Reynolds had been his generous admirer and even a purchaser of his pictures, and in Stubbs's own day sixty-five of his works had been exhibited by the Society of Artists and fifty-three by the Royal Academy, general indifference to his artistic status continued long after his death. Landseer's father, John Landseer the engraver, almost alone of the pre-Victorians and indeed of the Victorians themselves, gave Stubbs a place of honour, ranking his animal paintings with the works of Rubens, Rembrandt and Ridinger.

Very little biographical detail on Stubbs exists and the main source of information comes from an unpublished memoir by the artist's friend, Ozias Humphrey, who kept a rough record of the artist's conversation, certain anecdotes and incidents connected with him. Two transcripts of these memoirs were made, one by Humphrey's illegitimate son, William Upcott, which was used by Joseph Mayer who wrote the first published work on Stubbs in 1879. Josiah Wedgwood in correspondence to his partner and friend, Thomas Bentley, also provides interesting detail of the enamel painting period of Stubbs's career. (*Letters of Josiah Wedgwood 1772–1780*, private publication 1903.) In 1898 Sir Walter Gilbey published privately his *Life of George Stubbs RA.* Nearer our own time, Walter Shaw Sparrow in several works gave Stubbs just approbation, considering him unrivalled among Englishmen of his period.

The young Munnings, who found dissection in the hunt kennels more than he could stomach, turned instead to Stubbs' *Anatomy of the Horse*, and wrote that it 'makes a large landmark in my youthful eyes' (*An Artist's Life*, London, 1950, p. 114); he described it as 'the most unique thing of its kind ever compiled; this heroic effort, an epic of the eighteenth century, is as great and unselfish a work as anything could be, and

as noble a performance by one Englishman for his country and the world as Gray's Elegy. We as a nation should be proud of it.' ('Stubbs the Artist ARA' *The Horseman's Year 1946/47*, London.) Geoffrey Grigson published an informative and enlightened article in 1938 in *Signature*, and no one in recent years has emphasized the fact of Stubbs's incomparable talent with greater conviction and erudition than the distinguished art critic, Basil Taylor, who has referred to him as 'Next to Leonardo da Vinci, the greatest painter scientist in history.'

Today in retrospect, and in the light of recent English exhibitions, especially that at the Whitechapel Gallery in 1957, Stubbs's natural versatility appears outstanding—anatomical drawings of exquisite precision, intense paintings of wild animals, perceptive portraits of famous racehorses, of farm horses and hacks. 'Mr Stubbs the horse painter' was no idle appellation. His talent never shines more radiantly than in such tranquil pictures as *Phaeton with Cream Ponies and Stable-lad c.* 1785 (pl. 37) where the browbands of the pale ponies echo the light blue stripes of the lad's shirt and the serpentine curves of the vehicle suggest the elegance of that harness age; or in the vivid simplicity of *Freeman, Keeper to the Earl of Clarendon* (pl. 38) painted in 1800 in the artist's old age and typical of the subtle characterization he brought to his portrayal of jockeys, grooms, hunt servants and farm workers against the background of their calling. In a century both coarse and cruel, Stubbs presents not only sporting occasions but also distils the essence of English country life with both true and sophisticated composure. Here lies genius indeed.

5 Sawrey Gilpin and James Ward

We must grant the artist his subject, his idea, his *donné*:
our criticism is applied only to what he makes of it.

Henry James, 1843–1916
The Art of Fiction

Several artists of ability were making their names in the sporting world by the latter half of the eighteenth century. Such men as John Nost Sartorius, George Morland, Philip Reinagle, Ben Marshall, all possessed varied and impressive talent, but it was Sawrey Gilpin and James Ward who were to influence in an important way the trend of British sporting art. Both were artists of uneven merit, but James Ward, born in 1769, endowed with extraordinary versatility bordering at times on genius, outshone Sawrey Gilpin on every count; yet it was Gilpin who first broke away from the formalized style of Wootton and his contemporaries and who innovated a new approach to the sporting subject in England. His career also pinpoints the important place the art patron played in the success, and survival, of the sporting artist.

Over-praised in his own day, virtually ignored in this century, Sawrey Gilpin, born only nine years after Stubbs, still remains something of an artistic enigma. Oddly enough, while Stubbs was constantly criticized by his contemporaries, Gilpin received more than his share of praise. Today it appears clear that Stubbs painted a horse with a rare touch of magic while Gilpin possessed a minor and more mundane talent. Nevertheless, in 1794 John Williams, art critic of the *Morning Telegraph*, wrote, 'Mr Gilpin is inferior to Mr Stubbs in anatomical knowledge but is superior to him in grace and genius'.

The Gilpin family, who were of some social standing, came from Cumberland.

After an Army career the artist's father, John Bernard Gilpin, eked out his modest means in Carlisle, where he became Captain of the Castle, by giving painting and drawing lessons. The times were difficult and the North was much involved with the Scottish rebellion and the exciting march south of Bonnie Prince Charlie, ruthlessly suppressed by the youthful Duke of Cumberland and his forces. It is ironic that this commander was to provide Sawrey Gilpin with his first commissions. Naturally gifted, there was never any doubt that the boy's career would lie in the world of art, and in May 1749, at the age of sixteen, he journeyed to London by coach to take up his apprenticeship with Hogarth's friend, the sociable Samuel Scott, a talented painter of marine and architectural subjects and a skilled exponent in watercolours. But stately ships on the Thames meant little to the new pupil: like James Ward a few years later, the horses and carts, riders and loaded waggons making their way to Covent Garden Market were much more absorbing, to be studied and drawn incessantly. Horses became his obsession, and a lucky one, with racing, hunting and scientific animal breeding already the fashionable pursuits of the day.

It is not known how Gilpin's work caught the eye of William Augustus, Duke of Cumberland, the first of his three influential patrons. The famous royal commander had become Ranger of Windsor Forest and the Great Park, and owner of an important stud which was to have a profound and lasting influence on English racing. He was to achieve permanent fame as the breeder of Eclipse and also of King Herod, ancestor of the vital Matchem line.

A young sporting artist could hardly have found a more valuable sponsor, and in 1758 Sawrey Gilpin visited Newmarket, and soon afterwards, while living in Kensington, occupied an apartment in the Great (Cumberland) Lodge at Windsor. Here he painted some of his earliest works for the Duke's Old Dining Room, including *A Bay Horse*, identified as the Duke's Dapper by Cade, and *A Brown Horse*, possibly Spiletta, a brood mare by Regulus.

Most successful of this rather stiff and static collection is the portrait *King Herod*, in which the horse, held by a groom in the Duke's scarlet and green livery, stands by the familiar rubbing house on Newmarket Heath. Successful both as a racehorse and as a sire, the stock of this big bay is reputed to have 'won over £200,000, forty hogshead of claret, three Cups and the Whip'. These are possibly the pictures referred to in the Royal Archives among the Duke of Cumberland's accounts, as 'Lady Day 1765 To Sawrey Gilpin for 3 portraits of Horses and drawings with Journeys to Newmarket £86 2s'. King Herod appears again in another picture painted during this period, *Cypron, King Herod's Dam, with her Brood* (pl. 28) which was exhibited at the Society of Artists in 1765, the first of his eighty-three works to be shown there. Cypron, bought by the Duke in 1755, stands under a massive oak tree with her yearling filly by Regulus; lying down at her feet is her tenth foal, Sejanus; beside her are Thais and the St Quentin mare with her colt, Senlis. In the background can be seen liveried grooms with Drone and Dunce exercising in rugs; galloping on the right are Dapper and Dumplin, and nearly out of the picture stands King Herod with an attendant. This difficult composition inevitably invites comparison with Stubbs's assured, deftly designed studies of mares and foals, several of which were also exhibited at the Society of Artists. Nevertheless young Sawrey Gilpin's group, though lacking strength and anatomically faulty, remains something of a *tour de force* for an inexperienced artist still feeling his way. There was nothing original in his approach to the subject; that was to come later.

An interesting picture, painted in about 1764 and exhibited in 1771, *William Augustus,*

Duke of Cumberland, inspecting his Stud (pl. 29), with its view of the tree-lined Long Walk at Windsor and distant glimpse of the Castle, was executed in conjunction with William Marlow, the landscape painter and also a pupil of Scott and provides a splendid example of Gilpin's ability to collaborate. In this facility lay his undoing, for with a too early marriage, a large growing family and the Duke's death in 1765, regular commissions of any kind became a vital necessity. Such artists as Barret, Reinagle, Farington, Hodges, Romney and Zoffany used him to paint animals in their pictures, leaving small time for his own original work. Many years later, J.W.Turner gratefully acknowledged that horses and cattle in his Royal Academy exhibits of 1799 and 1811 were by Sawrey Gilpin.

But the artist at his best possessed a rich personal talent and credit is definitely due to Gilpin for finally breaking away in his equestrian scenes from the formality of Wootton and Sartorius. Though his work lacked technical finesse, he nevertheless introduced a new romanticism and an exciting sense of mood and movement evident in such paintings as *A Grey Arab Horse* (pl. 43) and his diploma study in 1797 for the Royal Academy, *Horses Frightened by Lightning*—a theme first used by Stubbs. Obviously Gilpin must have been aware of such works as *Lion Attacking a Horse* (pl. 22), but nevertheless decided to compete in this same field, and with some success. *Horses Frightened by Lightning* probably painted for George III, shows remarkable understanding of animal temperament and vitality, a vitality that was to reappear in the works of James Ward and reached its zenith in the dramatic pictures of Géricault.

Though he had established himself as a painter of royal racehorses, more ambitious and fashionable subjects, historical and literary, now began to appeal to Gilpin. Wootton had used classical and battle compositions to enhance his reputation, creating a dangerous precedent. Pictures of Gilpin's scenes illustrating *Gulliver's Travels* appeared at the Society of Artists between 1768 and 1772, and the strong but graceful splendour of the Houyhnhnms showed an original approach in equine art, which brought the paintings popular acclaim from such collectors as Sir George Beaumont and the Duke of Bedford. Gilpin also painted *Darius Obtaining the Persian Empire by the Neighing of his Horse*, in which the light grey, with ceremonial trappings, is set against Doric columns, the whole covering a canvas $78 \times 106\frac{3}{4}$ in. This picture, though proving Gilpin's capabilities of mastering a crowded scene, provided for posterity something of a white elephant which has, however, been saved from permanent oblivion by the City of York Art Gallery.

Though resulting in a *succès d'estime*, such pictures often, for reason of size alone, meant uneconomic months of work, and to provide the daily bread and butter Gilpin made long journeys to paint a racehorse here, a couple of hunters there, or maybe some prize cattle. Many of his thirty-six works exhibited at the Royal Academy appear in the catalogue simply as 'A Horse', 'A Mare and Colt', 'Portrait of a Horse' and, a more uncommon subject, 'American Bears'. He also illustrated books for his elder brother, Rev. William Gilpin, the celebrated writer on the picturesque. This widening experience culminated in such confident popular portraits as *Sir Peter Teazle*, Lord Derby's dark brown colt, described as the best horse of his day and winner of the 1787 Derby. This picture was later engraved by William Ward.

It was during this time that commissions were received from the wealthy, flamboyant, young Colonel Thomas Thornton, forerunner of such picturesque figures as James Mytton and Squire Osbaldeston, sporting fanatics all. Obsessed by highly organized field sports of every type, his spacious home, Thornville Royal in Yorkshire, provided

a magnificent mecca for sixteen years for both sportsmen and artists, distinguished by its lavish hospitality. The latter, Shaw Sparrow suggests, may have been responsible for some undeniably mediocre work by Gilpin during this period but these lapses were more probably due to travelling and fatigue than the artist's inherent instability; for Gilpin has been described as possessing a gentle courage and loving kindness, a man respected for his extreme simplicity of manner and high moral character with never a hint of excess.

His belated election as an Associate of the Royal Academy and, at long last, as a full member in 1797, when he defeated the fashionable William Beechey by one vote, was influenced by two huge pictures from the many painted at Thornville Royal. The first, an immense study exhibited in 1792, was entitled *Colonel Thornton's Chestnut Thoroughbred Stallion, Jupiter*; in spite of its dimensions it still retains impressive power and atmosphere. But the second, breaking new ground in its savage realism, the spectacular *The Death of the Fox* (pl. 44), remains outstanding, not so much for its artistic merits as for the fact that, painted in 1793, it suggested a new dimension in sporting art which involved the emotions of the spectator. For a wager of twenty guineas, Thornton had undertaken to provide a local fox every February for eleven successive years that would give a run of twenty miles. After the first trial the bet was cancelled, the fox having covered twenty-three miles before being killed, and it was the climax of this chase that Gilpin recorded life-size on a canvas 146 × 102 in. for the Colonel's billiard room.

Some hounds were actually killed and pinned down in suitable position to serve as models but the leading hound of the pack, Madcap, represented in the painting with the bitch Merkin, escaped this fate. Strangely enough the hounds appear barely mudstained or exhausted by their marathon. Although hung in a bad light in the Royal Academy in 1793, this picture created something of a sensation and, reputedly, turned young Ben Marshall's brush from portraiture to the hunting and racing scene.

A contemporary critic described the painting in the *Sporting Magazine* (May 1793, p. 91): 'The public has long been indebted to Mr Gilpin for his valuable exertions which have greatly contributed towards the enrichment of our equestrian collections. In the particular scene before us Mr Gilpin has displayed much judgment and knowledge in his art: the hounds are equal to anything we have seen of the kind in our school.' However, another reviewer maintained 'This picture is executed in so slight a manner as to merit the appellation of a *sketch in oils*', but goes on to admit 'the eagerness in the distant dogs breaking through the bushes is an incident perfectly natural and descriptive of the subject'. Even in 1965, Michael Lyne's fine oil painting, *Marking to Ground*, owes something to Sawrey Gilpin's pioneer inspiration.

As inevitable financial nemesis began to overtake the extravagant Colonel Thornton, Gilpin, who was now earning between £700 and £800 per annum, fortunately found his third and kindest benefactor, Samuel Whitbread, political reformer, patron of the arts and wealthy brewer. In 1795 Whitbread employed Henry Holland at Southill in Bedfordshire to re-model an earlier mansion in the Regency style. Today original furniture and decorations still furnish the house in complete harmony, while pictures by such masters as Gainsborough, Opie and Romney rub shoulders with those of three minor English painters, Samuel William Reynolds, Sawrey Gilpin and his son-in-law and former pupil, George Garrard, all of whom received long and generous patronage.

From 1796 to 1802 Gilpin spent much of his time at Southill: over these years he

earned more than £1100. Here can be seen a varied collection of the artist's work, including *Gulliver Taking Leave of his Master* and a smaller version of *The Death of the Fox*. The original, hard to credit, disappeared without trace, but Gilpin made many copies of this subject. One, acquired for £5 by an ancestor of the present Marquis of Exeter, can be seen at Burghley House. Two paintings in the original Southill collection received particular attention from contemporary critics. One, a watercolour of *Daniel in the Lion's Den*, of limited competence and ineffective colouring, still hangs there; but the other, a group of tigers posthumously referred to as Gilpin's *chef d'oeuvre*, has disappeared.

In entirely different vein, still *in situ* and painted with delightful liveliness and invention, are several overdoors of birds and animals, among them magpies mobbing an owl, a pair of aggressive herons and, most attractive of all, in Mrs Whitbread's boudoir, two playful hares. Pictures of a farmyard scene and a watercolour of a stallion and mares at a lake both suggest something of the contented tempo of Gilpin's sojourn at Southill. When the Whitbread family was away, the kind genial artist kept an eye on the children and admitted engagingly, 'I am apt to be idle at Southill . . . there is a stupendous mousetrap in the form of a library, and when a poor nibbling mouse happens to shut himself up in it, how is it possible for him to escape?' (Roger Fulford *Samuel Whitbread 1764–1815. A Study in Opposition*, London, 1967, p. 102.)

Surprisingly, when nearly seventy, Gilpin became involved in some matrimonial trouble and wrote to his patron: 'April 2 1800. I really do not know what to say to you my dear Sir about myself. I can say nothing but what you know already, that I am the greatest of all fools, and yet such has been yours and Mrs Whitbread's kindness that I think you will bear with my folly better than any other person I know.'

During this time Gilpin was also receiving commissions from the Prince of Wales, later George IV; these are mentioned in the Royal Accounts: 'August 21, 1800. To painting the portrait of a Horse 3f. × 4ft. £31 10s.' And another entry 'October 17, 1804. To the portraits of three Horses, large size, landscape etc. £200.' And large this picture certainly was, being seven feet wide. It occupied the artist the whole summer and autumn at George Garrard's house in George Street, Hanover Square, and he often worked ten hours a day at his easel as difficulties arose or new ideas struck him and repainting became necessary. Finally 'very much overcome by too close application' according to Joseph Farington, he went to Southill to recover.

Two years later the artist's health began to fail and in 1807 he died. In his will he wrote: 'I leave to my dear, kind benevolent friends, Mr and Mrs Whitbread, my warm and grateful acknowledgements for a multitude of favours and whatever pictures and drawings of mine they will be pleased to select.'

In spite of popular recognition during his lifetime Gilpin's estate amounted to less than £300. A fulsome obituary notice spoke of 'the great truth and spirit of his compositions and extreme chasteness of colouring. His excellence consisted entirely in the portraying of the anatomy which he was completely conversant with, from the humblest of the domestic tribe to the roaring wanderers of the woods.' (*Sporting Magazine*, April 1807, p. 8.) The conformation and colour tones of Sawrey Gilpin's pictures sometimes fail to arouse admiration today; indeed the colours have not always stood the test of time. Though lacking the genius of Stubbs, the brilliance of Ben Marshall or the sheer technical competence of Herring, posterity should acclaim Sawrey Gilpin as an innovator, as the artist who introduced zest and imaginative fervour into sporting art.

James Ward's rich but uneven talent had a vigour and invention that could produce landscapes and portraits, historical and religious scenes, natural history and child studies, with a marvellous versatility that rarely lapsed into banality. Though his handling of movement and light derived much from Rubens, he possessed a remarkable originality that was unmatched by his contemporaries. He was also blessed with prodigious energy and ambition and during his long life, which covered ninety years from 1769 to 1859, 287 of his pictures were hung in the Royal Academy. It is impossible to assess his merits solely among the painters of sporting subjects, for at his best—unlike Sawrey Gilpin and his contemporaries in this sphere, except of course Stubbs—he must be considered as a significant figure in British art. His extraordinary talent certainly enriched England's inheritance of pictures of animals and field sports in an incomparable manner.

Son of a drunken father and nephew of a pious uncle, his childhood was spent in an atmosphere of contending moral issues and extreme material poverty, a situation that developed a quality of aggressive tenacity in a character naturally diffident and timid, and that perhaps explains the religious ferment and the megalomania that complicated his later years and resulted in some extraordinary pictures. At the age of twelve, Ward abandoned drudgery in a bottling warehouse to start his artistic career with John Raphael Smith, the engraver, and then, eighteen months later, he continued his studies under the somewhat spasmodic tuition of his elder brother, William Ward, the talented mezzotinter. Naturally gifted as a draughtsman, young James here had the opportunity of developing as a mezzotinter of great ability, but he had already discovered his gift for painting in oils. Closely influenced by his erratic brother-in-law, the brilliant but irresponsible George Morland, with whom for some years his name was to be linked, James began to produce pictures with an instinctive fluency in the same pleasing rustic style. In 1792 four of his works were exhibited in the Royal Academy of Arts and two years later on 1 January 1794, at the age of twenty-five, he was appointed Painter and Engraver in Mezzotinto to the Prince of Wales (George IV). It was many years, however, before Ward could afford to ignore the commissions that came to him as an engraver, and devote himself entirely to painting. As he explained to King George III, 'I engrave to live, Your Majesty, but I paint for the pleasure of the art'. It was against the advice of such influential patrons as Beechey and Hoppner that he finally made the fateful decision to abandon engraving, which took some financial courage in the circumstances. Hoppner maintained 'We shall . . . lose the best engraver, which we want, and shall encourage a bad painter, which we do not want.' Ward himself wrote later: 'In one year I believe I refused commissions for the copper for nearly £2000, while I do not recollect one single commission for a picture.'

Ward was a man of many-sided interests and enquiring mind. At one time he used a form of natural shorthand to note colour and subject tones in his watercolours and pencil sketches; he visited antiquaries to obtain historical details; and in an age when horses were valued for their utilitarian rather than their decorative qualities, he was the author of a forceful pamphlet, *The Folly and Crime of Docking Horses*, over a hundred years before the operation finally became illegal in this country. But James Ward frequently tended to be in advance of his time. His study, *The Finishing Post* (pl. 61), shows one of the few breakaways in the sporting art of that day from the rocking-horse gallop, and pre-dates Muybridge's revealing photographs by nearly a century. George III queried Ward's study of a galloping horse with all its legs off the ground, but the artist, on all fours then and there, demonstrated the practical truth of this position.

In the mid-eighteenth century a scientific approach to agriculture and to the breeding of livestock had developed, for the arrival of the Thoroughbred had coincided also with a new evaluation of cattle and sheep. The necessity and desire for exact pictorial records of these animals became obvious. A commission from Sir John Sinclair, President of the Agricultural Society, to paint a pedigree cow, proved a turning point in Ward's career. His undoubted skill in portraying animals received recognition in 1800, when the Agricultural Society jointly with Josiah Boydell, the publisher, put forward an ambitious project. Ward was commissioned to paint 200 pictures of the representative British breeds of cattle, sheep and pigs at fifteen guineas a picture, plus his travelling expenses. With his prodigious capacity for work and meticulous eye for detail, Ward studied anatomy, visited slaughter houses and covered hundreds of miles in a dilapidated gig. He spent three months in Wales alone making 580 sketches, and though horses played no definite part in the commission he made many studies of ponies and cobs seen in the Welsh hills. Pictures of draught horses of all sorts, Suffolks and a Leicestershire stallion also found a place. Through the financial failure of Boydell the scheme was never completed and Ward was heavily out of pocket, but nevertheless he had been given the opportunity to meet many important landowners who were to prove valuable patrons when his gifts as a painter of quality horses came to light.

It was in 1803 that James Ward spent a whole day in wrapt contemplation of the Rubens landscape *View of the Château de Steen* which had been bought by Sir George Beaumont and exhibited in London. In reply, breaking completely away from the Morland arcadian tradition and such pictures as *Outside a Country Alehouse*, he produced his monumental works, *Bulls Fighting, with View of St Donat's Castle in the Background* and *The Boa Serpent*. Though both were rejected by the Royal Academy, Ward's true calibre as an artist was established. The direct impact of Rubens' genius had released in him inherent artistic qualities of force and imagination that were to result in *Gordale Scar, Yorkshire* (Tate Gallery, London), *Two Fighting Horses* and the allegorical *Fall of Phaeton* with its cataract of twisting bodies, a subject also painted by Stubbs. A preoccupation with the savage aspects of animal life endured for the rest of his life and made a lasting imprint on sporting art. These romantic compositions fortunately allowed no neglect of more conventional work, for with domestic responsibilities bread and butter had to be earned. His improved financial position in the ensuing years was due largely to a lucky invitation incurred when painting cattle in Wiltshire. He had been challenged, somewhat disparagingly, to try his skill at the more elegant conformation of bloodstock, and the result was the very fine picture of Mr T. Cook's brood mare, *Grandillo and her colt, Skyscraper*, which was exhibited in 1809 and brought a steady demand for horse portraits from the sporting world: Sir John Shelley, the Marquis of Huntley and the Duke of Northumberland all became his patrons.

In the Royal Academy exhibition of 1810 the painting *Eagle, a Stallion* was shown (pl. 30). This portrait of a racehorse of the day—whose original owner had sold him in 1801 for 1200 guineas to settle gambling debts—can be considered a *tour de force*. The picture is teeming with vitality and a wealth of important detail: the Arabian-type pointed ears, the slightly bent hock, the little wild flowers in the foreground, the galloping horse in the far distance. None of Ward's contemporaries, except Stubbs could have begun to match the technical fluency of this portrait. No wonder Géricault had written of James Ward's animal paintings (and let's admit it also of Landseer's) '. . . les maitres n'ont rien produit de mieux en ce genre'. (*Géricault raconté par Lui-meme et ses Amis*, Geneva, 1947, pp. 103–104.) Underlying this understanding of animal

form and character, *Age, a White Horse*, a gaunt study of decrepitude painted in the years of the artist's own decline, illustrates James Ward's ability to depict emotion, fear, melancholy and pride, a new and extraordinary departure for the British animal painter and achieved without banality or sentiment. Reaching the height of his prolific career, he achieved membership of the Royal Academy in 1811, and with an ever increasing demand for his work his prices advanced with his popularity.

Ward assessed the picture of a horse as highly as that of a human figure, and whether the subject was a portrait, animal painting or landscape, he conformed to a scale of charges fixed by size. A canvas 10 × 12 in. cost 50 guineas which rose to 250 guineas for a nearly life-size portrait, a sum which necessitated payment by instalments from some of his noble patrons. But like Sawrey Gilpin he was always a conscientious, persevering artist, and he records in his diary that for a picture 30 × 24 in. of a horse, he had seven sittings, some of over six hours, followed by three days more on finishing touches.

By the year 1814 Ward was earning over £1200 a year, and fortune appeared to smile even more kindly when the following year he won the prize of 1000 guineas, given by the British Institution, for his design for *The Triumph of the Duke of Wellington*, an ill-fated adventure in allegory that was to prove his artistic Waterloo. Like Gilpin he could not resist the grandiose, and here, encouraged by influential but misguided advisers, and impelled by his own soaring ambition and manic temperament, Ward enlarged his original conception to heroic proportions until he was involved in a mammoth painting of life-size figures covering 735 sq. ft of canvas. Six of the best years of his life were wasted in this undertaking.

The strain of technical and financial difficulties, intensified by the death of both his favourite daughter, Emma, and his wife, reduced him to a state of nervous prostration. Outside commissions were neglected while he battled with his problems, and only the vital necessity to earn money drove Ward to make the journey north to paint one of his best hunting pictures, *Ralph John Lambton and his Hunter Undertaker*. Set against the lovely background of the Durham hills, the horse with its fine front and keen intelligent head stands alertly among hounds; each of these, with Ward's exact eye for detail, is a portrait in itself.

It was at this time too that he painted the lyrical *Huntsmen Drawing a Covert* (pl. 32), which emphasizes the woodland nature of the country. He turned for help to his earliest and most faithful supporters, the Levett family, and painted *The Deer Stealer* (pl. 45) for Theophilus Levett, who was so delighted with the picture that he raised the fee from 500 to 600 guineas, the highest sum Ward ever received for a private commission. It is a curious picture of great size, depicting a small grey Arab, barebacked, in a woodland glade, being used presumably as a stalking horse. The villain of the piece was based on a noted poacher. Finally, in 1821, when national enthusiasm had waned, the Wellington colossus was completed. Pronounced a failure by press and public alike, it was eventually consigned to the cellars of Chelsea Hospital.

Bitterly disappointed, saddled with heavy debts, bedevilled by incipient religious mania and already over fifty years old, Ward, with great tenacity and determination, started to re-build his career. His versatility was still outstanding; the brush that had depicted the sweet serenity of the Levett children ten years earlier became equally expert with the military panoply in the portrait of *Sir John Leicester, Bart., Exercising his Regiment of Cheshire Yeomanry on the Sands at Liverpool*, on his showy grey Arab, and could produce in 1827 the brilliant *Study for The Bunch of Grapes Tavern* (pl. 31), a

picture commissioned by the Duke of Bedford. It is a painting of extraordinary equine power in which soft sepia and olive tones predominate, to contrast with the pale skyline offering a distant glimpse of St Paul's Cathedral.

His reputation was somewhat restored by the picture *Bull, Cow and Calf*, and he had some success with a set of fourteen very fine lithographs—*Drawings of Celebrated Horses from Pictures Painted by J.W. and Drawn on Stone by Himself*. During 1827 he earned only £177, and though he produced at this time many pictures with religious themes, in 1847, having sold no work for four years, he was forced to ask the Royal Academy for help and was granted a pension. But his spirit was indomitable and in his eightieth year he painted the fine group *Council of Horses*, which was sold for £250. He exhibited at the Royal Academy for the last time in 1855 when he was 86 years old, and died in 1859.

James Ward's considerable talent encompassed many subjects—portraits, landscapes, history, allegory; but animals and their emotions provided his major inspiration and it is his appreciation of their strength and spirit as much as their decorative form that has produced his greatest pictures.

The artist lived at a time of great national tension, with the bogey of Napoleonic domination at its height, followed by the euphoria of Wellington's triumph at Waterloo—facts which at times swayed the balance of his volatile temperament and resulted in extraordinary contrasts in subject and content of his work. It is fortunate for posterity that financial exigency made him so often employ his talents on the animal world, for, with Sawrey Gilpin, he brought a new zest and fervour to sporting art.

6 Country pursuits

If Hunting, Hawking, Fishing, pleasure yeald
How much may Art exceede as if in Feild
You veiw'd each sport, by figure so exprest
The severall wayes they take Fowle, Fish and Beast.

Anon., 17th century.

Between 1700 and 1900, racing and hunting subjects provided the most important commissions for the sporting artist, as these activities remained the popular and fashion-able pastimes of the wealthy aristocracy. But in the life of rural England many other diversions played a prominent role, in particular shooting, coursing and angling. Many of the pictures they inspired possess the simplicity and quiet intimacy of personal experience, for although few sporting artists had the means or opportunity to follow hounds, Henry Alken Senr, F.C.Turner, John Ferneley Senr, and Joseph Crawhall being among the notable exceptions, most enjoyed sport with gun or rod. As a result, shooting and angling pictures were rarely the result of direct commissions, but often a record of personal pleasures; herein to a great degree lies their attraction and the popularity of the numerous engravings they gave rise to.

In eighteenth-century England, sporting activities remained very much local concerns, for life around the stately homes was virtually self-contained and organized with great efficiency. The fact that even a quarter of the peers and nearly half of the squires were educated at home and attended neither public school nor university meant that the sons of these families were involved in field sports from early youth. Tutors, local clergymen and possibly a nearby grammar school sufficed for academic instruction, but competence with horse and gun was considered more necessary than a smattering of Latin.

Of course the aristocracy, with London homes providing alternatives to country seats, enjoyed metropolitan diversions beyond the opportunity and incomes of the landed gentry, for whom rural pursuits had to provide both exercise and amusement. Among a certain type of highbrow and snobbish noblemen even hunting and shooting were considered pastimes suitable only for the plebeian. Horace Walpole, that dictator of manners and morals, pointed out that dancing, fencing and elegant horsemanship were to be preferred to the rustic and illiberal sports of guns, dogs and horses which 'characterize our English Bumpkin Country Gentleman'. This, however, was a minority opinion and the English sportsman, at home and abroad, became a symbol of envy and emulation. By 1792 the *Sporting Magazine or Monthly Calendar of the Turf, the Chace and every other Diversion interesting to the Man of Pleasure* was to appear, to set the seal of popularity and social importance on field sports. In this periodical, plates after works by the best sporting artists—Stubbs, Gilpin, Marshall and Cooper—were published, together with contemporary appraisals of exhibitions at the Royal Academy, 'with as much candour as possible of those performances most likely to afford entertainment to our sporting readers'. (May 1793, p. 88.) In this context, in 1793 a coach horse in a picture by Thomas Gooch was described as 'not a bad study' and his trotting mare 'executed with much spirit'. *The Prince of Wales' Mares and Foals* by George Garrard was described as 'nicely true to the originals', but Mr Chalon's *Portrait of a Bull* 'had little spirit'.

Hawking
Until the eighteenth century hawking had been the popular sport of royalty, noblemen and commoners alike, with ancient privileges extended to all free men. Birds were costly, scarce and difficult to train, and the sport required a retinue of attendants and broad acres; but many pictures such as the wooden panel at Wilton House by Edward Pierce the elder, testify to the sport's universal appeal, which reached the height of its popularity in early Elizabethan times. The arrival of the shot gun spelled its decline, and by the eighteenth century hawking, netting and liming of wildfowl gave place to shooting; nevertheless falconry terms such as hoodwinked, mews, hawker and cadger have all become a permanent part of the English language.

Hawking after woodcock and plover and, sometimes, heron was continued by a few devotees until the nineteenth century. A set of aquatints dated 1839 by R.G.Reeve after F.C.Turner (*op.* 1820–1846), dedicated to the Duke of St Albans, the Hereditary Grand Falconer of England, a title still held by the present Duke, records something of the ritual of the sport—*The Departure, The Rendezvous, The Fatal Swoop* and *Disgorging* (pl. 97). The mounted party of seven includes a lady sidesaddle; all wear the silk top hats first made by John Hetherington, the Charing Cross hatter, in 1797. These became *de rigueur* for both sport and every social occasion, whether cricket or church—even the cadger with his frame is no exception.

Shooting
Francis Barlow's engravings had shown the initial acceptance of the gun in the sporting scene, sometimes used on horseback but more often on foot, when stalking the birds,

which were shot sitting. Tillemans painted and engraved an interesting study of *The Duke of Kingston Shooting in Thoresby Park*, with ten pointers in a landscape singularly short of cover for game. Even Londoners could find targets on their doorstep, with snipe feeding on the marshes that are now Conduit Street and wildfowl returning at night to the Willow Walk at Pimlico. Birds were not generally driven until well into the nineteenth century, but walked up and flushed out of stubble and copse by spaniels, and until Victorian times, when large parties with big drives were organized, shooting remained very much an informal pursuit, often solitary or with just a couple of guns, accompanied by a keeper or a groom to hold the horses that had provided transport to the venue.

This informality is captured by Stubbs in several pictures: *Lord Albemarle and Lord Holland Shooting at Goodwood* (pl. 41), painted in about 1759; his portrait of *A Young Gentleman Preparing to Shoot*, dated 1781; and his famous set of four shooting studies (1767–9), engraved by William Woollet, memorable as lovely landscapes of the English rural scene as well as for their sporting content. Another outstanding picture, *The Reverend T. Levett and his Favourite Dogs, Cockshooting*, painted by James Ward (pl. 49) and exhibited in the Royal Academy in 1811, emphasizes this artist's ability to turn a mundane subject into a work of eloquent beauty. Colour in tones of sepia and bronze is applied with sculptured strokes, and the impetuosity of the spaniels contrasts significantly with the quiet concentration of their owner.

Samuel Howitt's delicate, diligent watercolours for *Orme's Collection of British Field Sports*, which were published as coloured engravings between 1807 and 1808, include eleven plates of various types of shooting. Howitt possessed, above everything else, an intimate knowledge of animal life and nature which makes his work of great interest to the sportsman. This is evident in a pair of paintings, *Woodcock Shooting*, which shows the characteristic flight of the bird against a cold wintry landscape (pl. 34) and its fellow, *Partridge Shooting*.

It is for artists such as Dean Wolstenholme Senr, William Jones, Philip Reinagle and Henry Alken Senr that shooting provided a constant subject. The composition of these pictures rarely varies, a couple of sportsmen with guns and two or three dogs, but the landscape provides constant contrast according to the habitat of the target—woodland, lake, moorland and pasture; and the niceties of the flight of woodcock, bittern, pheasant, grouse and partridge are knowledgeably portrayed. Though the name of Henry Alken immediately calls to mind scenes of hunting and racing, shooting subjects retained an outstanding popularity among his engraved works. Excellent mezzotinters such as R.G.Reeve, T.Sutherland, S. and J.Fuller and the artist himself, produced sets of engravings after his work in which few facets of the sport were ignored. Under his pseudonym Ben Tally Ho he included in the illustrations for his book *Sporting Discoveries* a section of seven plates on the 'Miseries of Shooting', in which the trials of tyro and expert were exploited with some humour.

Ben Marshall, a specialist of the racecourse, seldom used shooting as a subject, but Walter Shaw Sparrow seems to have established beyond any reasonable doubt that *Portrait of the Artist as a Young Man With a Gun and Dogs* (pl. 36) is a self-portrait of Ben Marshall himself. The round good-humoured face and kind eyes certainly agree with the generous, gregarious character of 'Marshall of Newmarket'. This portrait of the artist, holding his ramrod correctly between finger and thumb, with crumpled coat and well-worn gaiters, exudes rural informality. Marshall also painted a conversation piece of *The Weston Family*, the men out with their guns and spaniels, accompanied by

Mrs Weston in an ostrich-plumed hat, perched sidesaddle on a nice sort of short-legged bay cob.

Wealthy landowners commissioning portraits from more important artists of the day often demanded the inclusion of a gun and dogs, as can be seen in Gainsborough's fine portrait of William Poyntz of Midgham, with his dog, Amber. Arthur Devis, in his picture of *The Shoot at Tabley Park*, dated 1763, shows the sportsmen dressed in the short brown frock, a coat much worn for outdoor activities, smart, but in inclement weather quite useless for protection; and in this and many pictures the country boots of the period appear, 'Highlows', which come halfway up the calf, a fashion to be seen in Stubbs's painting of *Mr Poyntz of Bath loading his Gun*. As in most sports of the day a definite sartorial style developed; at a glance one could tell if hunting, shooting or fishing was the current activity.

As preservation of game for organized shooting became widespread, game laws of increasing severity were sanctioned. Food prices were rising simultaneously and a permanent state of warfare between poachers and gamekeepers developed. Savage measures against offenders followed and a law of 1816 made any man caught at night with nets on him liable to seven years transportation. Man-traps and spring guns were laid to maim poachers and were not made illegal until 1827. Sporting artists only record the happier side of country life.

Certain landlords were not unreasonable with their shooting rights and at the end of the season granted tenant farmers some sport. Pictures giving some suggestion of such occasions come from the brush of George Morland, with such titles as *Sportsman's Return*, *Sportsmen Refreshing*, suggesting not the wealthy estate owner but the modest yeoman. Morland was never at home with people of breeding and wealth, and spurned influential patrons for the flatteries of drinking companions; his pictures depict sport in England from the viewpoint of the under-privileged against a background of cottage or alehouse. Before his health and talent were wrecked by alcohol, Morland's pictures of pastoral England reflect the seventeenth-century Dutch masters and vie with Gainsborough's landscapes in their arcadian felicity. In studies of pheasant and partridge shooting, autumn tints and cloud effects, the faded scarlet of a coat and the chestnut tones of a shaggy cob would contrast effectively with a dark, gnarled tree trunk. At his best the artist could produce outstanding pictures but these must be set against a great quantity of mediocre works, painted to fob off pressing creditors. Shooting scenes were the most popular engravings among the myriads after his work, from the hands of more than sixty different engravers ranging from Rowlandson to Blake.

In this same *genre*, Luke Clennell's *Sportsmen Regaling* (pl. 35), a picture exhibited at the British Institution in 1813, illustrates the simplicity of the isolated country inn off the coaching routes. The shooters ride sturdy ponies measuring a bare fourteen hands, for only racehorses and hunters were bred for size, and the stalwart cheerful sportsman on this little grey must certainly have ridden a good sixteen stone (224 lbs). Luke Clennell studied with Thomas Bewick, the wood engraver, but was determined to become a painter in oils. Historical works brought him some success, but this country scene glows with quality and atmosphere, presenting a bucolic touch in the rustic setting which may well have been the artist's native Northumberland. From early on in life he was dogged by mental ill-health and died insane.

In complete contrast is *Buckshooting in Windsor Great Park* 'with Portraits of His Majesty's Deer Keepers' of 1825 by Frederick John Lewis (son of F.C.Lewis the engraver) who when a young man was employed by George IV upon sporting sub-

jects, but later painted landscapes. This organized culling of the deer became necessary every year, and the Thoroughbred horses, the royal livery of the keepers and the delicate woodland park scenery, combine to make a highly attractive record of shooting in unusual conditions (pl. 40).

Shooting parties in the nineteenth century became organized social occasions with huge bags. On the big estates the sport was run as a special activity at great expense. In 1796 only £264 had been spent at Longleat, a sum which leaped to £2555 sixty years later.

Those of the aristocracy with Scottish estates went north in August and to these peregrinations we owe such shooting pictures as John Ferneley's *James Bouclitch, Lord Kintore's Keeper, Shooting Roebuck at Keith Hall* of 1824, rich in detail and cleverly posed (pl. 39). Sport in Scotland filled the artist with delight and on this occasion he wrote home on 28 August 1824, 'My Dear Wife, I killed 2 brace of Grouse in Good Stile . . . on Tuesday . . . Mett Capt. Ross, their we kild 8 Roes one I kild myself . . . this I consider the pleasantest days sport I ever had . . . they are roused by a pack of hounds which makes it Shooting and hunting on Wednesday Whent a Salmon fishing & on thursday Sir Harry Mr. Fullgem Mr Wormwell and my self came hear yesterday whent a fishing today I am getting ready for work . . .' (Guy Paget *The Melton Mowbray of John Ferneley*, Leicester, 1931, p. 46.) Spelling and punctuation always foxed Ferneley, but then Lord Kintore himself addressed letters to 'Fernelli' and Lord Montrose to 'Fernally'. No-one enjoyed a day's sport more, and in such pictures as *Mr Edge of Strelley Hall, Notts, and his Clumber Spaniels*, the artist captures something of the happy lot of these fortunate country landowners.

Coursing

Coursing has been a favourite rural activity from time immemorial and it was Queen Elizabeth I who established a definite code of coursing, ordering the Duke of Norfolk to draw up certain rules. There is a Francis Barlow drawing of deer being coursed by greyhounds, an engraving of which was published in 1691, but from an early date the killing of the quarry seems to have been of secondary importance. The fundamental pleasure of the sport lay, as today, in testing the respective speed and skill of each greyhound. New rules allowed only two hounds at a time to take part and the hare was to be given three 'so hos' and 240 yards lead before the greyhounds were slipped. These different methods brought the hare into such prominence that coursing eventually became segregated from hunting proper, to form a separate sport which was enjoyed with informality by country landowners on their own estates to test the abilities of their own greyhounds.

John Nost Sartorius in *Coursing—Two Gentlemen with Greyhounds*, dated 1806, shows a typical scene with two horsemen galloping, the greyhounds nearing a long-legged hare, and in the distance the inevitable large country house (pl. 42). Ward's picture, *Coursing in Sussex*, which originally appeared at the Royal Academy in 1819 as *A Gentleman and His Keeper with his Favourite Horse and Dogs, and Two Greyhounds*, shows the sport pursued again in the solitude of a wooded hill with a picturesque vista of distant countryside.

In the latter half of the eighteenth century several coursing clubs sprang up. The most famous was founded at Swaffham in 1776 by Lord Orford, eccentric nephew of Horace

Walpole, but meetings were frequently held at Ashdown, Amesbury, Newmarket and Deptford, and of course Altcar, today's venue of the Waterloo Cup. A splendid picture of the more sophisticated coursing engagement was painted in watercolours by James Pollard and engraved by him in 1824. Entitled *Coursers Taking the Field at Hatfield Park*, it shows various attendants with couples of greyhounds, and apart from a handful of scattered pedestrians the rest of the field is mounted on horses of quality breeding. Included in the scene are four ladies in bright habits, and with the kaleidoscope of greys, bays and chestnuts and the warm tones of the brick Elizabethan mansion it makes an engaging record of the sport.

Most artists of field sports used coursing as a subject, and these include Samuel Alken, James Barenger, R.B.Davis, Dean Wolstenholme Senr, George Morland, G.H.Laporte and others. Coursing also brought commissions to many artists, including John Wootton and Sawrey Gilpin, for individual portraits of popular and famous greyhounds. Ben Marshall painted a spirited picture of Colonel Thornton's favourite greyhound in about 1805, an animal of some size, and Philip Reinagle portrayed Thornton's renowned Major at Carshalton on the day of the Thousand Guineas wager.

Lord Orford in the latter part of the eighteenth century had tried several crosses in greyhound breeding, including lurchers, deerhounds and Italian greyhounds, to give greater speed, endurance and finer skins. The bulldog, oddly enough, provided the ideal alternative, but not in the first cross. However, introduction of the blood brought long-term success and also the brindle coat. With this later type, John Ferneley Senr when only twenty-five was particularly successful with his *Portrait of a Greyhound in a Landscape*, showing more than a hint of his developing talent for animal form; in the distance a trio of small galloping figures is introduced, a feature to be seen so often in his big hunting compositions. His picture of *Treasure, Gabrielle, Butterfly and Harpy*, dated 1833, the property of the Rev. Francis Best of South Dalton near Beverley, exploits admirably the exquisite elegance of the well-bred greyhound.

Cockfighting
Cockfighting had been considered a manly diversion by the Greeks and Romans, and remained as fashionable as racing in the eighteenth century, when many titled sportsmen owned fighting cocks. Numerous country houses and local inns had their own cocking pits, and the Royal Cockpit built by Henry VIII in St James's Field (Birdcage Walk) survived until 1816. This is the scene of Hogarth's picture *The Cock Fight, 1759, Royal Sport Pit Ticket*; Whitehall, Cambridge and Newmarket were also favourite headquarters of the sport. The birds were scientifically bred and trained, and professional 'feeders' and 'setters to' were employed. Each cock was named and a list of competitors at mains with starting prices was published in the *Racing Almanac* (forerunner of Weatherby's *Racing Calendar*), which listed all cock matches as well as horse matches over the value of £10. Wagering was heavy among all ranks of the community. The popular Twelfth Earl of Derby, who gave his name to the classic race, was even more addicted to cockfighting than to the turf and kept as many as 3000 cocks on his estates; in their leases his tenant farmers undertook to walk a certain number of birds. When eventually Lord Derby staged fights in his own drawing room his matrimonial difficulties understandably came to a head and the marriage ended in divorce.

Controversy reigned over the cruelty of the sport, for birds were armed with needle sharp spurs of steel or silver to make attacks more lethal and therefore, by one argument, more speedily resolved and less cruel. Plumage was also cut and shaped to facilitate more effective thrusts. A life-size picture, *The Trimmed Cock*, originally ascribed to Francis Sartorius but by a virtually unknown artist, Robert Hodgson (*op.* 1780–7), shows the method of attaching the spurs and the origin of the phrase 'to show the white feather': when getting the worst of a fight a cock would lift its hackles which made visible the under-rim white plumage. Another painting of a cock by Hodgson, *Old Trodgon* (pl. 46), records on the canvas 'won in 1785 50£, in 1789 100£ and in 1787 200£. Fed by B Robson.'

Pictures of the sport of cockfighting are not numerous. Ben Marshall's *Two Game Cocks: Black Breasted Dark Red and Streaky Breasted Red Dun* show in fine detail the type of bird bred for the sport, and his *Cock in Feather* and *Trimmed Cock* are not only informative but also fine studies of these richly coloured birds. Engraved by C. Turner in 1812, in second state the plates were reduced in size and entitled *Peace* and *War*. Most decorative of all, his *Fighting Cock* shows a bird strutting free with his wives in a farmyard.

Cockfighting was abolished by law in 1849, but even a hundred years later still flourished in secrecy in the Midlands and the North.

Angling

Angling, though increasingly popular in the eighteenth century, remained something of the Cinderella of the sporting diversions. Being a solitary pursuit, few landowners concerned themselves personally in its enjoyment but regarded it as an amusement for the young boys of the family. Carefully stocked lakes and ponds were found on most estates, rivers teemed with tench, roach, carp and pike; salmon were found in the Thames and there was no country lad who could not tickle trout. There was usually a certain generosity in granting angling permits, a privilege eagerly sought by the penurious villagers, for fish provided a welcome source of food. But Thomas Bewick wrote of other benefits: 'Angling has from time immemorial been followed, and ought to be indulged in unchecked by arbitrary laws as the birthright of everyone, but particularly . . . it unbends the mind of the sedentary and the studious, whether it may be those employed at their desks or "the pale artist plying his sickly trade".'

Fly-fishing, known as 'fishing at the top', was introduced during the fifteenth century and both natural and artificial flies were used. The first representation of an angler with a float is found in the *Dialogues Creaturarium Moralisatus* of 1460. From this time on angling seems to have attracted more artists and authors than any other rural sport. The instruction and advice of Izaak Walton's *Compleat Angler*, first published in 1653, is almost as relevant today as it was in the seventeenth century, and by 1923 this fisherman's *vade mecum* had run into 168 issues and editions with nineteen different illustrators. Francis Barlow's *Dead Fish in a Landscape* and *At Sunset After a Day's Fishing*, to be seen at Clandon Park, are two of the very few oil paintings contemporary with *The Compleat Angler*, and in the latter a medley of different fish, trout, pike and gudgeon, merge in a colourful heap with diverse birds including magpie, woodpecker and heron, to make a composition of outstanding decorative power and charm.

Angling attracted a vast number of artists outside the school of sporting art. Such portrait painters as John Zoffany used this piscatorial motif with diverting effect to

break the formality and monotony of the poses of his sitters, both parents and children. With equal skill landscape artists such as Turner, Cotman, de Wint, Cox, and Constable in *The Young Waltonians*, placed fishermen adroitly in their pictures to provide a contrasting focal point.

The purely sporting artist received few direct commissions for angling pictures; many of those that were painted were the result of personal addiction to the sport, allied to the desire to experiment with landscape effects. George Morland when seeking a haven from his creditors in the Isle of Wight in 1799 found boon companions among the local fishermen and the encounter resulted in some fine sea-fishing pictures. Morland's most superb picture of the sport, *The Angler* (pl. 48), emphasizes the truth of W. E. Henley's dictum: 'In all the range of British Art there are few things better than a *good* Morland.' The deep sepia and green tones of the tree-fringed pool are magically enlightened by the tiny touch of scarlet of the neckerchief of the lone fisherman. This artist also exploited the feminine element, with ladies' furbelows and shady hats in a rowing boat providing grace and colour to *A Party Angling*. Thomas Rowlandson in two watercolour studies, *Anglers near a Watermill* and *A Snug Angling Party*, merges sport and dalliance in delightful proportions. In the print, *Fashionable Angling from a Punt*, drawn and engraved by Robert Pollard, ladies wield their rods comfortably seated in wheelbacked chairs. Robert's brother, James Pollard, produced many fishing studies in which the anglers themselves were painted with naive but ill-proportioned charm, yet rod and line with detailed expertise.

James Stark, who was articled for three years to John Crome ('Old Crome'), painted angling scenes of the Thames near Windsor evocative of his master, with the same lyrical feeling for tree-lined river banks. William Jones (fl. 1825–47), one of eight sporting artists named Jones working at the start of the nineteenth century, was a painter with a sensitive feeling for landscape and the ripple and shadow of running water, who understood the niceties both of angling and of artistic composition, and produced such attractive studies as *Fishing* (pl. 47), a work pervaded by the quiet and patient tenor of this sport. Philip Reinagle, usually a portrayer of horse and hound, painted a few angling scenes, while Henry Alken Senr, with adroit brush for any sport, exploited the humorous side of fishing. Some Alken watercolours, however, are more serious in intent. The figures are portrayed with an authority of stance and angling technique that suggests this hunting artist could also ply with grace and skill a pretty rod. Abraham Cooper also took relaxation from his animal portraits in painting many studies of his own favourite sport.

Several artists portrayed the different techniques of angling with a keen eye for tackle and technique, showing the gentry using rods of four pieces and the countryman a home-made rod of three pieces. Specialist shops for angling requisites sprang up, but most rods were home-made from cane, reed or hazel; and creels, as now, were handwoven from local osiers. In a woodcut of 1850 after Edward Duncan, a fisherman wears waders covering the thighs, but these were probably of leather. Although rubber galoshes appeared in the 1830s, rubber wading boots were only adopted at the end of the nineteenth century, and sciatica must have been an occupational hazard.

Riding

In addition to these quieter pursuits, the perennial recreation of country life was riding. The health and well-being of the horses loomed large with any landed property owner,

and much time was spent in home concoction of liniments and ointments for their injuries and ailments. In 1719 Lady Fermanagh wrote to her husband at some length on the subject: 'The Horse . . . had several holes broak in his leg' and they had 'put in a rowell and lard poultis . . . to draw out the anguish'. At much the same time, Ralph Palmer, in correspondence with Ralph Verney, deplored the fact that 'sure the quadrupedes are all betwottled'.

Until the middle of the nineteenth century, few women took a very active part in field sports, but quiet hacking on horseback was considered both suitable and stimulating. The saddle was regarded as a panacea for most ills, both physical and mental. 'There's nothing like a rattling ride for curing melancholy,' wrote Winthrop Mackworth Praed. Equestrian costumes were also delightfully becoming, whether as worn in Sir Godfrey Kneller's *Portrait of the Countess of Mar*, dated 1715, with embroidered waistcoat and stiff full skirt in heavy brocade, or in the style of the smart one-piece habit in bright green laced with black, shown a hundred years later in a fashion plate of *La Belle Assemblée*.

A picture of considerable interest for the light it throws on riding fashion, and also of outstanding elegance and beauty, is *Hon. Marcia and Hon. George Pitt Riding in the Park at Stratfield Saye House* by Thomas Gooch, exhibited at the Royal Academy in 1784 (pl. 50). The artist, a painter of racehorses and dogs as well as equestrian portraits, shows in detail the girl's short-coated fawn riding habit and tall hat with plumes, which reflect the height of contemporary *haute mode*. He also clearly depicts the sidesaddle of the period with its off-side pommel and lack of balancing strap, an unfortunate omission for the safety of the female rider. Equally fashionable are the barbarous cropped ears of her fine fronted black horse, a mutilation originally derived from the mediaeval custom of clipping ears in various shapes to identify animals commandeered for war or running out on common land; in early Georgian times cropping was used to 'smarten' the appearance of hacks and hunters. This insufferable indignity appears in numerous pictures by many artists, including James Seymour's *A Kill at Ashdown Park*.

The stylish long-legged riding seat of the Hon. George Pitt suggests the trained horseman, and his green coat, contrasting with the bright bay tones of his hunter and the feathery parkland trees, proves Gooch a master colourist. The glimpse of Stratfield Saye House, framed by the horse's legs, makes a highly effective topographical detail. It is a memorable picture, that exemplifies the leisure diversions of the English aristocracy of the period. In complete contrast are two riding scenes by Henry Alken Senr from *Humorous Specimens of Riding, etc., etc.* (pls. 51 and 52). *Yeomanry of England Paying a Visit* (1821) is not concerned with members of the Volunteer Cavalry Force established in 1794, but shows two yeoman farmers, here on pleasure bent, with plump sedentary wives securely perched on pillion saddles, a mode of travel that endured in rural districts well into the nineteenth century. The other, *Lords View in the Park*, would suggest that horsemanship in the Row, then as now, lacked expertise, with knees six inches from the saddle or heels at a tangent. Riding at that date, however, was not only a health-giving diversion but a vital and everyday mode of travel. Gooch and Alken present both the elegant and functional forms.

Country diversions were not confined to field sports and equestrian activities. Prize fights for large purses in open-air rings or covered booths attracted hundreds from the towns, and scenes both satiric and comic found Cruikshank and Rowlandson in their element. Bear and bull baiting possessed many partisans and the latter was not finally

made illegal until 1836, though the *New Sporting Magazine* five years earlier had closed its pages to cockfighting as well as bull baiting and prize fighting.

The English Sporting Eccentric

The even tenor of country life produced that unique anomaly, the English Sporting Eccentric. Possibly the boredom of bad weather, impassable roads and maybe dull wives impelled these extrovert characters to feats of bravado, foolhardiness and even cruelty.

Sawrey Gilpin had found a generous patron in Colonel Thomas Thornton, the dedicated sportsman, assessed, however, by his contemporaries as a bounder and a show-off. The revival of hawking was the Colonel's particular obsession, but foxhunting and horseracing also claimed his time and fortune. In addition he was an outstanding shot and an athlete of extraordinary ability: in a match he leapt over six barred gates in six minutes and then repeated the feat on horseback. Sporting entertainments at Thornville Royal were on a grandiose scale attended by great publicity, with reindeer, roebuck and fallow deer, Russian and French wild boar, and cormorants wearing silver rings round their necks for fishing, kept on the estate. White terriers were bred, a rarity at that date. The Colonel would hunt a white buck with bloodhounds, giving the animal an ostentatious funeral when it was accidentally killed.

Sawrey Gilpin and Philip Reinagle collaborated in recording the sporting activities of the Colonel, the most important being a portrait of him with his famous twelve-barrelled gun; Reinagle painted another study, of uncanny perception, hinting at the instability verging on madness in his sitter's make-up. Prodigal living resulted in Thornton, an ardent Francophile even in the Napoleonic era, seeking financial refuge in France; he died in Paris in 1823.

Recorded with some acerbity by the sporting journalist Nimrod (Charles James Apperley) in 1835 are the *Memoirs of the Life of the late John Mytton Esq*, illustrated with a hint of caricature by Henry Alken Senr with some assistance from T. Rawlins. These plates, etched by Alken after his own watercolours, show in vivid detail the more reckless and hair-raising of Jack Mytton's exploits: wild duckshooting in the snow, clad only in a shirt; swimming the Severn at Upperton Ferry to keep with hounds; riding a bear into his own dining room in full hunting kit; setting fire to his nightshirt to cure an attack of hiccups; driving his tandem across country at midnight; and, the classic example of his contempt for danger, upsetting his gig at breakneck speed for the edification of a timid travelling companion.

The goodlooking John Mytton in golden youth is portrayed by J.F.Herring Senr (pl. 53) and William Webb; these portraits were painted before his fortune had been dissipated on the turf and his first-class brain and iron constitution ruined by alcoholism, which led to his death in the King's Bench debtors' prison at the age of thirty-eight.

The famous Squire Osbaldeston, Master of the Quorn, a sportsman of very different character, was nevertheless unable to resist a challenge of any kind, whether racing, steeplechasing, shooting, cricket or billiards, or even a duel with pistols against Lord George Bentinck. He played single wicket against professionals and rowed against Thames watermen, but most famous was his wager in 1831, when he was forty-four years old, to ride 200 miles on Newmarket Heath in ten hours. Changing horses every four miles, stopping thrice for weak brandy and water, and lunching off a cold partridge, he finished his historic feat with cool and confident aplomb and one hour eighteen

minutes in hand, a scene painted by Henry Alken Senr. Osbaldeston can be seen among the fashionable Meltonians in several pictures by Ferneley, Lambert Marshall and others. Ferneley also made a series of paintings, somewhat functional in character, of the bizarre exploits of Count Sandor, the Hungarian nobleman who found English a sad, difficult language but who made Leicestershire his sporting playground in 1839 and has gone down to hunting posterity for announcing he had jumped 'all de doors between Melton and South Croxton'.

7 Racing: the sport of kings

The rage for horses has become a positive epidemic; many persons are affected with it whom one would have credited with more sense.

Lucian, *c.* AD 125–190

From Saxon times a love of horseracing appears to have been inherent in the people of England, but few public race meetings were formally organized until the sixteenth century. The Company of Saddlers of the city of Chester ran one of the first events on Shrove Tuesday in 1539 with a decorated wooden ball as prize. By 1624 this had become an important race and the reward a silver bell, and 'bell courses' at such places as Doncaster, Croydon and Enfield Chase became established. At the end of Charles I's reign, racing was taking place in Hyde Park and at Newmarket, but it was not until the Restoration in 1660, when the sport was revived and encouraged by Charles II, that it really came into its own, with cups and bowls valued at 100 guineas taking the place of silver bells.

One of the first pictures of an English horserace comes from a plate $30 \times 11\frac{3}{4}$ in. etched by Francis Barlow (pl. 55). The title, incorporated in a medallion design of the Royal Arms, records *August 24, 1684. The Last Horse Race Run before Charles II of Blessed Memory at Dorsett Ferry near Windsor Castle*. It is embellished by thirty-two lines of flowery verse and a statement 'Drawn from the Place and Design'd by Francis Barlow 1687'. The etching provides details of both period and local interest, with the Castle dominating the scene and overshadowing the roughly constructed little covered platforms. These stands were a frequent feature at early meetings, when official headquarters and weighing rooms were often housed in canvas booths; in fact, for many years at both Ascot and Cheltenham only coloured tents for spectators and cowsheds

for the horses were provided. Barlow shows King Charles watching proceedings from the comfort of his coach with six horses; and the four runners, before the advent of the Thoroughbred, appear small, neat and compact in conformation, their riders brandishing lashed whips. Here too can be seen the usual posse of mounted spectators who in those days galloped along the course shouting encouragement. A hundred years later, in 1788, Rowlandson in his *Racing at Brighthelmstone* continues to show only one very small high covered stand for the gentry, while the many onlookers ride cobs and ponies.

Barlow's picture was the first in a new field; it was followed by paintings by such artists as Tillemans and Wootton who, with their talent for landscape, used the picturesque panorama of Newmarket Heath in their racing scenes with a flair that was not displayed by contemporaries such as James Seymour and Francis Sartorius, who were both content merely to portray the racehorse and his rider in functional detail.

It was this formative period in the development of the Thoroughbred before 1780 that led to the birth of horseracing as we know it today and which was responsible for the subject taking such a prominent place in sporting art. Continental links vanished in the process and the artistic emphasis became completely British. The influence of contemporary Arabian stallions on bloodstock breeding can hardly be over-estimated, and it must be remembered that though the most important, the Byerley Turk, the Godolphin Arabian and the Darley Arabian never actually ran in a race, they stamped their descendants with unmistakable quality and provided the prepotency which founded the dynasty of the Thoroughbred. Their status value explains the innumerable repetitive portraits of these sires by Wootton, Seymour and Sartorius. Owners also demanded pictures of the immediate descendants of these horses, for their speed and stamina were quickly to prove infinitely superior to that of other breeds. In fifty years the Thoroughbred was established as the racehorse of the age and was to provide a perennial subject for the sporting artist for the next two hundred years.

One of the great characters and early guiding lights of the turf, painted by Ben Marshall and Philip Reinagle as well as John Wootton, was the famous Tregonwell Frampton, who introduced orderly rules and procedure into the sport of racing. By 1727 Mr John Cheney of Arundel had produced the first Racing Calendar, and by 1752 the Jockey Club was established with its headquarters at Newmarket; it was to become the supreme authority to direct the sport of racing. Among its early members and subscribers were such influential patrons of the turf as the Duke of Cumberland, third son of George II; the Duke of Ancaster, Master of the Horse to George III; the Duke of Bridgwater, one of the richest men in England and initiator of England's inland waterways; the Third Duke of Grafton, Privy Seal under Lord North's government; the Duke of Devonshire; the Duke of Richmond who established Goodwood Races; the Duke of Hamilton, the most stylish gentleman rider; Lord March (who became the notorious 'Old Q'), the fourth Duke of Queensbury; the last Marquis of Rockingham, one of the many Prime Ministers of England who combined the interests of bloodstock breeding and politics; and of course both Sir Charles Bunbury and the Twelfth Earl of Derby, whose name was to be given to the most important race in the country. They founded important studs and, almost without exception, commissioned portraits of their famous horses from the leading sporting artists of the day.

The Duke of Cumberland not only established the fortunes of Sawrey Gilpin, but bred the phenomenal Eclipse. This extraordinary colt was by the Duke's Marske, a stallion initially considered to be of little merit, but the subject of a splendid painting by Stubbs. The foal's birth in 1764 coincided with the Great Eclipse of the sun. His great-grandsire

was the Godolphin Arabian and he was the great-great-grandson of the Darley Arabian. Bright chestnut with white blaze and sock on his off hind leg and black spots on his quarters, he was to prove the greatest horse of the century. At the dispersal sale after the Duke's death in 1764, Eclipse was bought by Mr Wildman, a Smithfield salesman, for 75 guineas, and in spite of an intractable temper and difficulties in training, he made his debut as a five-year-old carrying eight stone (112 lb) in the Fifty Guineas Plate of four miles at Epsom on 3 May 1769. His extraordinary speed resulted in a runaway win from the rest of the field in the first heat and it was then that Dennis O'Kelly, an Irish adventurer who became a Lieutenant-Colonel in the Middlesex Militia, made his famous wager on the next heat, 'Eclipse first and the rest nowhere'; his words were quickly proved right. O'Kelly immediately acquired a half share in the horse for 650 guineas and by the end of the year for a further 1000 guineas became sole owner. Eclipse remained unbeaten, carrying weight over long distances and actually winning the King's Plate for six-year-olds at Winchester with twelve stone (168 lb). His career on the turf lasted only one year and five months, as no horses could be found to run against him. In all, he won twenty-six races and matches and amassed over £25,000 in stakes, but his success at stud where he earned a further £25,000 for his owner was no less spectacular. Eclipse sired 344 winners, including three winners of the Derby and one of the Oaks.

Many artists painted pictures of the horse, but Francis Sartorius is credited with more portraits of Eclipse than the rest of his contemporaries put together. The horse provoked something of an artistic challenge, for his appearance was unusual for a Thoroughbred racehorse of the period; his height at 15·3 h.h. was exceptional, and both Stubbs and Sartorius show his length of body with little wither and his quarters higher than his forehand. His shoulders were particularly long and sloping to give him his exceptional stride, but both artists suggest he possessed sickle hocks. Contemporaries alleged he looked more like a hunter than a racehorse, though his head, small and Arabian in character, bore testimony to his Eastern forebears. A sketch of Eclipse by Stubbs shows the horse almost roach-backed, but his two pictures, *Eclipse with Mr Thomas Wildman and his Two Sons* (pl. 56) and *Eclipse* (the stallion is held by a groom, with a jockey in the colours of Colonel O'Kelly), painted in 1770, both emphasize the horse's exceptional points and outstanding quality.

Stubbs could paint several portraits of the same horse with extraordinary perception as his four pictures of little Gimcrack, who changed hands several times and whose owners included the Earl of Grosvenor and Sir Charles Bunbury, testify. The first shows the steel-grey colt in the foreground with his trainer, jockey and stable lad, being rubbed down on Newmarket Heath and, in the background of the same picture, winning the actual race. Stubbs painted him also when the horse's coat had turned to silver, standing in the foreground of a house and park. Every portrait emphasizes, in spite of a plain big head, Lady Sarah Bunbury's description of him as 'the sweetest little horse that ever was'. Standing only a quarter of an inch over 14 h.h., winner of twenty-seven races on the principal courses in England and when sent to France covering twenty-two and a half miles within the hour for a wager, Gimcrack became something of a legend in his own day.

Though such racehorse owners as the Duke of Richmond and the reckless gambler, the Earl of Grosvenor, possessed an appreciative eye for real artistic merit and commissioned pictures by Stubbs, in general patrons demanded little artistic flair in the pictures of their horses. They required a portrait that depicted their Thoroughbreds

with the good points somewhat over-emphasized and the weak factors in their conformation understated; the general composition of the picture, the supplementary figures and landscapes could be ignored.

Francis and John Nost Sartorius had a great vogue as painters of contemporary Thoroughbreds and patrons were numerous; but as W. Shaw Sparrow so rightly points out, even John Nost, the most gifted of the family, ought to have learnt much more about landscape painting and figure drawing: 'the semi-primitive is often irritating whilst the wholly primitive is not'. (*British Sporting Artists*, p. 85.) Artistic competition in the racing field at this time was limited, for Stubbs's versatility led him away from the purely sporting subject, and James Ward and, in a much lesser degree, Sawrey Gilpin, also diversified. But the market for equine portraits was increasing as racing became established as a major sport, supported not only by the influential aristocracy but also by a much wider public taken from the spreading and prosperous towns of northern England and the Midlands.

Under the aegis of the Jockey Club racing was taking place on ninety courses with permanent stands erected for spectators. In the early eighteenth century it had been customary for riders to wear waist-length tight-fitting jackets in colours for identification, as in Stubbs's picture of the lanky *Molly Longlegs*, but in 1762 individual registered colours for different owners were introduced which restricted the free palette of the painters of racing scenes. The new regime also made important rulings on such vital matters as 'warning off' notices, certificates of the age of runners and appointment of stewards, and some limitations in specified weights led to the rejection of the crippling 10 to 12 stone (140 to 168 lb) burdens. Under the driving force of Sir Charles Bunbury, finest judge of a horse in his day, the five Classic races were founded between 1778 and 1814. These supreme tests, all for three-year-olds, the St Leger, the Derby and the Two Thousand Guineas, and for fillies only, the Oaks and the One Thousand Guineas, were to establish the ideal type of Thoroughbred. They have provided the subjects for hundreds of pictures by sporting artists, from the Sartorius family to Lynwood Palmer and the contemporary animal painters of today.

Aptly enough, Sir Charles Bunbury's chestnut colt Diomed won the first Derby on 4 May 1780; in the painting by Francis Sartorius he towers over his jockey Sam Arnhull. The artist also distorts the horse's hind leg in the convention established fifty years earlier by Wootton and Seymour. Of sartorial interest are Arnhull's black riding boots with their brown tops; these are a development from the former white stockings and short gaiters and eventually became general wear for jockeys. By the end of the eighteenth century a new generation of animal artists began to emerge. Ben Marshall became the most successful portrayer of the racing scene, for in addition to understanding equine anatomy he introduced the professional adjuncts of the sport—saddles, horse-rugs, grooms at work, which brought fidelity and warmth into his pictures.

Ben Marshall (1768–1835)

Born in Leicestershire in 1767, Marshall studied industriously for three years under the portrait painter Lemuel Francis Abbott. Tradition maintains that after seeing Sawrey Gilpin's savage picture, *The Death of the Fox*, at the Royal Academy in 1793, he resolved to apply himself to the sporting scene. The field was wide open; attractive subjects and influential patrons were ready to hand, but Marshall's own temperament and inclination also played their part.

A fortunate association with John Scott, the engraver, led to a long series of plates published by the *Sporting Magazine*; these brought Marshall's name before a wide public and he decided to settle in Newmarket, the hub of the racing world. As he explained in his famous quip to Abraham Cooper, 'I have a good reason for going. I discover many a man who will pay me fifty guineas for painting his horse, who thinks ten guineas too much for painting his wife.' In more serious vein he declared 'A painter should never be satisfied—when that is the case he has done improving, and when he ceases to improve he ought to die.'

Marshall never completely abandoned portraiture, and some of his work in this field emulates Zoffany's in its eye for character and detail. These qualities are evident in pictures of such personalities as the pugilist, Gentleman Jackson, that mountain of flesh and personal friend, Daniel Lambert, and the celebrated shot, J.J.Shaddick. At Newmarket he made several studies of leading jockeys of the day; his *Portrait Sketches of S. Chifney Junr, Wheatley and Robinson* (pl. 57), painted in about 1818, in addition to being excellent likenesses, suggest individual variations of riding style, especially the Chifney advice to ride 'as if you had a silken rein as fine as a hair and that you were afraid of breaking it'. (The Druid (Henry Hall Dixon) *Post and Paddock* p. 83.)

The Druid, a popular nineteenth-century sporting journalist, asserted that Ben Marshall drew horses as a well-taught man rather than as a lover of a four-legged subject, an opinion echoed by Sir Alfred Munnings who held that Marshall's pictures of figures were always better than those of horses. But the quality and symmetry of Thoroughbreds inspired some of his best work, and such splendid portraits as *Diamond with Fitzpatrick Up* and of *Emilius Standing Outside a Stable*, the 1823 Derby winner, stamp him as a master of the blood horse. His vigorous, live approach to the sporting scene was something of an innovation in his time, and his flair for making the muscular elegance of a racehorse stand out from the canvas, a chiselled effect he was prone to exaggerate, allegedly using his thumb as much as his brush, brought general acclaim and valuable commissions.

His introduction into his pictures, often with a touch of caricature, of stable lads and hangers-on, vividly evokes the early nineteenth-century racing scene. This is nowhere more evident than in *Anticipation with Bourbon* (pl. 58), painted in 1817, the year in which Anticipation, winner of the Ascot Gold Cup in 1816 and again in 1819, was beaten half a length by Lord Cavendish's Bourbon. The two horses are attended by a very seedy collection of individuals.

In 1819 Marshall suffered terrible injuries when travelling in the Leeds coach which overturned because of the drunkenness of the driver. His artistic skill was seriously impaired, but two years later he was courageously building a new painting room to produce outstanding portraits of such horses as Banker, Mameluke, the 1827 Derby winner, and Zingaree with the Chifneys. But the critics with their earlier heartless disregard of his disabilities had done their damage and Marshall's star was on the wane. With admirable initiative he turned to journalism. Under such pseudonyms as Observator and Breeder of Cocktails, he became an efficient racing correspondent and reported meetings with a vivid and controversial pen for the *Sporting Magazine*, receiving approval from R.S.Surtees when he was editor.

Among the more notable younger artists was Abraham Cooper, son of a Holborn tobacconist, who had spent his early years with Astley's Circus, famous for its equestrian dramas. Here a natural gift for drawing led to the patronage of the owner of the Meux

Brewery and some training from Ben Marshall. Cooper's own competence, personal charm and addiction to hard work quickly led to the first of his 189 contributions to the *Sporting Magazine* (his engravers included J.Scott, J.Webb and E.Hacker) and ultimately to his 352 pictures contributed over fifty-eight years to the Royal Academy, where he obtained full membership in 1820.

Cooper's reputation as a painter of field sports mounted in spite of excursions into classical and historical subjects. He was himself an adept flyfisher and a good shot. Commissions came thick and fast from the important racing owners of the day, and earned him Guy Paget's apt title of 'Animal Painter Extraordinary to the House of Portland'. The latter connection brought direct patronage from Lord George Bentinck, a man of equivocal character, who at one time had sixty horses in training. Racing had fallen into disrepute, for excessive betting by all classes of society had resulted in rough houses, chicanery and 'nobbling'. Lord George, though he personally lost £27,000 in one year, devoted his energies to improving the standards of the sport and introduced punctuality, paddock parades, number boards and the use of a flag in the method of starting, which eliminated many dubious practices. In 1836 he won the St Leger with Elis, and by outwitting the bookmakers made a fortune on the race. It was a fifteen-day journey walking the horse by road to Doncaster, the usual method, and when Elis was still seen in his stable at home a week before the race, rumours that he was a non-runner became a certainty. However, with a specially constructed box, an idea invented twenty years earlier by a Mr Terrett to transport his horse Sovereign from Worcestershire to Newmarket to run in the Two Thousand Guineas, Elis, drawn by six post horses at the rate of eighty miles a day, reached the course fresh and fit in two and a half days, having had an exercise gallop at Lichfield en route. He won the race from the favourite, Scroggins, with great ease. The picture painted by Abraham Cooper, *Elis Ridden by John Day*, with Lord Lichfield's trainer, Doe, alongside and the horsebox in the background, was exhibited two years later at the Royal Academy, and with its companion portrait of Mr Greville's Mango, the 1837 St Leger winner, proved something of a triumph for Abraham Cooper, for racing was not a popular subject at Burlington House. The artist also painted the 1834 Derby winner, Plenipotentiary, a big horse (derogatively described by the Druid as 'thick as a bullock', *Post and Paddock* p. 201), cleverly suggesting some of his great muscle and girth.

His conversation piece *The Day Family* (pl. 59), emphasizes the artist's ability for portraiture: John Day, leading jockey of the period, stands, whip in hand, beside his mother and wife seated in a mule carriage, and his sons, Samuel on John Day's own Venison (much fancied for the 1836 Derby), and young William on Château d'Espagne. Inconsistency and mediocrity sometimes appear in Abraham Cooper's work, but as there were eight contemporary sporting artists with the surname Cooper, it is inevitable that some poor paintings have been ascribed to Abraham, not always with justification.

John Frederick Herring Senr (1795–1865)
Few artists of the racing scene can have received more acclaim from contemporary critics than John Frederick Herring Senr. His obituary in the *Sporting Magazine* described him as 'a man who fairly dwarfed Marshall, Gilpin, Stubbs and Sartorius, and first showed the world not only how a thoroughbred horse should be drawn, but made the half-bred bear his part in the pastoral scenes such as canvas had never known before'. (November 1865, p. 323.) Current opinion, just over a hundred years later, would hardly

support this lavish evaluation though his portraits of famous racehorses, including thirty-three consecutive winners of the St Leger and eighteen of the Derby, provide a unique record of the English turf. The Thoroughbred was certainly the artist's first love, though late in life he switched his affections to the farmyard scene. Herring's father was of American-Dutch extraction, trading as a fringe maker in Newgate Street in London, where the Royal Leeds Union Coach passed the door every morning—a sight that fascinated young John Frederick. As a child he was either drawing horses or handling a whip, and it is said that the indulgent driver of the London–Worthing coach gave him his first lessons in managing a team. When he was twenty, Herring travelled north to become for some years a professional driver, eventually on the important Doncaster to Halifax Mail Coach; he also painted inn signs, coach panels and horses.

A perceptive passenger, Mr Frank Hawkesworth, enabled Herring to substitute the brush for the ribbons, and in 1818 the Royal Academy accepted his *Portrait of a Dog*. He possessed an innate gift for animal portraiture and he was inevitably drawn to Newmarket and its racehorses. Herring worked there for three years, but realization of his own limitations sent him to Camberwell in 1833 to study under Abraham Cooper, then the fashionable animal painter of the day. Herring's output was prodigious. He received commissions from King George IV, King William IV and Queen Victoria, and for thirty-three years he painted nearly all the celebrated racehorses of the day. Over a hundred of these pictures were engraved, bringing him enormous popularity. The Druid asserted that his great racing scenes were generally achieved with the aid of a sketch book containing drawings of ideal horses and jockeys which a few strokes from life at the post converted into portraits. Much of his work was certainly stereotyped in style, with meticulous brushwork emphasizing the slope of a shoulder or the sweep of rounded quarters as in his portrait of the 1825 St Leger winner, *Mr Richard Watt's Memnon with William Scott Up*, the jockey wearing the harlequin colours of Lord Darlington (pl. 54). The artist could certainly record the great quality of the contemporary Thorough-bred, but his pictures remain especially valuable as documentaries rather than as compositions of grace and harmony; these latter qualities which were well within his scope were reserved for his pastoral scenes at the end of his career.

Such pictures as *The Start for the Derby 1834*, and his contrivance of painting classic winners of different years together in imaginary compositions, allowed the opportunity for contrast and comparison as shown in the picture of *Plenipotentiary, Touchstone, Priam and Grey Momus*. In the *Doncaster Gold Cup* painted in 1838 James Pollard collaborated with Herring providing the background detailed figures and racecourse stands, but the four horses, with the Earl of Chesterfield's bay colt, Don John, beating Mr Orde's mare Beeswing, emphasize Herring's characteristic use of a *ventre à terre* action to depict a full gallop (pl. 60).

Few sporting artists of the age attempted an alternative to the rocking horse position when suggesting speed, though paleolithic cave artists had shown more initiative. The convention had endured throughout the equestrian art of the Egyptians, the Assyrians and Greeks, and was continued by the Chinese and Japanese. Diepenbeck, in a galloping war horse, had certainly shown the forelegs flexed, and James Ward had made a real attempt at verisimilitude in his sketch, *The Finishing Post* (pl. 61). In Stubbs's picture painted in 1791 of the Prince of Wales's (later George IV) *Baronet with Sam Chifney Snr Up* (pl. 62), the jockey in green and black is shown characteristically leaning backwards with an apparent slack rein and the horse appears to have all four legs off the ground; and in *Bay Malton with his Jockey John Singleton Up* only the off-

hind foot of Lord Rockingham's horse touches the turf. But these efforts of Stubbs to rationalize the movement of the galloping horse, deprecated by his contemporary critics, are nullified by their curious pose—they appear as if suspended from above, a fact possibly reflecting the long study of those carcases hanging from the roof at Horkstow. Herring's racehorses, sometimes elongated to absurdity, bear even less relation to reality than Barlow's prancing racers in his print of the *Last Horserace Run before Charles II of Blessed Memory* (pl. 55). Even early in the eighteenth century 'running' horses were still trained on Gervase Markham's theory that they must be 'kept always girt that their bellies might not drop and thereby interfere with the agility of their movement'. Racing then was still a test of stamina rather than pace, events being frequently run in three or four heats often over four miles, and a horse beaten by a distance (20 lengths) was eliminated from later heats. Though different ideas gradually prevailed, length of back was considered synonymous with a capacity for speed at full stretch, and became the artist's hallmark of the successful Thoroughbred racehorse. Nearly another fifty years were to elapse before the American Eadweard Muybridge's instantaneous photographs of animals in motion resulted in a new look in sporting art. It is therefore understandable that Herring, and most of his contemporaries, preferred to present that miracle of speed, the Thoroughbred, on his more immobile occasions.

Herring never lacked rivals in the world of racing. David Dalby of York painted many of the northern horses, often at three guineas a time, including a good likeness of Crucifix, winner of the 1840 Oaks and remarkable for her long lean neck. Though he lacked Herring's expertise in the manipulation of paint, and his jockeys are woodenly presented, Dalby's horses are well modelled. Between 1838 and 1860 the prolific Harry Hall achieved great popularity, over sixty of his portraits of racehorses were engraved and 114 plates after the artist appeared in the *Sporting Magazine*. His quiescent pictures, meticulous, and often splendid likenesses, lack the touch of quality which Herring, even at his most static, gave to the Thoroughbred horse.

Painting with great success at the turn of the century, Henry Bernard Chalon (1770–1849), of Dutch extraction, was an artist of a different calibre who in his use of colour and composition took Stubbs as his model and depicted horses with a decisive touch. In *The Bibury Welter Stakes, 16 June 1801*, he cleverly suggests, with some subtlety, movement and speed, and for good measure includes a portrait of the Prince of Wales in the background, a tactful detail as Chalon received valuable patronage from the Royal Family.

The most important portrayer of the racing Thoroughbred at that time might well have been John Ferneley Senr (1782–1860), if foxhunting had not laid such a claim on his considerable talent. Between 1830 and 1843, this artist visited Newmarket several times and painted many classic winners of the day. Sixteen of his aquatints, engraved by E. Duncan, were commissioned by various owners and they depicted such notable performers as Chorister, Priam, St Giles and Phosphorous.

For one of his patrons, the Earl of Jersey, a hard-riding Leicestershire foxhunter, he painted several pictures, including *Riddlesworth with Robinson Up* (pl. 65) and *Bay Middleton*, the 1836 Derby winner. Into both these static poses, and in all of his racehorse studies, Ferneley infuses the breath of life.

Mobility and action were always the keynote of Henry Alken Senr's approach to the sporting scene, and his few pictures of sport at Epsom and Newmarket are a witness to his own inimitable vitality. Alken's real contribution to racing lay in the realm of

steeplechasing, the activity that attempted to combine the thrills of both horseracing and foxhunting.

Races for horses that had been 'regularly and truly hunted' had often formed part of the programme at *bona fide* flat meetings, and had been instigated by Queen Anne; in fact the Ascot Course had originally been a private ground for hunters ridden regularly with the Queen's Royal Buckhounds. Matches over obstacles for a couple of horses had taken place on Newmarket Heath as early as James I's reign, but the first recorded steeplechase for more than two riders took place in Leicestershire in 1792 for one thousand guineas, when Mr Charles Meynell, son of the famous Master of Hounds, beat Lord Forester and Sir Gilbert Heathcote from Barky Holt to Billesdon Coplow and back, a distance of eight miles.

Henry Alken in 1839 painted four episodes of *The First Steeplechase on Record*, or *The Night Riders of Nacton*, a spectacular, moonlight steeplechase, that allegedly took place in 1803. The quaint nightshirts and nightcaps of the riders, the ghostly landscape and amazed expression of the horses made the engraving by J.Harris immensely popular. Every critic was quick to point out that in the first issue though one horse crashes through a five-barred gate, the shadow of the shattered gate is unbroken and the horse casts no shadow at all. In a series of eight small paintings, dated 1829, of *The Grand Leicestershire Steeplechase* Alken cleverly depicts in splendid likeness the seven horses and their top-hatted riders, all famous Meltonians, facing desperate disasters over fearsome obstacles.

The sport, in spite of some criticism from Nimrod on the grounds of cruelty, became well supported and fashionable. Tom Colman, proprietor of the Turf Hotel, St Albans, often referred to as 'The Father of Steeplechasing', established races for several years at this centre. Cheltenham came early into the picture and by 1835 a Grand Steeplechase over four miles took place, with fences 'numerous and strong, beginning with a newly built wall 5 feet high, 2 brooks etc. . . '. (*Sporting Magazine* May 1835, p. 295.) In fact, by June 1837 the sport could be enjoyed on the doorstep of London itself. Mr John Whyte opened the Hippodrome at Notting Hill, covering 200 acres, with seventy-five stables and separate tracks, one for training and exercise, another for flat racing and a third for hurdles and steeplechases, the latter over two and a quarter miles with natural fences and brooks. Heavy clay sub-soil, however, often curtailed racing, but twenty-three days were enjoyed during the four years of the Hippodrome's existence before builders and developers took over. From a set of four paintings by Henry Alken of the last steeplechase there, the scenes are all backed by the twelve-foot high palings and show arcadian trees and fields with only the Kensington Kiln in sight to remind us that this was the age of the industrial revolution. Many artists found some difficulty in presenting the exciting hazards of steeplechasing and discreetly confined their talents to flat-racing, but mobility and 'the swinging pace', his own term, came naturally to Alken.

F.C.Turner, born in 1795, held the reputation of following hounds more often and being in at the death of more foxes than any other sporting artist in existence, or, as the *Sporting Magazine* phrased it 'he can both wield and *follow* the brush with equal credit'. He used his cross-country experience to bring some touch of vitality to his rather stereotyped compositions, and in *The Leamington Grand Steeplechase* of 1837 he certainly puts over the rigours of the sport. The first 'Grand National', known as the Liverpool Grand National Steeple Chase, run in 1839, was won by Lottery belonging to Mr Elmore, a well-known horse dealer, who originally bought the 'chaser for £180 at Howcastle Fair. Turner painted a set of four pictures of this event, showing the packed stands, the rails flanked by spectators, leaping and riderless horses (pl. 63), but at the end

55 Francis Barlow *Aug. 24 1684. The Last Horse Race Run before Charles II of Blessed Memory at Dorsett Ferry near Windsor Castle* 1687
Etching $11\frac{3}{4}$ × 30 in. (29·8 × 76·2 cm.)
Courtauld Institute of Art, London

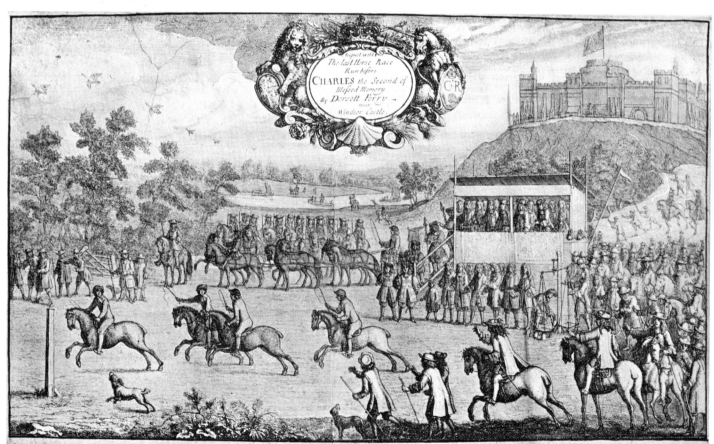

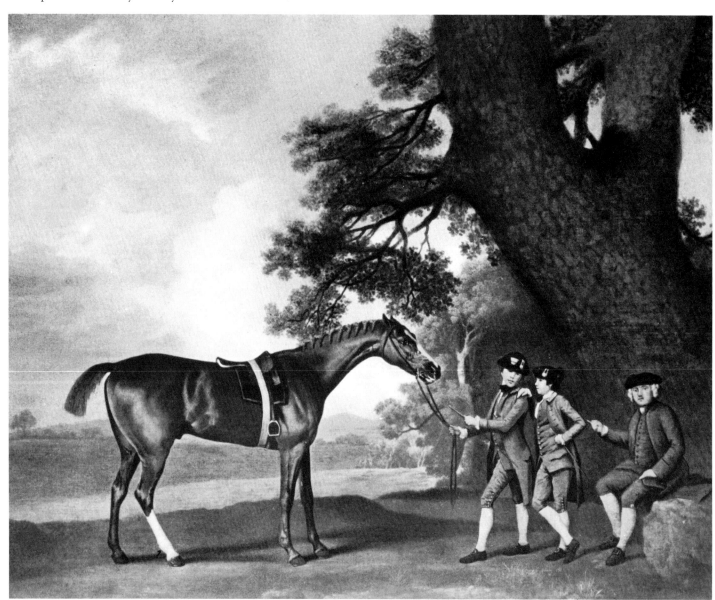

57

Jaffrey Wheatley Robinson

58

opposite

60 John Frederick Herring Senr and James Pollard *The Doncaster Gold Cup 1838*
Oil on canvas 44 × 81 in. (111·8 × 205·7 cm.)
By permission of H.J.Joel Esq.

61 James Ward RA Study for *The Finishing Post c.* 1810–20
Panel 5¾ × 10 in. (14·6 × 25·4 cm.)
By permission of J.Peter W.Cochrane Esq.

59 Abraham Cooper RA *The Day Family* 1838
Oil on canvas 37⅜ × 50 in. (95 × 127 cm.)
South African National Gallery, Cape Town

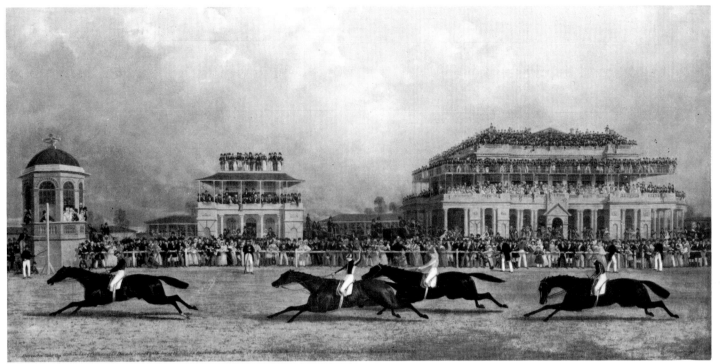

60

61

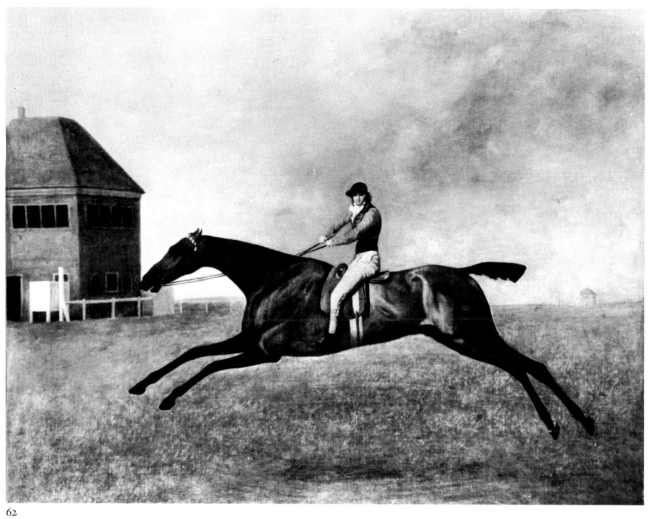

62

63

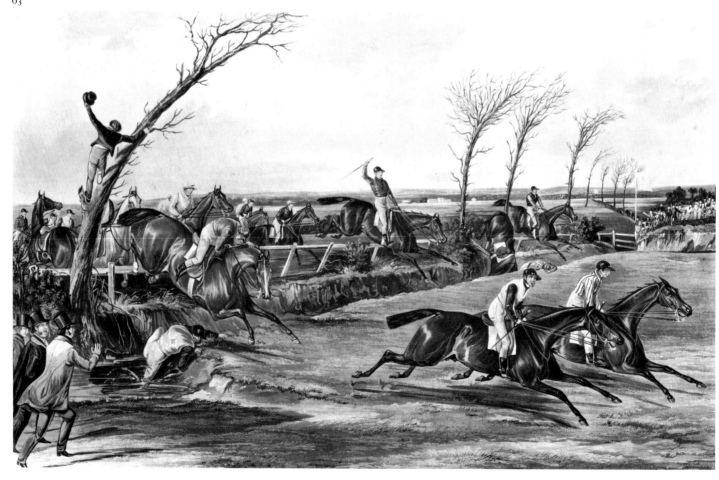

opposite

62 George Stubbs ARA *Baronet with Sam Chifney Snr Up* 1791
 Oil on canvas 40 × 50 in. (101·6 × 127 cm.)
 By permission of Lord Irwin
 Courtauld Institute of Art, London

63 John Harris, after F.C.Turner *The Liverpool Grand National Steeplechase* 1839
 Aquatint from a set of four
 Messrs Arthur Ackermann & Sons, London

64 John Ferneley Senr *Riddlesworth with Robinson Up* 1831
 Oil on canvas 34 × 42 in. (86·4 × 106·7 cm.)
 By permission of the late Sir Humphrey de Trafford MC

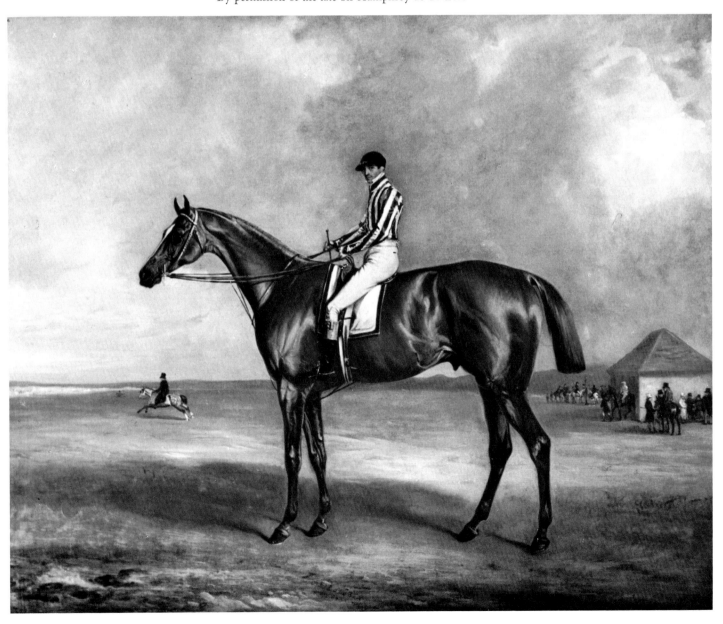

opposite

66 Henry Alken Senr *Full Cry*
Oil on canvas, from a set of four hunting scenes 16 × 22 in. (40·6 × 55·9 cm.)
Messrs Frost & Reed, London

67 Henry Alken Senr *Treeing the Fox*
Oil on canvas 16 × 22 in. (40·6 × 55·9 cm.)
From a set of four hunting scenes
Messrs Frost & Reed, London

65 Pieter Tillemans *Mr Jemmet Browne at a Meet of Foxhounds*
Oil on canvas 38½ × 48½ in. (97·8 × 123·2 cm.)
From the collection of Mr and Mrs Paul Mellon, Upperville, Virginia, USA

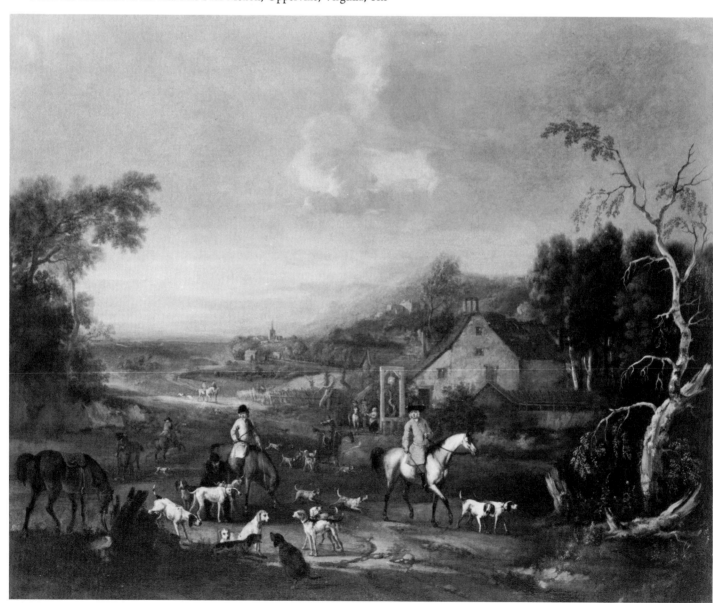

66

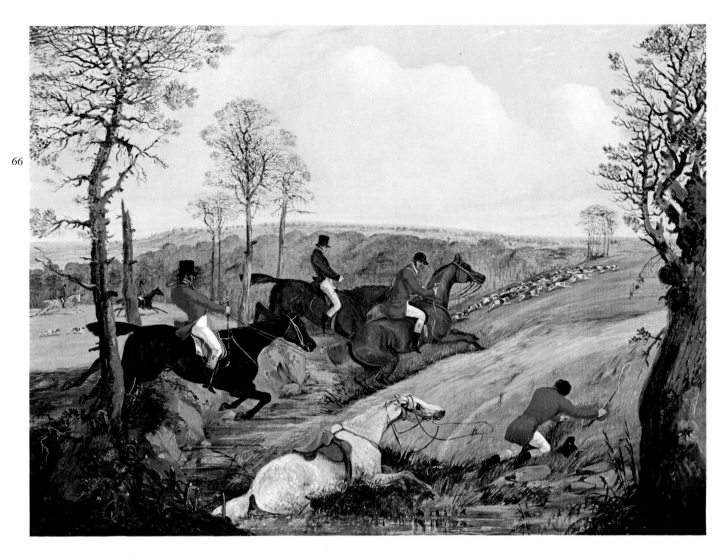

67

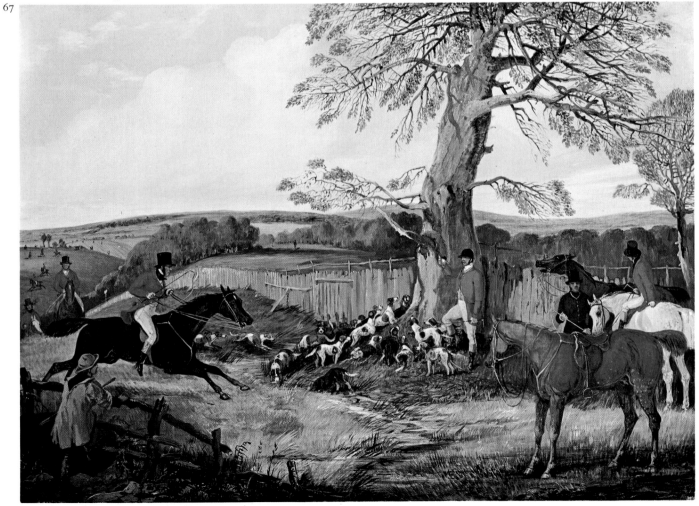

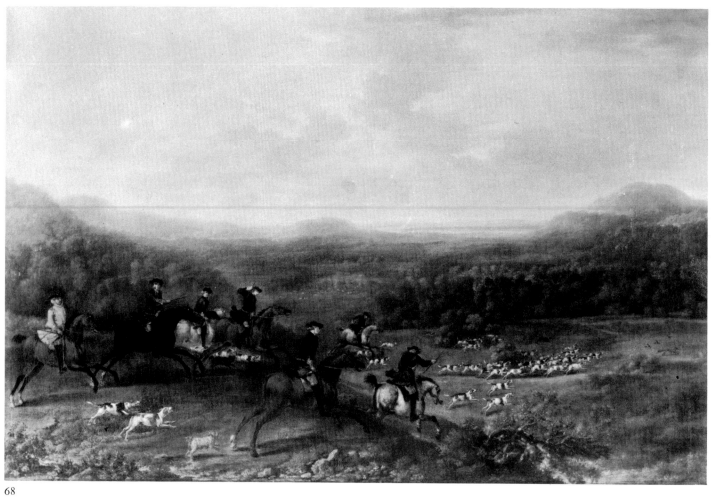

68

69

opposite

68 John Wootton *Fox-hunting Scene*
Oil on canvas 45 × 69 in. (114·3 × 175·3 cm.)
From the collection of Mr and Mrs Paul Mellon, Upperville, Virginia, USA

opposite

69 From the drawing by J.Baker Esq. *A Hunting Scene: A Difficult Fence*
Oil on canvas 15 × 29¾ in. (38·1 × 75·6 cm.)
Private collection, England

70 John Nost Sartorius *Breaking Cover*
Oil on canvas 21¾ × 29½ in. (55·2 × 74·9 cm.)
From the collection of Mr and Mrs Paul Mellon, Upperville, Virginia, USA

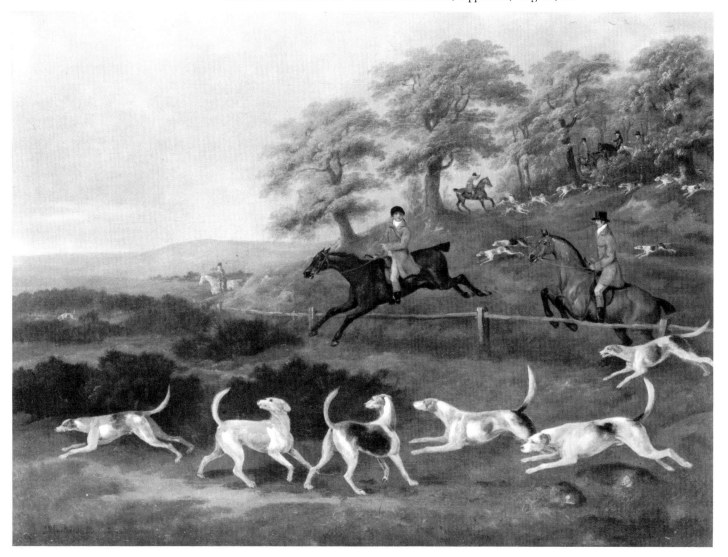

71

72

opposite

71 **John** Harris and William Summers after John Frederick Herring Senr *False Start*
Aquatint $41\frac{1}{4} \times 20\frac{3}{4}$ in. (104·8 × 57·8 cm.)
From a set of four, published by Messrs Fores, 1 September 1856
Messrs Fores, London

72 J. Godby and H.Merke after Samuel Howitt *Coursing* 1807
Coloured engraving $23\frac{1}{4} \times 19$ in. (59·1 × 48·3 cm.)
From *Orme's Collection of Field Sports*, published by E.Orme 1807
Messrs Arthur Ackermann & Son, London

73 Dean Wolstenholme Senr *The Epping Forest Hunt c.* 1805
Oil on canvas $56\frac{3}{4} \times 76\frac{3}{4}$ in. (144 × 195 cm.)
South African National Gallery, Cape Town

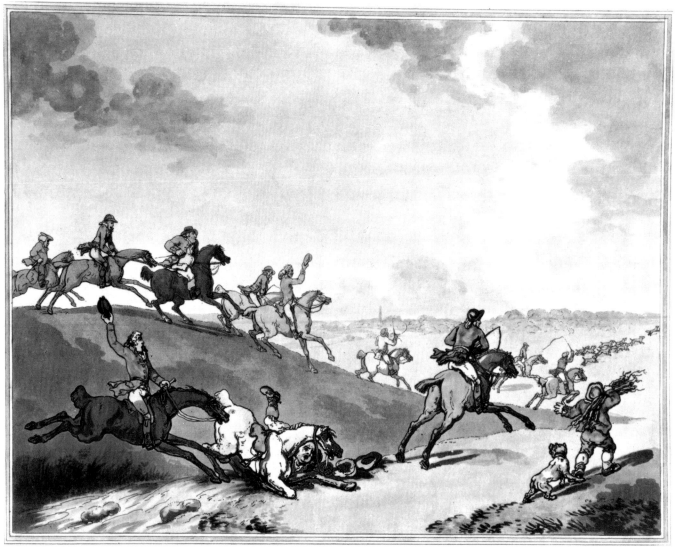

opposite

74 Thomas Rowlandson *The Chase* 1787
Coloured etching 30 × 20¼ in. (76·2 × 51·4 cm.)
From a set of six, published by J.Harris 16 March 1787
British Museum

75 Thomas Rowlandson *The Return from the Hunt*
Watercolour 11⅞ × 19¼ in. (30·2 × 48·9 cm.)
Courtauld Institute of Art, London

76 William and Henry Barraud *Charles Davis, Huntsman to Queen Victoria's Buckhounds, mounted
on his Grey Hunter, Hermit c.* 1849
Oil on canvas 27¼ × 35 in. (69·2 × 88·9 cm.)
Messrs Arthur Ackermann & Son, London

77 Henry Bernard Chalon *The Earl of Shrewsbury's Groom holding a Hunter in the Grounds of Ingestre Hall*
Oil on canvas 39 × 50 in. (99·1 × 127 cm.)
From the collection of Mr and Mrs Paul Mellon, Upperville, Virginia, USA

78 John Ferneley Senr *The Belvoir in Full Cry* 1823
Oil on canvas 40 × 78 in. (101·6 × 198·1 cm.)
By permission of The Duke of Rutland

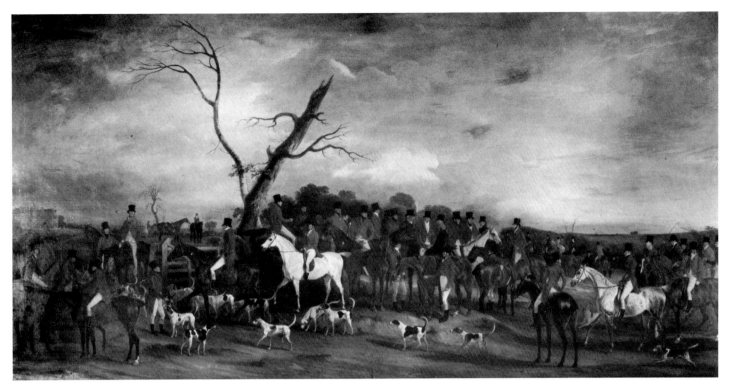

79 John Ferneley Senr *The Quorn at Quenby* 1823
Oil on canvas 75 × 154 in. (190·5 × 391·1 cm.)
By permission of Sir Richard Bellingham Graham
Photo: Courtauld Institute of Art, London

80 John Ferneley Senr *Mr George Marriott* 1844
Oil on canvas 34 × 45 in. (86·4 × 114·3 cm.)
By permission of Helena, Countess of Kintore

opposite

82 James Pollard *The Mail Coach in a Flood*
 Oil on panel 12 × 16 in. (30·5 × 40·6 cm.)
 By permission of N.C.Selway Esq.

83 James Pollard *The Last Run of the Royal Mail Coach from Newcastle to Edinburgh, July 5, 1847*
 Oil on canvas 17¼ × 26¾ in. (43·8 × 67·9 cm.)
 From the collection of Mr and Mrs Paul Mellon, Upperville, Virginia, USA

81 James Pollard *Trafalgar Square* 1834
 Oil on canvas 29½ × 30 in. (74·9 × 76·2 cm.)
 Messrs Arthur Ackermann & Son, London

82

83

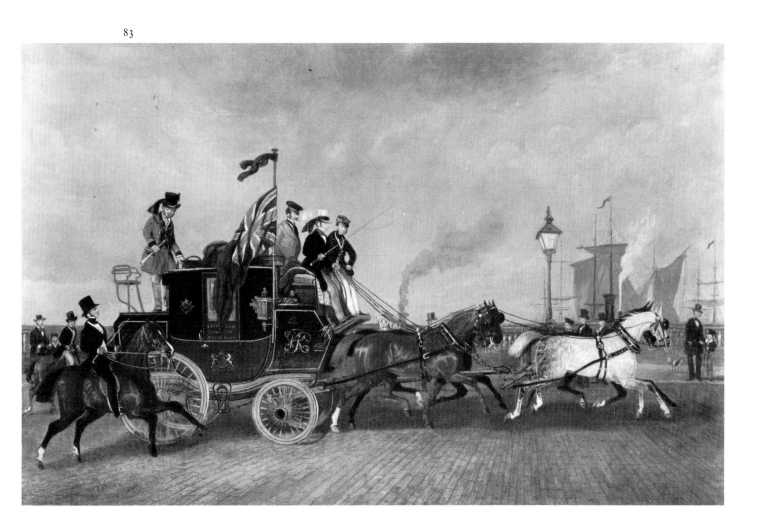

84 William Shayer *The Timber Waggon*
 Oil on canvas 40 × 33 in. (101·6 × 83·8 cm.)
 Leicester Museums and Art Gallery

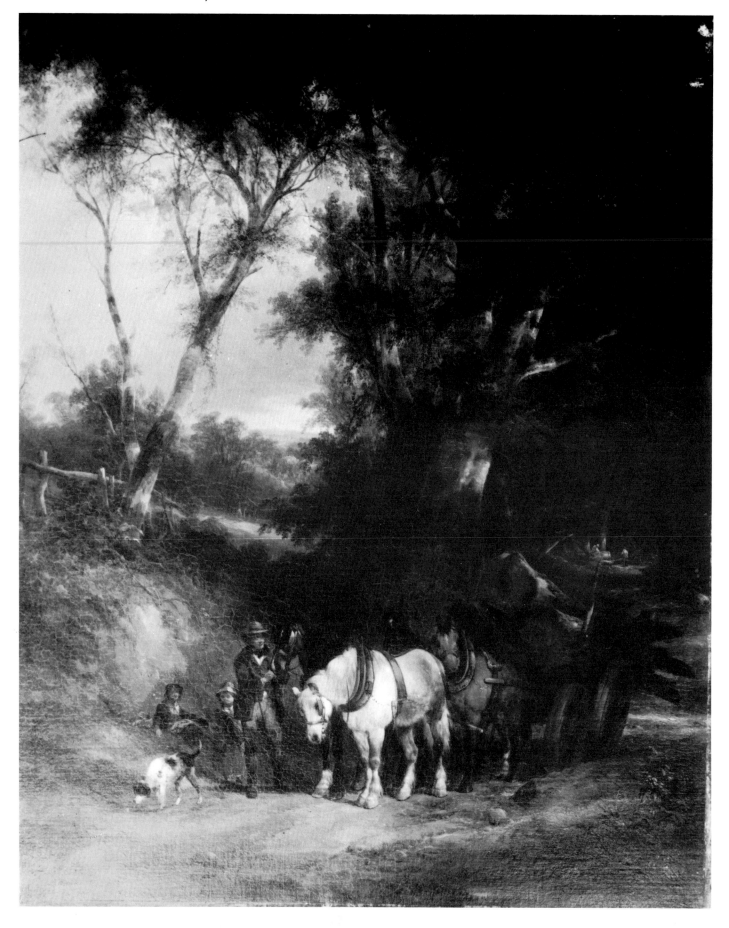

of the gruelling four and a half miles, not one shows even a hint of exhaustion. James Pollard also painted several steeplechasing scenes, not without ability, but this sport demanded a new technique and a photographic eye with which these conventional painters, steeped in tradition, were not endowed.

Sporting artists between 1700 and 1850 produced hundreds of examples of the Thoroughbred horse but, surveyed in retrospect, these pictures convey little of the miracle of the swift development of this new equine breed. The Darley Arabian measured barely 15 h.h.; Marske, the sire of Eclipse, actually stood under 14·2 h.h., and the height of the Thoroughbred at that time only *averaged* 14 h.h. Eclipse, considered a very big horse in his day, was 15·3 h.h., yet Bay Middleton, the 1836 Derby winner, was already $2\frac{1}{2}$ in. taller. By the mid-nineteenth century, with selective breeding, favourable environment and feeding, the Thoroughbred on average had become six inches taller than his forefathers.

This metamorphosis does not come over in the pictures of the racehorses of the period. Seymour's Flying Childers, Stubbs' Marske, Herring's Beeswing, Ferneley's Bay Middleton, suggest little of the progressive development and increase in size. Artists presented more successfully the gradual recession of Arabian characteristics—the increase in length of back and often in length of pastern, both considered desirable adjuncts for speed. By the mid-nineteenth century the length and slope of the shoulder, which gave the Thoroughbred his sweeping stride, was well established and emphasized, especially in the pictures of Herring and Ferneley. Nowadays a hint of the lithe qualities of the greyhound appears in the silhouette of the modern Thoroughbred, as speed and ever greater speed becomes the evolutionary aim.

To evaluate accurately the swift evolution of this miracle horse in his first 200 years by means of sporting pictures would require some actual measurements of contemporary conformation, but for appreciation of the changing beauty of this horse and of the transformation of the sport of racing, artists of the period have richly endowed our records.

8 The hunting field

Where all around is gay, men, horses, dogs:
And in each smiling countenance appears
Fresh blooming health and universal joy.

William Somerville 1675–1742
The Chace

No subject has persisted in British sporting art with greater enthusiasm and pictorial effect than that of hunting, whether the quarry be stag, hare or fox. The sport in its modern idiom dates at least from the Saxon occupation and as an artistic theme can be traced from the Bayeux Tapestry to Francis Barlow's engravings for his own works on field sports, to pictures of hunters and hounds by Sir Alfred Munnings.

At the beginning of the eighteenth century, the slow, heavy Southern-mouthed hounds were being superseded by the swifter Northern hounds, or, more exactly, by a breed that amalgamated the tenacity of the one and the nose of the other. But speed was still not a necessity, for a nobleman invited neighbouring friends to hunt stag or roebuck with his own pack, and seldom had to pass the boundaries of his own vast and probably heavily-wooded domain. The squire and his intimates were more likely to take hounds out to hunt hare, but if Reynard went away first, this alternative quarry was happily accepted. The general changeover to foxhunting was, however, certainly on the horizon; some packs such as the Charlton and the Bilsdale had already switched their sights and 101 foxhunts had been established by 1835.

In this context Pieter Tillemans' picture of *Mr Jemmet Browne at a Meet of Foxhounds*, (pl. 65) set at Riverstown, Co. Cork, is interesting as an early record of foxhunting and highlights typical facets of the very early eighteenth-century scene. Hounds are light-

coloured and large, of mixed type; two riders arriving in the distance with a further couple suggest a trencher-fed pack and Mr Browne himself rides a grey hunter, pony-size by modern standards. The simplicity of the occasion contrasts markedly with the scenes of crowded meets at Kirby Gate and hunt breakfasts with collations of cold game pie painted a hundred years later by John Ferneley and Sir Francis Grant, and the sophistication of the lawn meet of the Beaufort near Petworth, captured by William and Henry Barraud.

In the hunting pictures of John Wootton and Francis and John Nost Sartorius, the sport is often set in a picturesque wooded landscape in summer leaf (pl. 70), for it was not until the reign of George III that hunting was forbidden until after harvest, and in the first volume of the *Sporting Magazine* in 1792, 25 December is advertised as the opening date of the foxhunting season. It was only after 1750 that the character of the sport was revolutionized by the change in English agricultural methods and that a new look appeared in the hunting field. Since the Saxons, and earlier, cultivation of the land had been practised by the open strip method; some hedges had always been planted to enclose reclaimed woodland or marsh, a forest or a park, but enormous areas remained unfenced. Hunting pictures before the latter half of the century rarely show riders jumping, and then from a stand and more often than not over timber out of a wood. James Seymour's drawings of *Stables of Running Horses and Hunters* do, however, include one huntsman taking a flying leap over a five-barred gate and another clearing a stream with amazing gusto and a flourish of his whip.

More efficient methods of farming had been brought about with the first enclosure acts in 1709. In the reign of George III over 3,500 more were to become law under a government not otherwise remarkable for radical legislation. At first enclosures were large, often 200 acres, but effective drainage enabled these to be profitably sub-divided —in the West Country by stone walls, elsewhere by wide ditches. In the grazing counties of the Midlands whitethorn and blackthorn hedges were planted; these were protected until bullock-proof by sturdy timber guard rails on either side—the formidable 'oxers' jumped so spectacularly by Ferneley's foxhunters. All these obstacles provided new hazards. A painting from a mid-eighteenth-century drawing by J.Baker Esq. shows stout riders dismounted, dragging their reluctant horses through fences (pl. 69). Huge areas of woodlands were cleared to provide cleft timber, and Leicestershire and its neighbouring counties, once open arable country, had, by the 1780s, become almost entirely grassland, divided by big fences and newly planted gorse coverts. It became the best hunting country in England. There the crack packs, the Quorn, the Belvoir, the Cottesmore, the Pytchley and later the Fernie, were established and were collectively known as the Shires, and here were born and bred such able sporting artists as John Boultbee, Ben Marshall, John Ferneley Senr and Junr and C. Loraine Smith.

Before the arrival of this golden age of foxhunting, however, several artists were invited to paint pictures of the many provincial hunts scattered up and down the country. Sawrey Gilpin and Philip Reinagle went to Yorkshire to paint scenes for Colonel Thornton, and John Nost Sartorius travelled north in 1805 to paint the Raby Hunt. Even more interesting, in 1795 Francis Sartorius went to Dorset where the famous Peter Beckford had commissioned three pictures, two portraying a couple of favourite hounds—names and breeding recorded on the canvas—and a stiff composition, *Beckford's Hounds and Hunt Servants.*

Hunting scenes, unlike special portrait commissions, offered scope to the artist with

an eye for landscape and also some pitfalls for those ignorant of sporting tradition. Wootton and his early contemporaries rarely portrayed that most popular of all hunting scenes—the Death—not from squeamishness but from the fact that the slow hounds of the day rarely killed their quarry. The enclosure acts spelt the decline of stag-hunting and, as the wily fox took over with speedier hounds, this dramatic moment in the chase became a more frequent event and, incidentally, enabled artists to portray huntsman and field in an effective group, with horses and riders immobile, and no complexities of galloping and jumping to be solved.

The new type of foxhunting also brought some sophistication of ritual which for several decades sporting painters were to use as popular subjects. 'Brushing', or giving the first man up at the death the privilege of cutting off the fox's brush, was a practice that had led to altercation and over-riding and eventually the brush was given by the Master, as it is today, to anyone of his own choice in the field. R.S.Surtees makes Mr Facey Romford, MFH, attach the trophy of honour to the delectable Miss Lucy Glitters's bridle, a fact recorded by John Leech.

'Capping' was introduced in the mid-eighteenth century, when the huntsman, at the termination of a successful hunt, was rewarded with a half-crown from each member of the field, collected by a hunt servant in his hat, as shown in an early nineteenth-century aquatint engraving by James Pollard. The custom of hanging up the fox's body in a tree had originally been introduced to excite the pack and encourage keenness, but though found to serve no useful purpose, it was continued for many years to benefit the huntsman by enabling the stragglers in the field to arrive on the scene in time to be capped. This method of delaying tactics was used pictorially by many artists. R.B.Davis, who followed hounds keenly on foot with a sketch board in hand, shows one huntsman at some very considerable height up a tree and the field appearing in the far distance. *Hunting in Cornbury Forest*, painted in 1786, a curious collaboration of three artists, Francis Sartorius, W.T.Tonkins and Esmond Escourt Esq., a local amateur, shows the famous huntsman Thomas Catch halfway up a big oak tree, hanging up the dead fox. The picture can still be seen at Badminton. Alken often introduced these final obsequies (pl. 67), with horses and riders exhibiting real exhaustion and disarray suggesting recent hard riding; but in the Shires, as the pace of hunting accelerated, treeing the fox became outdated.

Other manners and modes of the sport were also in the melting pot, not least the style of riding. In Jan Wyck's and John Wootton's paintings the long straight-legged position in the saddle prevailed, a legacy from the days of protective armour when a bent knee was a physical impossibility. But the necessity for pace and jumping across country led to a general shortening of stirrup leathers and a more secure, if less elegant, seat in the saddle. Francis Sartorius, Sawrey Gilpin and James Ward began to show this more relaxed style of riding.

Clothes in the hunting field also became more stereotyped, for practical reasons. The long, leather thigh boots of Stuart fashion gave serious discomfort to a bent leg, so the tops were turned down to below the knee. The pale untreated inside leather can be seen on Mr Jemmet Browne's boots in Tillemans' picture (pl. 65) and also in his picture *Rider with Dog* and in many scenes by John Wootton. It is from this custom that the coloured 'tops' of today's hunting boots—which first began to be worn in early Georgian times—derive. Riding or driving to the smart meets of Leicestershire, the fashionable foxhunter would cover these light tops by protective mud boots, as worn by Count Matriscewitz in Sir Francis Grant's *The Melton Hunt Breakfast 1839*, and riders in pictures

by Henry Alken Senr. Members of a hunt originally wore coats of any colour, but the green coats seen in Wootton's and Sartorius's pictures of the Heythrop and Duke of Beaufort's Hunts are a legacy of stag-hunting days. The private livery of certain masters of hounds was also adopted for the hunt staff and members of the hunt, as in the tawny yellow of the Berkeley, still worn today by master, huntsman and whippers-in, and the blue and buff of the Duke of Beaufort's, the prerogative granted by the Duke to the members and also worn by the Duke as well unless, however, he was hunting hounds himself, when he wore the ducal green livery. This tradition is still maintained.

Scarlet originally became popular as the hunting colour among the members of the hunt when British officers, home from the Napoleonic wars, followed sport in their uniform coats. In early pictures by Wootton, Seymour, the Sartorius family and Stubbs, foxhunters wear the brown, green or russet coats of country life, with the hunt servants frequently in fawn, and not until the end of the century do pictures begin to be unduly scattered with scarlet, a fashion which many artists failed to handle with subtlety.

These niceties of tradition and mode posed the artist with problems beyond the mere composition of a pleasing picture of horses, hounds and riders; in addition to sartorial detail, the method and manner of hunting had to be presented feasibly and accurately.

George Morland's hunting studies depict the sport in a truly bucolic and arcadian idiom. His instinctive, rather than premeditated, methods of producing a picture resulted in spontaneity and freshness. Untidy huntsmen ride through a countryside thick with leafy vegetation on stout grey cobs, replicas, one imagines, of that near-white old horse he kept stabled next to his studio. It was not only his fondness for riding—when prosperous he kept half a dozen horses at livery—but his attentive study of pictures by Stubbs and of *The Anatomy of the Horse*, that bring such conviction and quality to his simple hunting scenes; his close friendship with Thomas Rowlandson was another indirect influence. The fine draughtsmanship and powers of caricature of this artist were of a different school, giving a touch of gross rollicking humour to the sporting panorama. In such watercolours as the six scenes of *The Village Hunt*—a set which includes *The Chase* (pl. 74)—Rowlandson suggests the exuberant type of sport organized primarily to stimulate the trade of the local innkeeper, while in such a disaster as *The Return from the Hunt* (pl. 75), the artist treats the basically tragic theme with irony, a fact even more evident when it is remembered that Nimrod was to affirm so categorically that the odds against an accident in the field stood at 480 to 1, and a fatality at 105,200 to 1. Nimrod was not only the leading sporting journalist of the day but in 1822 had become hunting correspondent of the *Sporting Magazine*.

Dean Wolstenholme Senr also recorded the simpler pleasures of hunting, often in Essex and Hertfordshire which he knew intimately. A sportsman and gentleman by birth, law-suits over property reduced Dean Wolstenholme to poverty and an amateur artistic talent had to provide a livelihood. Though deficient in technical knowledge, his personal experience of sport, a good colour sense and a stern application to work resulted in some attractive pictures.

Some confusion in identifying Dean Wolstenholme pictures occurs, as both father and son used the same name, with only occasionally the differentiation of the addition of 'Junr' to the son's signature. Both painted the same subjects and settings, but Dean Wolstenholme Junr, although he had benefited from professional training and attained

great popularity with the engravers, suffered from an excess of elaboration. In *Full Cry in the Provinces* he presents with real effect the formidable Roothing ditches as a tough proposition for horse and rider. The *Epping Forest Hunt* by Dean Wolstenholme Senr (pl. 73), exhibited in the Royal Academy in 1805, shows the dramatic taking of the stag and must be considered the artist's finest work. A topical background touch is the farmer on his shaggy pony, a reminder that democratic principles in the hunting field had already begun to play their part. It was no longer an activity reserved only for the privileged, a fact which John Conyers was later to emphasize at a meeting of members of the Essex Hunt when he declared, 'The humblest man in the population provided only that he be decent and well-behaved, may ride by the side of a duke when both are in pursuit of the fox; but in what other country but dear old England could such a right be seen?' (R.F.Ball and T.Gilbey, *The Essex Foxhounds*, London, 1896, p. 101.) Many packs were now supported by subscription and the right to hunt was no longer the prerogative and responsibility of great private landowners. Even the snobbish Nimrod, the Pomponius Ego of Surtees's creation, admitted that foxhunting linked all classes together, for status was assessed not by birth but by horses and horsemanship. In fact Morris, the butcher of Melton Mowbray, hunted regularly with the Quorn and always wore his blue apron. The Cockney sportsman had become a reality, and at Croydon, not ten miles from Charing Cross, hunting could be enjoyed with foxhounds, staghounds or beagles, and the City merchant could still be home for his five o'clock dinner.

But emancipation did not come to the woman rider until the mid-nineteenth century, apart from an occasional quiet hack to the meet with groom in attendance, for the increasing speed and dangers of the hunting field were considered incompatible with decorum. In Mr Meynell's day, at the turn of the century, C.Loraine Smith's sisters are alleged to have hunted in Leicestershire in grey skirts and scarlet blouses, and this artist certainly paints a group of ladies in *Rendezvous of the Quorn Hounds at Groby Pool on Tuesday, April 16, 1822*. But R.S.Surtees voiced the general opinion in *Ask Mama*: 'Women *have* no business out hunting'—no respectable young women, that is. Such gay ladies as the delectable and discreet 'Skittles', the pianist Clari and the notorious Mrs Nelly Holmes made their shocking appearance with the fashionable packs, but sporting painters have been tactfully reticent on this point.

Artists were commissioned, of course, to paint portraits, not of mistresses, but of famous masters and huntsmen, and in these they incorporated contrasting types of horses, hounds, accoutrements and landscape. Ben Marshall was in his element with this type of picture, for he could depict with knowledge and fluency both man and animal, and rarely failed to produce a carefully composed work painted with distinction. In his portrait, *The Earl of Darlington with his Hounds*, no detail is lost, from the intelligent eye and powerful shoulder of the grey hunter to the characteristic crooked angle of his lordship's headgear, for he rode, according to Nimrod, 'with his cap on his ear'. John Nost Sartorius and Abraham Cooper both painted the Earl of Berkeley's huntsman, Tom Oldaker, and Ben Marshall also made at least three portraits of this famous figure who for thirty-two years hunted a country that spread from Berkeley Castle in Gloucestershire to Wormwood Scrubs. Oldaker wears the long full-skirted coat in the deep yellow of the Berkeley livery and still wields the twist bugle-horn of ancient tradition.

Marshall very rarely painted hunting in progress, but his contributions to the records of the sport rest in such splendid pictures as *Francis Dunkeld Astley, MFH*; *The Fifth*

Duke of Gordon on Tiny with Hounds and Grooms; and *Tom Sebright the Huntsman of the Quorn*. All are presented with discriminating detail, recording changes in style such as that flat hats had given way to top hats, half-bred cobs had been replaced by bigger clipped-out blood horses, and cropped ears had generally disappeared and bang tails arrived.

Many other artists were occupied with the hunting celebrities of the day. William Barraud's portrait of *John Warde of Squerryes* at Westerham is a brilliant likeness of this Father of Foxhunting, a Master of Fox Hounds for 52 years, who rode at nearly 18 stone (252 lb) with his renowned hunter Blue Ruin, a blue roan bred by a Maidstone gin distiller and named accordingly. This portrait brought the artist commissions, and in collaboration with his younger brother Henry, a landscape and figure artist of merit, Barraud painted the effective portrait of *Charles Davis, Huntsman to Queen Victoria's Buckhounds, mounted on his Grey Hunter, 'The Hermit'* (pl. 76). The scarlet and gold royal livery set against the typical heathland hunting country of Surrey contrasts with the silver tones of the horse, a splendid type of hunter by Grey Skim out of an Arabian mare that had carried a trumpeter in a Dragoon Regiment in India. Charles Davis, son of the huntsman of the King's Harriers, had caught at the age of twelve the beneficent eye of George III, who appointed him a whip under his father and provided a lavish £1 per week allowance, on the understanding he continued his schooling. In 1826 he became huntsman of the Royal Buckhounds, a pack which used carted deer as quarry, and held the post under four sovereigns. He was described as taciturn and wanting in geniality, and this unsmiling portrait by the Barrauds would appear a clever likeness. Davis died at the age of seventy-nine leaving a considerable sum of money to Queen Victoria.

His brother, Richard Barrett Davis, made his name as a sporting artist, having received, under royal patronage, training from Sir Francis Bourgeois, RA and Sir William Beechey, RA. He was appointed Animal Painter to various members of the Royal Family and received commissions from half the dukes and earls of England. He also painted several portraits of Hermit and several scenes with the Royal Buckhounds, but his work often shows a weakness in composition, tending to lack authority and impact.

Painting these hunting portraits took artists to the estates of their patrons, often combining long uncomfortable journeys with the prospect of sport at a stately home. Though the talent of J.F.Herring Senr was exploited primarily in the realm of racing, he gave to his hunting scenes, in which his own experience was small, an unexpected verve, though unfortunately he possessed a poor eye for a hound. Nevertheless, the impact of Thoroughbred blood can clearly be discerned in his long-backed horses and they are often shown galloping and jumping over such obstacles as a park paling fence out of some ancestral demesne.

The artist Henry Bernard Chalon was as notable for his purely animal studies as for his sporting scenes but he painted racehorses and hunting subjects for such patrons as the Earl of Darlington and Lord Grosvenor. He was influenced perhaps more than any of his contemporaries by Stubbs, as can be seen in his striking picture of *The Earl of Shrewsbury's Groom holding a Hunter in the Grounds of Ingestre Hall* (pl. 77). Here Chalon perceptively suggests the stamina required of the hunter of the day, when a capacity to carry weight was of vital importance, for the Georgian eating habits had produced a generation of corpulent horsemen. The horse's deep girth, a sure sign of substance, is deliberately emphasized.

Though both the Wolstenholmes, J.F.Herring Senr and Junr, J.Dalby, John Boultbee, J.Barenger, G.H.Laporte and many others were fulfilling the demand for hunting scenes for sporting dining rooms, the most gifted exponents were undoubtedly Henry Alken Senr and John Ferneley Senr, who both used with contrasting effect the new sophistication appearing in the hunting field. Smaller enclosures and bigger fences had brought exciting hazards and fashion had also arrived on the scene. The small Leicestershire market town of Melton Mowbray became the hub of the sporting world, with over £50,000 spent seasonally by hunting visitors, and even Beau Brummel kept a few hunters near Belvoir, though the Druid referred to him as 'a mere kid-glove sportsman'. (*Post and Paddock* p. 116.) Alken and Ferneley, each in his own highly individual style, remain unrivalled in their ability to capture the intoxication and verve of this halcyon period of the chase.

Henry Alken Senr (1785–1851)
The ramifications of the Alken family, originally domiciled in Denmark, are even more complicated than the Sartorius dynasty. Undoubtedly Henry Thomas Alken (Henry Alken Senr), born at 3 Dufours Place, Golden Square, Soho, on 12 October 1785, was the most talented, and he became one of the most important and versatile names in British sporting art. However, various members of the family shared the artistic flair; there was Samuel Alken Senr (Henry Thomas's father), an etcher and architectural draughtsman; another son, Samuel Alken Junr, was an aquatinter and collaborated with artists such as Thomas Rowlandson and George Garrard; and, to complicate matters, Henry Thomas Alken had five children of whom Samuel Henry (Henry Alken Junr, also known as Henry Gordon) and Sefferen Alken both became artists, trading on their paternal name and copying his style; but to the experienced eye, the work of Henry Alken Senr possesses a quality of instantaneous vision that is unmistakable (pls. 66 and 98).

Trained originally as a miniaturist under Thomas Barber Beaumont, his pictures, often in watercolours with pencil, never lost this early delicacy, and their dimensions in an age of the grandiose were always modest. The features of both his named and anonymous foxhunters are delineated with meticulous care. Early marriage and personal volition resulted in his also working as a graphic journalist under the pseudonym of Ben Tally Ho, which secret identification he eventually let out under the influence of a convivial evening in Melton Mowbray. He further augmented the matrimonial budget by professionally schooling young horses, and this latter occupation explains the equestrian disasters that play such a noticeable part in his pictures. Horses fall over fences, into ditches, run away; and riders are seen, not without a touch of satire, in situations of parlous peril. Here is an artist who understands the unpredictability of the green Thoroughbred horse; and falls, as the artists shows, were very much an occupational hazard. His pictures abound with gaiety and high spirits, and all-pervading is the new vital impetus of speed in the hunting field. In fact his best hunting scenes resemble steeplechases, when 'the pace was too good to enquire'. Often painted in sets of four, they teem with accurate detail in which poor horsemanship plays a frequent and humorous part. Scent always seems to be breast high and hounds stream across the countryside, hunters are docked, with neat pulled manes, there is a nice differentiation and understanding of tack—the young horse in a snaffle, the puller in a long-cheeked double bridle; nose

bands are absent and martingales are rarely shown, for Alken's horses, so frequently at full gallop, tend to carry their heads low. Riders universally wear the top hat and all the thrusters, except the parson, sport a scarlet coat. A splendid set of eight scenes of the Quorn Hunt, engraved by F.C.Lewis in 1835, illustrates an important article by Nimrod. Here one meets all the celebrities of the day, Sir Harry Goodricke (the Master), Squire Osbaldeston, Lord Forester, Lord Alvanley, who, as hounds went away, would cry, 'Harden your hearts and tighten your girths!', the famous character and roughrider Dick Christian, and many others. Alken not only portrays the individual riders but also their named horses, and the third plate 'Tally Ho and Away' shows a scene like the charge of the Light Brigade, while in plate VI the second horses take over. This innovation was originally introduced by Ralph Lambton and his brother when hunting with the Quorn and was understandably popularized by Lord Sefton when he became Master, for he rode at 20 stone (280 lb) and often used four different horses.

Alken also painted fine studies of covert hacks. These horses, ridden to a meet by sportsmen to save their hunters, were expected, in this Melton world of excess, to rattle along at twenty miles an hour. Equally perceptive are his paintings of hunters returning home, when he cleverly suggests the tired, exhausted horse. As illustrator, as writer, as etcher and, of course, as a brilliant artist in watercolours and oils, with subjects as diverse as steeplechasing, driving scenes and flirting parties, Alken's versatility was outstanding. Between 1810 and 1816 he even exploited the fashion for decorated *papier mâché* trays for a leading manufacturer, Henry Clay of Covent Garden, who paid Alken high fees for decorating them with different hunting and coaching scenes.

John Ferneley Senr 1782–1860

The less volatile talent of John Ferneley Senr pursued a more predictable course, to provide foxhunting scenes and horse portraits that were not only informative but of great artistic quality. Born in 1782, son of the wheelwright and carpenter of Thrussington in Leicestershire, John Ferneley worked for his father in this heart of the Quorn country where hunting, horse and hound were the breath of life. As a boy he drew from prints and sometimes decorated with naive hunting scenes the foreboards of wagons sent in for repair. The young Fifth Duke of Rutland of nearby Belvoir Castle, whose perceptive eye was impressed by the vigour of the youth's long narrow painting of the *Billesdon Coplow Run* (a recent and famous event), bought the picture, influenced Ferneley's parents and providing some financial aid made possible a three-year apprenticeship in London with Ben Marshall—a painter also Leicestershire born and bred.

Ferneley all his long life was never short of commissions. After an early brief excursion into landscape painting in Lincolnshire and a couple of trips to Ireland, on the advice of the wealthy sportsman Tom Assheton Smith who, like the Duke of Rutland, became both patron and friend, in 1819 he settled in Melton Mowbray to paint the local sporting scene until his death forty-six years later. Early in his career, however, he briefly travelled around to paint such pictures as *Meet of the Keith Hall Foxhounds* in Aberdeenshire in 1824; *The Cheshire Hunt* in 1828; and *Breaking Cover: The Sedgfield Hunt 1834*, with its fine north country background.

With three packs, the Quorn, the Belvoir and the Cottesmore, providing six days

of hunting a week, Melton was a gold mine for millers, farmers, farriers, saddlers and local tradesmen, and also provided a wealth of patrons and subjects for a sporting artist. Three thousand horses flooded the town in the season—hunters, covert hacks and carriage horses. As Colin D.B.Ellis remarks, 'the early Meltonians seem to have done little else but kill horses, swap horses and pay extravagant prices for horses!' (*Leicestershire and The Quorn Hunt*, Leicester, 1951.) and certainly quality hunters fetched anything from £300 to £700. But modest John Ferneley steered clear of inflation: his fee for a horse portrait remained at ten guineas all his long professional life, he asked sixty guineas or thereabouts for a large hunting picture and seven guineas for a cow. On Sunday afternoons his studio at Elgin Lodge became the meeting place for the elite of Melton to discuss the week's sport and admire the latest picture on the easel.

Ferneley's hunt scurries, such as *The Melton Hunt Crossing the Brook under Tilton-on-the-Hill* or *The Belvoir in Full Cry* of 1823 (pl. 78), painted for the Earl of Wilton, though often meticulous in their inclusion of named horses and riders, nevertheless picturesquely evoke the high open pastures of the Shires, with a gaunt tree breaking the horizon, hounds spread-eagled in the wide distance, and hunters galloping and jumping; here is epitomized the spirit of fox hunting *par excellence*. Also, of course, there were the crowded meets when a field of 200 or more was a common occurrence. They demanded such pictures as *The Quorn at Quenby* 1823 (pl. 79) which shows thirty-three named riders and the smart *de rigueur* swallow-tail cutaway coats. For this painting twenty members of the hunt were each to subscribe £100 and by a throw of a dice decide the ownership. The winner was Sir Bellingham Graham, Master for a couple of seasons, but according to the artist's account book, only forty-two subscriptions of five guineas finally materialized.

Few artists could paint portraits of these quality horses with greater skill and detail than Ferneley. Most of them were nearly Thoroughbred, with the stamina and pace to keep with the new type of hounds which were being progressively bred for speed. Characteristic is his eye for detail—the blemish on a horse's knee, the scar of an old girth gall, and always the meticulous veining round the muzzle. Ferneley made each horse a personality. Commissions from famous sportsmen came apace. A fast worker, he could finish a large canvas in a fortnight, and most of the hard riders of the day became his patrons—the Marquess of Westminster, the Earl of Cadogan, Lord Jersey, Lord Middleton. One of the best portraits, *Mr George Marriott*, was commissioned by the Earl of Kintore (pl. 80). It portrays the renowned draper of Melton who for years, superbly mounted, showed the way for the yeoman brigade in the blue coat and metal buttons, the accepted wear of the wealthy sporting graziers and such humbler folk. On receiving the painting his lordship wrote, 'Ferneley, I was DELIGHTED with the picture of Old Marriott'. And well he might be. Few hunting portraits of both horse and rider manifest greater verve and character.

Ben Marshall, J.F.Herring and John Ferneley all bore sons to carry on the sporting art tradition, and though Lambert Marshall, J.F.Herring Junr., John Ferneley Junr and Claude Loraine Ferneley received some contemporary acclaim, the paternal talent in each case is diluted. Among the foxhunters themselves, in addition to Charles Loraine Smith several amateur artists also made some impact, including Sir John Dean Paul and Sir Robert Frankland, and most important, Sir Francis Grant, a future President of the Royal Academy. Intended in early youth for a legal career, the artist dedicated himself to foxhunting and, under Ferneley's tutelage, to painting. Such pictures as

Sir Richard Sutton and His Hounds and the famous *Melton Hunt Breakfast*, with every human, horse and hound a splendid likeness, led to his distinguished career as a fashionable Victorian portrait painter. Nevertheless, at his death in 1878 he chose Melton Mowbray and not St Paul's Cathedral for his final resting place.

But before that date the hunting image had changed again, women had taken their active place in the field, railways had brought the Shires within reach of London and a new generation of wealthy sportsmen was to arrive from the prosperous manufacturing towns.

9 The lure of the road: highway, byway and park

If I had no duties, and no reference to futurity, I would spend my life in driving briskly in a post-chaise with a pretty woman.

Dr Samuel Johnson, 1709–84

The dramatic and colourful impact of a coach and four clattering down the King's highway understandably proved irresistible to many British artists; and there was sport galore, and danger too, in the competitive element that sprang up between the performance of rival coaches and the skill of individual whips.

Though coaches had appeared in England as early as the sixteenth century and by Stuart times their number had become something of a traffic problem in London's narrow streets, at the Restoration of Charles II in 1660 only six stage coaches for the general public existed in the whole of the country. For decades diaries abound with details of the hardships endured by travellers, all due primarily to the appalling condition of the roads, which in winter dissolved into a morass of mud and in summer baked hard into four-feet-deep ruts; vehicles overturned, were stranded in bog and marooned in floods. Lord Ashburnham in December 1697 was much provoked at being unable to attend his rent audit in Sussex by reason of the 'badd wayes made worse by the present season . . . but no six horses in Town would undertake the journey on any account.' (East Sussex Records Office, Ashburnham Mss 841, p. 192.) The stage coaches established late in the seventeenth century, took four to six hours from Stanmore to London even in William III's reign, and a Spanish Prince visiting the Duke of Somerset in Petworth in 1703 spent fourteen hours travelling from Portsmouth, the last nine miles taking six hours. Stage wagons, with nine-inch-wide wheels and three horses for every ton of

weight, used to travel at walking pace as far north as York, carrying goods and a few unfortunate passengers too poor to afford a coach fare, but the week-long journey only started 'God willing'.

Though eventually every parish was legally bound to maintain its roads, the final result without any outside supervision remained deplorable and even the establishment of the Turnpike Trusts and maintenance tolls effected little durable improvement. The wealthy families, nevertheless, were great travellers, and understandably their visits to relatives and friends all over England were of some duration, as a trip from Suffolk to Devonshire would take eight days and cost £100.

Thomas Rowlandson's revealing talent makes witty pictorial comment on the stage coach journeys of the late eighteenth century, when speed was still irrelevant—passengers could make a call, dally over a bottle of wine, with two hours being taken for dinner.

Julius Caesar Ibbetson, a boon companion of George Morland and unfortunately infected by the same alcoholic addiction, emphasizes the informality of the rustic travelling scene in the *Departure of a Coach* (pl. 85), painted in 1792. Effective composition and sensitive colouring make this little picture outstanding and leave one full of regret that Ibbetson's erratic output included few sporting subjects. A little earlier Gainsborough had found an antidote to endless portrait commissions, in drawing and painting rural scenes and landscapes with wagons and farm horses, as in *The Market Cart* and *Sunset: Carthorses Drinking at a Stream* (Tate Gallery, London). These scenes, Dutch in style, show the simple transport methods of the remote country folk, and often include sheep and the lush trees which Richard Wilson so unkindly likened to fried parsley. Poetic, rather than romantic, these studies filled Gainsborough's studio at his death; they influenced the work of Rowlandson and such animal artists as William Shayer (1788–1879), enriching his arcadian picture, *The Timber Waggon* (pl. 84), which is typical of the contemporary country scene. His son, William J. Shayer, a sporting painter of merit, made his rural coaching studies an important subject, using attractive Sussex backgrounds often with a distant glimpse of the Channel, and bringing realism to these pictures with teams stained by mud and sweat, and dusty, dishevelled passengers.

The road took on an entirely different complexion with the arrival in 1784 of the first mail coaches pioneered by John Palmer. These superseded the riding postboys against much Post Office opposition and led to the establishment of a service that was to be the envy of Europe. Coaches were specially designed, weighing a ton, painted red and bearing the Royal Arms on the door. They also carried four inside and four outside passengers, and were granted the official favour of running toll free. This postal service quickly spread throughout the country with a reputation for speed and punctuality and, above all, safety, for each coach was supplied with a guard armed with cutlass and blunderbuss, and at a time when highwaymen were a very real menace, no hold-up of the Royal Mails ever occurred. The growing success of Palmer's organization of these services was ensured by the work of the great road makers: John Metcalf, totally blind but nevertheless responsible for the construction of many northern highways; in the early nineteenth century Thomas Telford; and, most important of all, his contemporary John Loudon McAdam, who experimented in making a surface smooth and flat using hard stone broken into small pieces so that a coach always remained upright. He became General Surveyor of Roads and saw his process of 'macadamizing' adopted in all parts of the world.

Travel was revolutionized. By 1819 seventy stage coaches a day were running between Brighton and London; by 1835 seven hundred mail coaches, their punctuality a legend, and 3300 stage coaches, the best travelling at ten miles an hour, ran regularly all over England. The former four-day journey between London and Exeter had become a trip of seventeen hours, and Edinburgh could be reached in two days, teams being changed at important inns with lightning precision in under two minutes. Mr Chaplin, proprietor of five of the chief coaching yards in London, kept 1300 horses in work. Nimrod was to write in 1837, 'Coach travelling is no longer a disgusting and tedious labour, but has long since been converted into comparative ease and really approaches something like luxury.' (*The Chace, The Turf and The Road* p. 76.)

Life and adventure were brought to the isolated countryside. Ordinary people began to find it possible to travel further afield than the next parish. Artists were presented with new exciting subjects in both town and country for, in the world of the gentry, feats on the road became as popular as activities in the hunting field and on the turf.

Horses were bred to match the beautifully designed, privately owned curricles, phaetons and chaises that made the streets of Georgian London, Brighton and Bath a kaleidoscope of equine grace and fashion. And it was the Prince Regent who really set the pace—in youth an avid foxhunter and also dashing whip, driving blood horses to the suicidal Highflyer Phaeton, a vehicle he made all the rage with the young *beaux* of the day. Eventually with increasing avoirdupois and age he settled for Welsh ponies and a specially designed, down to earth. low-hung phaeton with tiny wheels, which became very much *à la môde* with the ladies.

Private individuals took to the road in a big way. Vehicles were designed for specific purposes—smart curricles, much favoured by the Corinthian whips for town as well as country, had springs that elegantly followed the curve of the body, and horses attached by the transverse bar had to be perfectly matched in size. The Duke of Wellington possessed a striking yellow curricle with silver bar and harness appointments.

Phaetons of all types, including the Stanhope designed by the Hon. Fitzroy Stanhope, the mail and demi-mail, were favourite turn-outs, but the most elegant had already been immortalized in Stubbs's *A Lady and Gentleman in a Carriage* (National Gallery, London), a high-hung perch-phaeton with green body and primrose wheels. Later they were modified into the fashionable ladies' vehicle, accommodating the voluminous crinolines becomingly. Such renowned firms as Tilbury, Hooper, Holland & Holland, were designing coachman-driven vehicles—state coaches, dress chariots, formal landaus and barouches, and the travelling dormeuse with fixed wooden top for luggage—as well as smart turn-outs for sportsmen with their country dog carts and slatted boots for carrying pointers and greyhounds. The whiskey, akin to a curricle, was very light in construction to 'whisk' along. The variety was infinite, colourful and picturesque, and a challenge taken up by several sporting artists.

James Pollard must be considered the outstanding exponent of harness pictures for, born in 1792, he lived and painted through the heyday of the brief coaching era; in addition, his career coincided with the perfection of the aquatint, and through this medium his work reached a wide and appreciative public. His father, Robert Pollard, a Newcastle man, had established himself as an engraver and print publisher in London, and his topographical and sporting etchings and aquatints had been much in demand. James's birthplace in Islington Spa was close to the northern coaching routes and by 1812

Robert Pollard published his son's first engravings after his drawings—the subjects, predictably, were *Coach, Stage Coach, Barouche* and *Tandem*.

In 1815 James's first series of well-known coaching prints, with Robert Havell Junr as engraver, was produced; but after three years he often drew and etched his own subjects and was incorporated into his father's firm, R.Pollard and Sons. Nevertheless, such talented aquatinters as T.Sutherland, R.Reeve and others were responsible for the more attractive prints after his works.

Pollard's vivid, accurate pictures of the coaching age must be considered as a documentary rather than an artistic approach to the scene. Travelling about the country in search of subjects, various events of the road were experienced at first hand, but often his precise style with its elongated figures, neat unruffled horses and flat delicate water-colour tones appears painted to a set formula. Teams perhaps are *too* well matched, leaders and wheelers move in exact symmetry, misadventures, however extravagant, seldom appear disastrous; yet Pollard's pictures exercise persuasive charm while providing a minute and truthful record.

In *The Elephant and Castle on the Brighton Road*, a calling point for passengers from all parts of the capital, he shows a fascinating collection of vehicles, from stage coaches and a six-horse wagon to a fly van specially for luggage, post chaises (the taxi-cab of the day) and a private posting chariot. His two scenes, *The Royal Mails departing from The General Post Office: Day-time* and the contrasting *Night-time*, show the coaches after loading up at their different inns, with splendidly appointed fresh horses, moving off promptly to the music of the coach horns, making the most dramatic moments of all in London's busy day. The turmoil of traffic, which even in Georgian London had become a problem, dominates the scene in Pollard's oil painting, *Trafalgar Square* (pl. 81), dated 1834 but possibly finished a couple of years later as the National Gallery is shown as completed.

Driving clubs became all the rage employing sophisticated teams such as those in *The Four-in-Hand Club, Hyde Park* (correctly it should be described as The Four Horse Club), painted by James Pollard and engraved by J. Harris in 1838. Other fashionable clubs were the Benson and the Benevolent Whip Club, all supported by coaching sportsmen with attendants in appropriate livery, and the coaches painted in specific colours. These Corinthians were able to handle the teams and ten-foot whips with style and expertise on smart drives to Richmond, Harrow and Windsor. Pollard shows *The Taglioni Windsor Coach* (pl. 100), named after the celebrated ballerina who appears as a motif on the door panel, passing through Cranford Park with a pair of skewbalds as wheelers. It was owned jointly by Lord Chesterfield and Count Batthany. This type of equipage was a status symbol and served to raise the standards of road behaviour generally. These aristocratic amateurs aped the professionals in every detail—language, gait and appearance—wearing the many-caped benjamin with huge mother-of-pearl buttons. Outstanding whips such as Harry Douglas of the Manchester Defiance, James Witherington of the Worcester Wonder and Jo Walton of the Cambridge Star became idols of the day, and even country squires enjoyed not only playing the coachman but looking like one.

Pollard records authentic adventures befalling travellers up and down the country—*The Mail Coach in a Drift of Snow* shows the York to Edinburgh coach stuck in the snow with the guard, mounted on the offside leader according to standing orders, galloping off with deceptive ease with the vital mails; in *The Mail Coach in a Flood* (pl. 82) the horses are surprisingly unperturbed by the breast high Thames. *Lioness Attacking a Horse*

of the Exeter Mail Coach is based on a real incident which took place at Winterslow, near Salisbury, in 1816. It shows passengers beating a hasty retreat to the Pheasant Inn, and the lioness, which had escaped from a nearby menagerie, savaging the offside leader. A keeper eventually coped with the situation and the horse happily recovered.

Pollard only depicts a team galloping three or four times, for neither horses, passengers nor coaches could have stood 'springing' them for long on the hard road, and mail coaches were forbidden by law to gallop. However, if one horse in the team trotted, legality was satisfied, and in *Mail Behind Time* Pollard shows this 'Parliamentary Horse', the near-side leader, rattling along at a trot as the rest of the team stretch at full gallop as they pass the Bald-faced Stag at Finchley. Incidentally, these pictures provide an admirable record of the important coaching inns of the day, many of which were to sink into oblivion after the arrival of the railways.

Several contemporary sporting artists in addition to Pollard tried their hand at the driving scene. Henry Alken Senr produced a set of six pictures on the theme of *Gigs and Their Drivers*, as well as studies of famous coaches such as *The Brighton Mail* and *The Holyhead and Chester Mail at Hockley Hill near Dunstable in the Snow*. His set of eight coaching scenes, little pictures only measuring $7\frac{1}{2} \times 8$ in., make a fine record of travel in the early eighteenth century. From a team struggling up a steep hill in summer heat, changing horses at a remote country halt, to dealing with a broken trace in thick snow, they are all produced with Alken's own inimitable flair for character and detail. Even Ferneley forsook the hunting panorama in 1818 to paint *The Mail Coach in Melton High Street* for the Hon. George Petre; and in another picture, *The Cabriolet*, he shows a prominent Leicestershire sporting figure, Mr Massey Stanley, driving past the Achilles Statue in Hyde Park. Sponsored by Count d'Orsay, the cabriolet was an elegant two-wheeled carriage which could carry two people comfortably sheltered from wind and weather; it quickly became fashionable. After being licensed in 1823, it was eventually to become the plebeian hackney 'cab' of which Mr Jorrocks remarked so pungently, 'Most dangerous things, these cabs: nothing but a belly-band between the rider and eternity.'

John F. Herring Senr painted two contrasting studies in the genre: *The Cab Horse, St James's*, depicting a splendid grey in luxury loosebox watched by a nonchalant cigar-smoking 'tiger', and *The Cab Horse, St Giles's*, showing another grey, but one lamentably over at the knee, in a slum mews with his shabby driver. Herring, who early in life experienced more first hand contact with the coaching world than any of his contemporaries, remains somewhat pictorially reticent on this subject. His few coaching scenes on the road, however, often provide interesting background of country inns, as in *The London to Leeds Mail Coach changing Horses at the Swan Inn, Bottisham, Cambridge* and *Ready for the Change*, and give an opportunity to judge the coach horse of the era; those used for the private drags were often cast-off racehorses, while the stage-coach horses owed much to the blood of the Cleveland Bay.

In this age of heavy wagers, trotting horses, ridden and driven, were frequently matched against the clock or each other, and Herring for once surpasses himself in suggesting speed and vitality in *The Celebrated Trotting Horse Confidence*, painted in 1842 (pl. 87). Purchased in New York by Louis Buonaparte for 750 guineas and given to the Duke of Gordon, this remarkable horse was never beaten and his last match, for £100 a side, over two miles on Sunbury Common on 18 October 1839, was won in 5 minutes 39 seconds. William J. Shayer in 1840 had also painted a spirited study of Confidence. Two aquatints by Charles Hunt after Herring had at this time as subject

85 Julius Caesar Ibbetson *The Departure of a Coach* 1792
Oil on panel $10\frac{1}{4} \times 13$ in. (26 × 33 cm.)
From the collection of Mr and Mrs Paul Mellon, Upperville, Virginia, USA

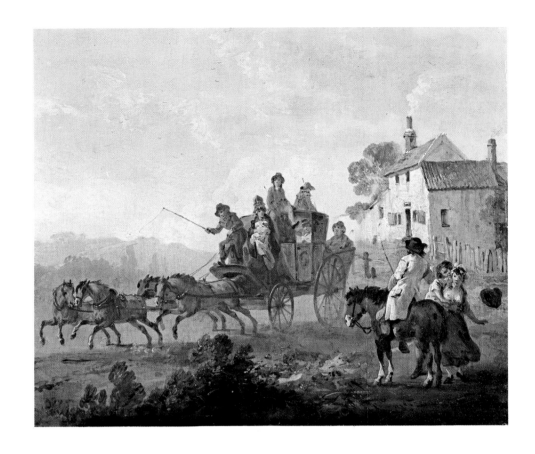

86 Charles Cooper Henderson *The Shrewsbury Wonder passing the Holyhead Mail on the Outskirts of a Town*
Oil on canvas 24 × 36 in. (61 × 91·4 cm.)
Messrs Arthur Ackermann & Son, London

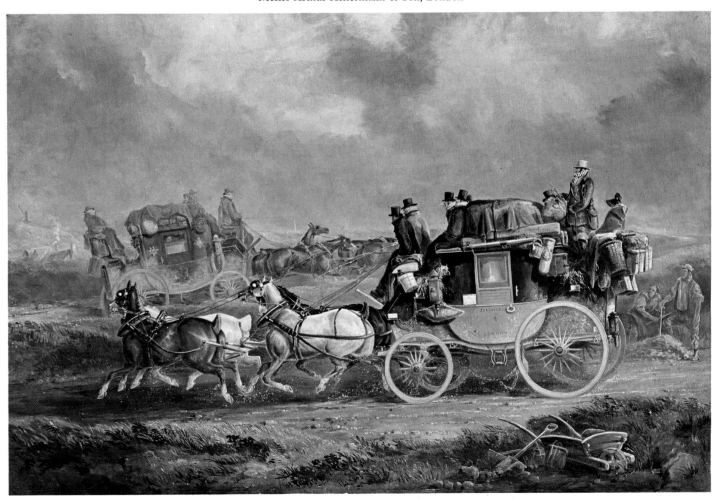

opposite

88 Charles Cooper Henderson *Foxhunters in a Cocking Cart*
Watercolour 13 × 8 in. (33 × 20·3 cm.)
Courtauld Institute of Art, London

89 Charles Cooper Henderson *Royal Fly Van*
Hand-painted lithograph 15 × 9 in. (38·1 × 22·9 cm.)
By permission of J.N.Drummond Esq.

87 John Frederick Herring Senr *The Celebrated Trotting Horse, Confidence* 1842
Oil on canvas 40 × 50 in. (101·6 × 127 cm.)
Private collection, England

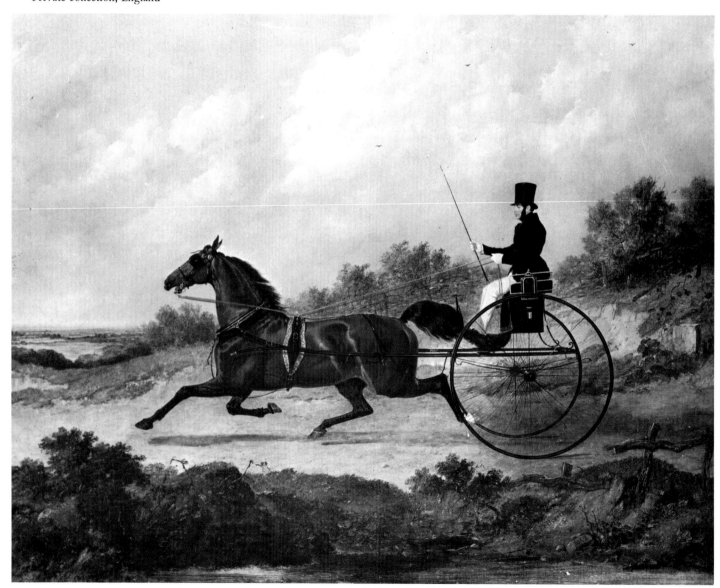

88

89

90 After Henry Bernard Chalon *The Bradwell Ox* 1830
Engraving 21 × 17⅛ in. (53·3 × 43·5 cm.)
Published by R.Ackermann 1830
Museum of English Rural Life, University of Reading

91 George Morland *Bargaining for Sheep* 1794
Oil on canvas 55 × 78 in. (139·7 × 198·1 cm.)
Leicester Museums and Art Gallery

92 William Ward, after Thomas Weaver *The Unrivalled Lincolnshire Heifer* 1813
Coloured mezzotint 23¾ × 17¾ in. (60·3 × 45·1 cm.)
Museum of English Rural Life, University of Reading

93 R.Whitford (fl. 1866) *Mr Lane's Cotswold Sheep*
Oil on canvas 30 × 28 in. (76·2 × 71·1 cm.)
By permission of the Director, Agricultural Economics Research Institute, Oxford

94

95

opposite

94 Thomas Sutherland, after Thomas Woodward *England's Glory c.* 1825
Coloured aquatint $24\frac{3}{4} \times 18\frac{3}{4}$ in. (62·9 × 17·1 cm.)
By permission of the Director, Rothamsted Experimental Station, Harpenden

95 Richard Ansdell RA *A Scene at Wiseton* 1843
Oil on canvas 83 × $21\frac{1}{2}$ in. (210·8 × 54·6 cm.)
By permission of The Earl Spencer

96 George Stubbs ARA *Labourers*
Mixed method $20\frac{5}{8} \times 27\frac{5}{8}$ in. (52·4 × 70·2 cm.)
Painted, engraved and published by the artist, 1 January 1789
Paul Mellon Centre for Studies in British Art (London) Ltd.

LABOURERS.

97 R.G.Reeve after F.C.Turner *Disgorging*
From a set of four aquatints, *Hawking*, published by
J.W.Laird 1839
Messrs Fores, London

98 Henry Alken Senr *The Whissendine Appears in View*
Line etched by the artist, aquatinting by F.C.Lewis
20½ × 12½ in. (52·1 × 31·8 cm.)
From a set of eight plates, *The Quorn Hunt*, published
by R.Ackermann 1835
Messrs Fores, London

99 Thomas Rowlandson *Dr Syntax Setting Out*
Engraving $4\frac{3}{4} \times 8$ in. (12·1 × 20·3 cm.)
From title page of *The Third Tour of Dr Syntax in Search of a Wife* 1821
Photo: Radio Times Hulton Picture Library, London

100 R.G.Reeve, after James Pollard *The Taglioni Windsor Coach*
Acquatint $11\frac{1}{8} \times 16$ in. (28·3 × 40·6 cm.)
Published by J.Watson 1837
Messrs Fores, London

102 Joseph Crawhall *The Greyhound*
 Watercolour on paper
 $14\frac{5}{8} \times 14\frac{5}{8}$ in. (37·1 ×
 37·1 cm.)
 Burrell Collection, Glasgow
 Art Gallery and Museum

103 Charles Towne *Bulls Fighting* 1809
 Oil on canvas $11 \times 12\frac{7}{8}$ in. (27·9 × 32·7 cm.)
 By permission of Captain Jack Gilbey and *The Field*

101 Thomas Sidney Cooper *The Victoria Jersey Cow* 1848
 Oil on panel $17\frac{3}{4} \times 24$ in. (45·1 × 61 cm.)
 By gracious permission of Her Majesty the Queen

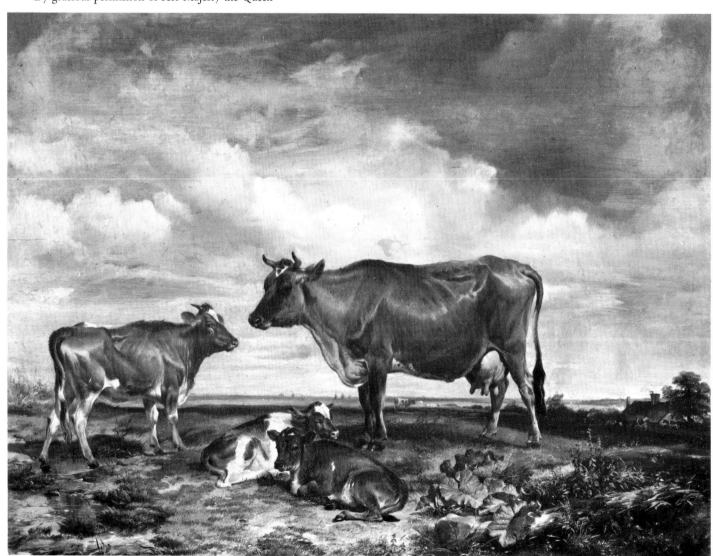

102

103

104 John Leech *Miss Lucy Glitters Shows the Way*
Lithograph from R.S.Surtees' *Mr Sponge's Sporting Tour* 1853
Photo: Radio Times Hulton Picture Library, London

105 John Leech '*Come Hup, I say, You Ugly Beast*'
Lithograph from R.S.Surtees' *Handley Cross* 1854
Photo: Radio Times Hulton Picture Library, London

107 John Ferneley Senr *Miss Catherine Heyrick with the Palmer Children* 1827
 Oil on canvas $52\frac{1}{4} \times 45\frac{1}{4}$ in. ($132 \cdot 5 \times 114 \cdot 9$ cm.)
 From the collection of Mr and Mrs Paul Mellon, Upperville, Virginia USA

108 Sir Edwin Landseer RA *Lady Harriet Hamilton*
Pen and wash $6\frac{3}{4} \times 7\frac{3}{4}$ in.
($17 \cdot 1 \times 19 \cdot 7$ cm.)
By permission of the Duke of Abercorn

109 Sir Edwin Landseer RA *Queen Victoria and The Duke of Wellington reviewing the Life Guards*
1839
Oil on canvas 22×34 in. ($55 \cdot 9 \times 86 \cdot 4$ cm.)
Private collection, England

110

111

opposite

110 Edward Lloyd (op. 1866) *Horses and Dogs at Wynnstay* 1864
 Messrs Charles Hammond, London

111 John Ferneley. Senr *Archery Meeting at Bradgate Park* 1850
 Oil on canvas $46\frac{1}{4} \times 99$ in. ($117 \cdot 5 \times 251 \cdot 5$ cm.)
 From the collection of Mr and Mrs Paul Mellon, Upperville, Virginia, USA

112 William Huggins *Tried Friends* 1852
 Oil on mill-board $28\frac{1}{4} \times 36$ in. ($71 \cdot 7 \times 91 \cdot 5$ cm.)
 Walker Art Gallery, Liverpool

113 Richard Ansdell RA *Returning Home after a Day's Sport* 1869
Oil on canvas $29\frac{3}{4} \times 53\frac{1}{2}$ in. (75·6 × 135·9 cm.)
Richard Green Gallery, London

114 Thomas Blinks *The York and Ainsty Hounds on the Ferry at Newby* 1898
Oil on canvas $40 \times 33\frac{1}{2}$ in. (101·6 × 85·1 cm.)
Photo by permission of M.Newman Ltd

115 Lynwood Palmer *Jean's Folly, Cherry Lass and Black Cherry* 1913
Oil on canvas $40\frac{1}{2} \times 50\frac{1}{4}$ in. (103 × 127·7 cm.)
Walker Art Gallery, Liverpool

116 Sir Alfred Munnings PRA *A Southerly Wind and a Cloudy Sky proclaim it a Hunting Morn* 1903
Black and white drawing 13 × 20 in. (33 × 50·8 cm.)
City of Norwich Museums

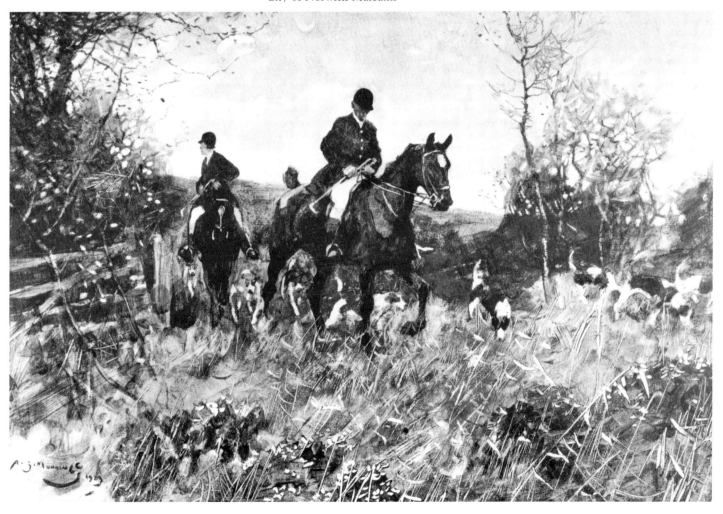

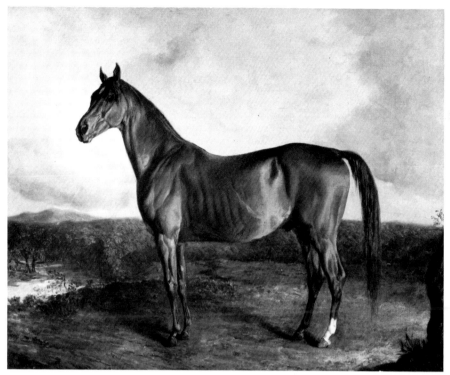

117

118

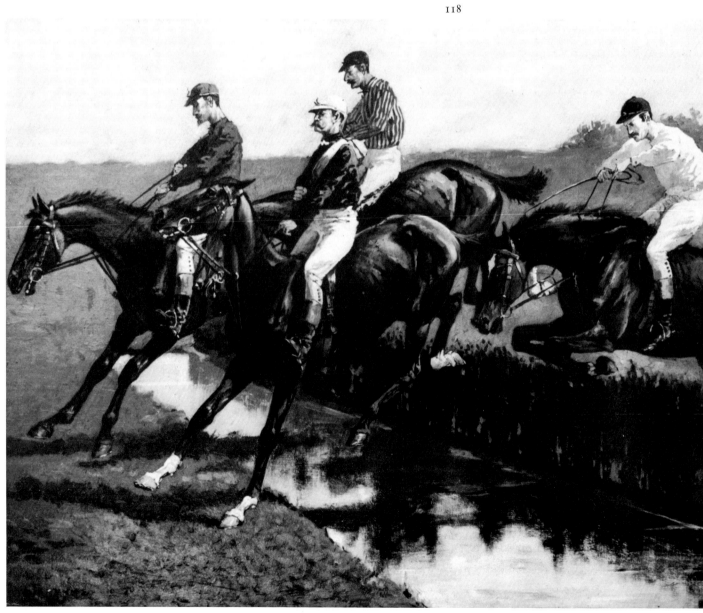

opposite

117 Edward Troye *American Eclipse*
 Oil on canvas 24 × 29 in. (61 × 73·7 cm.)
 National Museum of Racing Inc., Saratoga Springs

118 Frederic Remington *Steeplechase at Cedarhurst c.* 1885
 Oil on wood panel·14½ × 18¼ in. (36·8 × 46·4 cm.)
 National Museum of Racing Inc., Saratoga Springs

119 Emil Adam *Persimmon* 1896
 Oil on canvas 40 × 54 in. (101·6 × 13·72 cm.)
 By permission of the Stewards of the Jockey Club, Newmarket

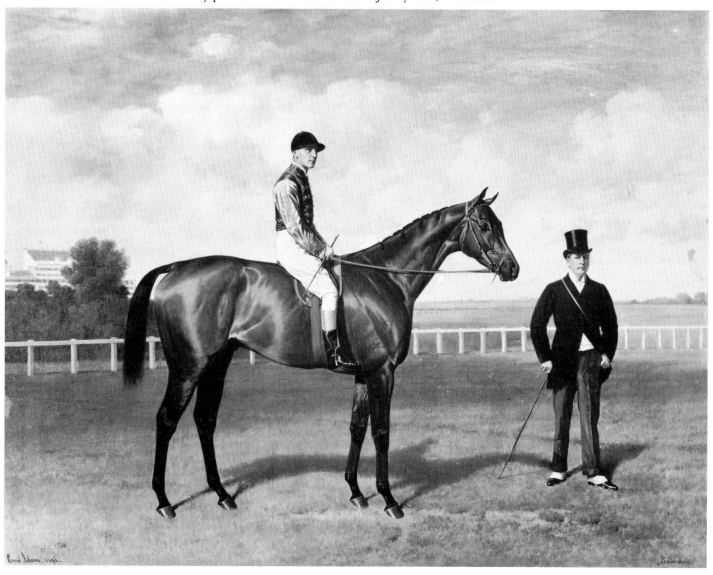

120

121

opposite

120 Robert Polhill Bevan *Showing at Tattersalls c.* 1919
 Oil on canvas 23 × 28 in. (58·4 × 71·1 cm.)
 Ashmolean Museum, Oxford

121 Robert Polhill Bevan *The Cab Horse (Putting To) c.* 1910
 Oil on canvas 25 × 30 in. (63·5 × 76·2 cm.)
 Tate Gallery, London

122 Joseph Crawhall *The Meet*
 Gouache on linen 20¼ × 17¾ in. (56·5 × 45·1 cm.)
 Burrell Collection, Glasgow Art Gallery and Museum

123 Henry Barraud *Their Royal Highnesses Edward and Alexandra, The Prince and Princess of Wales,*
 Riding in Windsor Park 1868
 Oil on canvas 34 × 44 in. (86·4 × 111·8 cm.)
 Messrs Arthur Ackermann & Sons, London

the famous trotting mare, Lady Hampton; there is also his less well-known painting dated 1839 which records a tandem match of two famous trotting horses, Tommy and twenty-four-year-old Gustavus. Driven by Mr Burke of Hereford, a well-known whip, the horses covered at a trot a measured five-mile stretch of road between Hampton and Sunbury nine times within three hours, when considerable sums of money changed hands.

At the turn of the century such painters as John Cordrey provided studies of coaches with design, appointments and passengers' luggage observed in all their minute detail. C.B.Newhouse presented the driving scene in less academic vein, although with a keen eye for accuracy, and his talent was much appreciated by such engravers as R.G.Reeve, F.Rosenberg, J.Harris and others. Most popular was an aquatint after Newhouse's *Going to the Moors*. Here the three sportsmen are seen travelling in the dangerously high two-wheeled cocking-cart known as the 'suicide gig', in which fighting cocks or gun dogs could be carried in the boot.

At the height of the coaching age, no artist excelled Charles Cooper Henderson. Born in 1803 of influential family, he studied as a boy under the gifted water colourist Samuel Prout, but later trained for the legal profession. A prolonged tour of France and Spain was to influence Cooper Henderson's ultimate career, for it was here he acquired his intimate knowledge of harness horses, equipment and coaching custom. His marriage in 1829 brought paternal disinheritance, and Charles Cooper Henderson, fortunately for posterity, took to the brush for a living, making scenes on the road and, above all, the Royal Mail coaches his speciality.

In this vein his skill and eye were unique, for he combined realism and vitality with the accurate portrayal of harness detail. Such compositions as *The Shrewsbury Wonder passing the Holyhead Mail* (pl. 86) brilliantly suggest the dust and biting wind, in contrast with *The Royal Mail passing Brighton Pavilion*, all sunshine and panache. Mails also left London in the evening, and his lamp-lit night scenes, gloomy and romantic, prove the artist's real feeling for dramatic effect.

Among his most discerning work are watercolours of the calibre of *Foxhunters in a Cocking Cart* (pl. 88), which depicts the niceties of vehicular design and also cleverly suggests equine and human character. This cart, driven at speed and obviously very late for the meet, has a touch of irresponsibility and abandon reminiscent of a remark given to the world still unconscious of colour problems by 'Daddy' Fownes, last of the professional coachmen, who stated 'No white man was ever born who could drive tandem. Perhaps black men can. I don't know!' In contrasting mood there is also his delicate hand-tinted lithograph, cleverly observed, of an early Pickford's goods wagon (pl. 89) with tilted top, straining horses and muffled driver. Cooper Henderson also paints an occasional disaster, when serious accidents were an all too-prevalent hazard. Opposition coaches led to reckless driving, with drunken and incompetent drivers sometimes increasing the dangers. Near Leicester in 1796, a coach was split in two and sixteen people killed, four seriously injured; artists avoided the complexities of these ghastly incidents, but Cooper Henderson could always suggest the tension of rough highways and unbalanced horses.

The peak days of the coaching era were virtually ended by 1845. In spite of the horse-masters' derisory remarks about the first railways and public apprehension about the hazards of steam trains, by 1842 the eighty mail coaches daily leaving the London General Post Office had dropped to eleven. By 1848, 5000 miles of railway were open and 2000 miles more under construction, and the brilliant coaching epoch had become

a romantic memory. Redundancy claimed coachmen, ostlers, grooms and guards, and the country inns became ghost hostelries, empty and neglected.

James Pollard painted *The Last Run of the Royal Mail Coach from Newcastle to Edinburgh, 5 July 1847* (pl. 83), the coachman's and guard's hats draped with black crepe and the Union Jack flying at half mast—a melancholy occasion, for it marked the end of the great days of travel on the road.

10 The farmyard: pedigrees and pictures

'The man as can form a ackerate judgment of an animal can form a ackerate judgment of anythin'.'

Charles Dickens, 1812–70
The Pickwick Papers

Logically field sports would appear to bear small relation to the activities of the farm-yard, but the fact remains that many able eighteenth- and nineteenth-century British sporting artists discovered in the significance of pedigree stock an additional subject that brought lucrative commissions. This outlet for their talents merits consideration, for artists cannot be separated from the influences of their own times; though the portrayal of the more grotesque show animals of the period may provoke Kipling's question: 'It's clever, but is it art?' Whatever the answer, these pictures can certainly be considered the forerunners of modern graphic and pictorial advertising.

Two contrasting spheres of the agricultural artistic scene developed—the arcadian and the functional, both illustrating the background of modern pedigree stock. Curiously enough, though the initial influence of England's sporting and animal painters had derived from the continent, no native Cuyp or Paulus Potter emerged. There is a hint of Flemish pictorial quality in George Morland's studies of rural life where barn and stable appear dilapidated and decayed, sheltering cattle and sheep, mediocre, lean and of indeterminate breed. Here neglect and indolence furnish the keynote, for neither yeoman nor yokel ever appears actively working the soil and, in such works as *Bargaining for Sheep* (pl. 91), *The Farmyard* and *Winter: Cattle*, Morland gives vivid glimpses of a countryside agriculturally impoverished and unsophisticated, and pictorially merges stark realism with romantic imagery.

Robert Hills, his contemporary, painted animals in delicate landscapes using water-colours with soft grey and blue tonal washes over delicate pencil and pen outline. His gentle, unassertive pictures, in addition to possessing a rustic charm, show an understanding of anatomy and truthfully record the domestic animals of the day, as in *Alderney Cows and Calves*, painted in 1820, and numerous small oil paintings and water-colours of the ordinary undistinguished dairy cow.

In 1858 J.F.Herring Senr relinquished fashionable commissions of the racing Thoroughbred to escape the smog and turmoil of nineteenth-century London and his own asthma, and start a new career as painter of the pastoral scene near Tonbridge in Kent. Here a flood of tranquil, romantic pictures of cattle, donkeys, farm horses, barnyard fowls and ducks confounded the critics by selling at high prices; but in most Englishmen a farmer *manqué* struggles to emerge.

The eighteenth century was not only an age of economic and social revolution, but agriculturally great innovations were also afoot, for the enclosure acts were making possible a transition from mediaeval to modern methods of farming. The first pioneers of this metamorphosis of the land were Jethro Tull and Charles Townshend, to be followed by Thomas William Coke of Norfolk and, outstanding in the quartet, Robert Bakewell. Born in 1725 at the family farm, Dishley Grange near Loughborough in Leicestershire, Bakewell's influence on animal breeding led directly to Britain's position today as the most important supplier of pedigree stock to all the civilized world. Endowed with natural initiative, enterprise and intelligence, his primary aim was to improve the type of common livestock on ordinary farms, in order that they should fatten more quickly and produce more tender meat and finer wool. Serious farmers from all over the country came to him for advice, and such renowned cattle men as the Colling brothers, John Booth and his sons, and Andrew Cruickshank in Scotland, who were responsible for the development of the Shorthorn, the Hereford and Aberdeen, owed their success to Bakewell's early experiments. Bakewell's influence can be gauged by a comparison of the records at Smithfield: in 1710 the average weight of beeves at the London meat market was 370 lb; by 1795, the year of Bakewell's death, it had risen to 800 lb.

Influential landowners everywhere acquired pedigree stock, and before the end of the century important agricultural societies were formed, holding annual shows. As a result the competitive element quickly emerged and, as with the Thoroughbred horse, owners of every degree were quickly demanding pictures of their winning stock in fine show condition. Size and weight eventually became exaggerated characteristics, and animals of mammoth proportions began to be specially fed in order to be put on public exhibition all over the country. Many of the prints give the exact weights and measurements of the animals concerned, and print makers were quick to adapt to the popular demand. Today it is difficult to realize the outstanding importance of these repetitive prints, but stockbreeders everywhere required illustrative publicity for their wares to inform the illiterate countryman of the splendid bulls, heifers, boars and stallions. One of the earliest cattle prints is a line engraving dated 1780 by John Baily after George Cuitt Senr, a Yorkshire artist: *The Blackwell Ox* of the Teeswater breed. Cattle provided by far the most popular subject, over thirty breeds being portrayed by these farmyard artists.

Breeders at all levels employed the leading animal artists of the day. Even Stubbs was commissioned by one owner, a young yeoman farmer John Gibbons, to paint a portrait of the Lincolnshire Ox, and brought the animal to London where it is shown

with a game cock against a background of the Serpentine. The picture was exhibited in 1790 at the Royal Academy and, engraved by George Townley Stubbs for a hundred guineas, it became a popular print of the period. Allegedly the ox stood 19 h.h. and dwarfed its attendant; Stubbs nevertheless clearly indicates in this somewhat functional study the imprint of the modern Hereford. He received £64 12s 6d in two instalments for his work.

As a result of the abortive Boydell commission for which he completed most of the 200 drawings, James Ward received many demands for portraits of farm animals, and during his long career he painted over a hundred pictures of bulls, cows and calves, and nearly fifty of pigs. Though he was meticulous in his portrayal of breed characteristics, all his animal pictures avoid the coarse, wooden style endemic among many of his less-talented contemporaries such as Weaver and Boultbee. In such compositions as *Cattle in Regent's Park, 1807* (Tate Gallery, London) where a fine white Shorthorn bull, fierce and virile, runs with some nondescript cows, he succeeds in producing something of a minor masterpiece; and with pigs, grotesque and hairy, as in *Hog at Tidmarsh Farm* painted in 1797, artistic flair triumphs in an extraordinary manner over grossness.

Among the most active of the sporting painters in this farmyard field was George Garrard (1760–1826), pupil and son-in-law of Sawrey Gilpin, who also enjoyed the generous patronage of Samuel Whitbread. A specialist in animal subjects, in 1800 he took advantage of the wide public interest in pedigree breeds to produce an ambitious book, *Description of the Different Variety of Oxen, Common in the British Isles: Embellished with Engravings: Being an Accompaniment to a Set of Models of the Improved Breeds of Cattle, Executed by George Garrard, Upon an exact Scale of Nature, Under the Patronage of the Board of Agriculture.*

At Southill, and also at Woburn, for Garrard also worked for the Duke of Bedford, a number of splendid small plaster models of animals, including varieties of sheep and cattle, can be seen—examples presumably of those illustrated in his book. Nollekens dismissed Garrard, engraver as well as painter and sculptor, as a jack of all trades; nevertheless he presented the farming scene with precision and vitality, as in his most ambitious picture, *The Woburn Sheepshearing* in 1804, with its eighty-eight celebrated agriculturalists, all named in the accompanying legend.

In 1802, a Leicestershire artist of the equestrian world, John Boultbee, painted the Durham Ox, bred by Charles Colling, which spent six years of its life travelling round the countryside. This singularly feminine-looking bovine with a girth of 133 in. was alleged to have been without a fault; and the engraving by John Whessell sold 2000 copies in a year at three guineas in colour and two guineas in black and white—a typical money spinner for John Day, the publisher. George III also encouraged Boultbee's aptitude for the farmyard scene and provided him with a house near Cumberland Lodge from where he painted cattle from the royal herds.

Thomas Weaver, born in Shropshire in 1774 and a pupil of John Boultbee, became noted for all animal subjects, including hunters and hounds, but his particular métier was portraits of pedigree cattle and sheep, many being engraved in mezzotint by William Ward. Among the most gross must be considered *The White Shorthorned Heifer That Travelled*, painted in 1811. This animal, bred by Robert Colling, brought valuable publicity to the breed, and there is a letter to Weaver to the effect that the beast even increased in weight after the portrait. For the same owner he painted several times the famous Shorthorn bull, Comet, sold when five years old for a thousand guineas. He

presents this famous sire, 'a beautiful improved shorthorned bull', as somewhat lacking in masculine impact.

Two other works of similar type by the same artist, both engraved by William Ward, are *The Newbus Ox* (a Shorthorned-Highland), and *The Unrivalled Lincolnshire Heifer* (pl. 92), owned and bred by Thomas Willoughby of Orby near Brough, who, like several owners of the day, also published the print himself.

In the field of animal art, Thomas Bewick the wood engraver alone rebelled against the over-fed monstrous animals of his day and also the practice of exaggerating their gross characteristics in contemporary portraits. Commissioned to make drawings in Brampton of cattle and sheep for a Durham report, he wrote in his memoirs, 'I soon saw that they were not approved, but that they were to be made like certain paintings shown to me. I observed to my employer that the paintings bore no resemblance to the animals whose figures I had made my drawings from, and that I would not alter mine to suit the paintings that were shown to me; but if it were wished that I should make engravings from the paintings, I had not the slightest objection to do so, and I would also endeavour to make facsimiles of them . . . I objected to put lumps of fat here and there where I could not see it, at least in not so exaggerated a way as on the painting before me.' (*Memoirs of Thomas Bewick, Written by Himself 1822–1828*, p. 15.) Bewick's opinion of the new improved breed of sheep which had superseded the Border backfaced kind was also to the point, for he asserted that the mutton of the former reminded him of blubber and the latter ate like 'dark, juicy venison'.

Most important in the records of English cattle is Bewick's fine woodcut in 1789 of the 'Wild Bull of Chillingham' that belonged to Marmaduke Tunstal of Wycliffe. The level topline and strong compact conformation proved that nature had been finely selective in conserving quality in this only surviving wild breed of cattle in England. The same realism is apparent in Charles Towne's splendid oil painting, *Bulls Fighting*, dated 1809 (pl. 103), a theme obviously suggested by similar works by George Stubbs and James Ward. Nevertheless, Towne's picture holds its own in dramatic appeal and, in addition, emphasizes the characteristics of the new Shorthorn breed of cattle. It contrasts well with another picture ascribed to him, *Longhorned Ox, Rubens*, painted with Kenilworth Castle in the background. This Liverpool-born sporting painter lived for many years with an Essex livestock dealer and excelled in studies of cattle. His picture, *Bull-baiting in Open Country*, provides a spirited record of a sport fast becoming obsolete and shows again his skill in portraying bovine physique.

Few animal artists could resist the boom in agriculture; even Landseer was to portray famous cows, rams and boars. Ben Marshall was also commissioned early in his career to paint animals for 'Farmer' George III. Far removed from his racing scenes is his picture for Mr J.Wilkinson, the Nottinghamshire cattle breeder, *The Shorthorn Bull, Alexander*, with three cows and a calf, painted in 1818 and later engraved by R.Woodman. Not to be outdone, in 1830 H.B.Chalon painted *The Bradwell Ox* (pl. 90), and on the engraving, published by R.Ackermann, is recorded the fact that this animal's live weight was 560 stone (7840 lb), sixty stone heavier than 'The Famous Lincolnshire Ox', and that at six years old it measured from end of nose to point of tail 180 in. and to top of shoulder 70 in., across the hips 33 ins., with a girth of 132 in.

Other exponents of the hunting and racing scene (who also turned to the farmyard were David Dalby who painted *The White Shorthorn Heifer, Birthday*, and William Barraud who exhibited in the Royal Academy in 1846 a fine portrait, *Thomas Carter's Guernsey Bull, Conrad*. William Henry Davis, brother of R.B.Davis, portrayed *The Fat*

Hereford Ox dated 1853, where the width of the horns illustrates the descent of these cattle from the original longhorned stock. He also completed a book of cattle studies for the Marquis of Exeter.

Bakewell's efforts had also been memorable in establishing new types of sheep, especially the improved Leicesters, recorded as having no rival from Shetland to Penzance. Many artists of the day established a symmetrical style of their own where sheep were concerned, so neat and precise is their show appearance, with faces and forelegs shaved to emphasize the massive mutton of their bodies—a contrast indeed to James Ward's arresting and imaginative *Sheep with Shorn Fleece*.

Weaver was much in demand for this work and was commissioned by the Third Earl of Talbot to paint *A Shepherd and Sheep at Ingestre Park, Stafford*. In pictures by T.Yeomans, a Grantham artist of the local Leicester Longwools, and in R.Whitford's paintings of Cotswold sheep from his own area, the animals all appear as similar as peas in a pod; sheep number seven in the painting, *Mr Lane's Cotswold Sheep* (pl. 93), sold in July 1866 at the annual sale held by Mr William Lane of Broadfield, fetched the then fantastic price of 210 guineas, though pictorially it appears exactly like its fellows. Over the shepherd's left arm is draped a sheep's coat, a cloth for protecting the fleece after grooming for a show, and stamped on it is the name of Wm.Lane, a progressive and prosperous Cotswold farmer; this marking has recently established the identity of the picture beyond doubt.

Scientific breeding had undeniably proved its point by the time of Richard Ansdell's picture, *A Scene at Wiseton*, dated 1843, which shows Lord Spencer and his famous Shorthorn bull, Wiseton, a massive but masculine animal (pl. 95). Also depicted are the steward at Althorp, Mr J.Elliott; Mr Hall, steward at Wiseton; and John Wagstaffe the herdsman. The stewards, with a sheepdog and greyhound as companions, appear in cloth gaiters, but they, like his lordship, all wear the ubiquitous black top hat. The artist, in addition to using considerable skill in colour and composition, suggests with some subtlety the importance and prestige which had come to British agriculture.

This new status had also influenced the heavy horse of the day, for Bakewell, impressed by the Dutch black stallions brought to England by the Earl of Huntingdon, himself imported several mares of that same type. To these and the old Leicestershire Black horse, a descendant of the mediaeval war horse imported originally from the Low Countries and mentioned by Defoe and other eighteenth-century writers, he applied his breeding methods and evolved the modern Shire heavy horse. One of these Black Shire stallions, a six-year-old, painted by John Boultbee in 1790, appears in aquatint by Francis Jukes. The horse, with its magnificent front, and pricked ears perpendicularly over the forefeet as conformation demanded, dominates a background façade of Dishley Grange. Bakewell was commanded by George III to bring one of these famous horses to be exhibited before him at St James's Palace.

Landseer's gifted young friend, Thomas Woodward, in 1825 painted another famous Shire stallion, England's Glory (pl. 94), 'allowed to be by the first judges the finest animal in the Kingdom in point of symmetry and strength never equalled'. Engraved in aquatint by Thomas Sutherland and dedicated to the Right Honourable John, Earl Brownlow, President of the Lincolnshire Agricultural Society, the print achieved great popularity, as most public houses decorated their walls with the famous animals of their district. At the turn of the eighteenth century these Black Shires were used to draw the heavy, slow coaches and became progenitors of the London dray horse.

Sporting artists with distinguished work to their credit were often content to fulfil these commissions of portraits of farm animals with basic simplicity, providing a functional picture for the engravers. Animal conformation with size exaggerated to excess, and not artistic composition, was the relevant consideration, to be exploited fully by the publishers in fulfilling the important advertising requirements. They looked, as Alice in Wonderland would assert, 'as large as life and twice as natural'. Nevertheless, these pictures though often primitive in design provide valuable records of the English farming scene, while paying homage to the innovators of scientific breeding and agricultural methods.

11 Sporting prints: the popular approach

Art, like morality, consists in drawing the line somewhere.

G.K.Chesterton, 1874–1936.

The British sporting print plays a considerable part in the enjoyment of sporting art and, though originally evolved on the continent, must be reckoned a peculiarly British invention. Its real heyday was brief, from the last quarter of the eighteenth century to the mid-nineteenth century, and coincided primarily with the enthusiastic Georgian racing, hunting and coaching activities, and especially the dashing Regency epoch. In an age of talented artists who recorded the important events of the sporting year, the prints of the classic races, celebrated horses, renowned hunts and more modest scenes of angling and shooting, fulfilled at small cost the sporting curiosity inherent in every Englishman, and print shops and publishers were not slow to meet the demand. Artists' works were presented, as a result, before a wide public and the role of the patron was gradually superseded.

The sporting print of the day might be considered, in its simplest form, the equivalent of modern photography and its popularity can hardly be over-estimated. There were few inns and farms in Georgian and early Victorian England that lacked a hunting or coaching scene or a Derby winner on the dining-room wall. At its worst it remained a mediocre representation of contemporary sport; at its best an important art form. The finest engravers produced work of such exquisite craft that it sometimes surpassed the original picture. The subject bristles with technicalities far too numerous and complex for discussion within the limited space available in this book. Suffice it to say that up to 1850 the reproduction techniques used for prints included woodcut, mezzotint, stipple and aquatint, dry point and soft ground etching, steel engraving and lithographing.

These ultimately led to the technical reproduction processes of today which, though splendid in their way, must be considered mechanical rather than artistic, their origin lying with the camera's lens and not the engraver's art. Unfortunately it is now virtually impossible to form a fully representative collection of British sporting prints owing to the scarcity of good impressions. During recent years many of the finest examples have been dispersed, but in the nineteenth century the levy of a glass tax resulted in many engravings being cut or varnished to avoid payment of duty on glazing, so ruining them for the collector.

Wood engraving, a process in which the design is chiselled away from the block to stand out in relief, was practised in England before the fifteenth century. Often used in illustrating early sporting treatises, it was to find spectacular rebirth in the skilled hands of Thomas Bewick three centuries later. Copper engraving goes back to the seventeenth and eighteenth centuries: the lines are incised by a burin on a flat copper plate which is then inked and wiped; the ink still remaining in the incised lines is pressed out as paper and plate go through the printing press.

The mezzotint, which derived from copper engraving, was a successful and popular eighteenth-century medium, originally evolved on the Continent by Ludwig von Siegen, who allegedly interested Prince Rupert in the process. In mezzotinting the ink is still held by indentations, but these, instead of being drawn on the plate, are produced by a rocker covered with teeth which, used over the entire surface, produces a dense network of tiny pits. In the adroit scraping of the plate—the skill of this process—subtle and deep variations in tone are obtained which make this medium a most beautiful form of printing. The English exponents became so skilled that the process was known on the continent as the *manière anglaise*.

Many sporting prints owe their fine quality and popularity to the perfecting of the aquatint process which, like the mezzotint, is a tone rather than a line method. Basically it is a form of etching using a porous ground penetrated by different exposures in the acid bath. 'Stopping out' was achieved by varnish, and colour was finally added in a series of flat washes, mostly by young assistants, sometimes by means of paper stamps on the plate. Paul Sandby, employed by the Crown and referred to by Gainsborough as the only man of genius who had painted 'real views from Nature' in this country, was the first to perfect aquatinting in England. The process, which might be termed a monochrome watercolour, and which, in the hands of a master, could retain much of the quality of a watercolour, was used to produce prints at a comparatively low cost, with more than 200 impressions of a first issue.

At the end of the seventeenth century, Hollar produced numerous etchings relating to different field sports at the rate of 4d per hour, the time being calculated by means of an hour glass; Barlow's work in the same medium has already been discussed. Engraved work, after the early sporting painters such as Wootton are, however, few; in fact only nineteen prints after works by this artist have been definitely ascertained. James Seymour's famous *Chaise Match* was etched in line and stipple in 1789 by J.Bodger, creating a precedent for the spate of future prints of leading bloodstock, though Barlow, of course, had produced the first etching of an English horserace as long ago as 1687.

George Stubbs hardly fits into this general category, although he had dedicated himself to learning the engraver's art for the plates of *The Anatomy of the Horse*. Little of his superb talent in this medium was given to the sporting subject, though there was an early plate of the racehorse Marske. His series of horse portraits for the *Turf Review*

in 1790 was to be 'engraved in the best manner from original portraits of the most famous racers at an immense *expence*, and solely for this work' by his son, George Townley Stubbs. The painter himself concentrated upon his wild animal and farming subjects in his engravings. The latter romantic arcadian theme was exploited successfully by such men as Morland, Ibbetson and Wheatley, but Stubbs's unsentimental direct presentations, although superbly worked, created small public demand. Using a mixed method of stipple and mezzotint, with sensitive precision and perfect co-ordination of eye and hand he produced such outstanding prints as *Labourers* (pl. 96), which appeared in 1789. This scene of elderly farm workers loading bricks into a cart drawn by an aged chestnut, was painted for Viscount Torrington at Southill. The horse, besides being a favourite old hunter, was the first Lord Torrington ever rode, and the real reason for the picture. The gradation and contrast in tone, the sunlight on the flank of the horse, the individual facial expressions, are all brilliantly worked.

The purely sporting subjects engraved by Stubbs himself include a mezzotint after his picture *Freeman, Keeper to the Earl of Clarendon* (pl. 38), with hounds and a wounded doe, and three fine studies of foxhounds also published by Stubbs in 1788. Each hound had first appeared in a painting made more than twenty-five years earlier of *The Third Duke of Richmond hunting with his brother Lord George Lennox and General James*. In an age when watercolours and aquatints were catching the public taste for colour, Stubbs' austere studies, though brilliantly executed in their tones of grey, received small acclaim.

Among sporting artists who became their own engravers was also James Ward, with his series of fourteen lithographs executed in 1823 and 1824 of famous horses as diverse as Copenhagen and Marengo—Wellington's and Napoleon's chargers—the racehorses Dr Syntax and Monitor, and *Little Peggy Thibet Horse Height 33 inches*; the whole collection was dedicated to His Most Gracious Majesty George IV. Ward's plan to make an engraving after his splendid picture *Ralph John Lambton on Undertaker and His Hounds* was handed on to his brother, William, and was finally produced in mezzotint by Charles Turner by what Ward described as a 'fraudulent movement' to become a most profitable commission.

The popularity of the British sporting print is perhaps accounted for by the wealth of capable and talented engravers working at this time who were happy to find steady employment in the world of field sports. Frank Siltzer in *The Story of British Sporting Prints* lists almost 150 names, and most prolific among these were Charles Hunt, John Harris, R.G.Reeve and T.Sutherland, all skilled aquatinters. The services of William Ward, one of the finest mezzotinters of his day, were greatly sought after by such artists as Hoppner and Reynolds; but influenced by his brother-in-law, George Morland, who had dedicated his career to the sporting scene, Ward often devoted his considerable talents to sporting prints. Many delightful engravings after Morland's pictures resulted in what Guy Paget has described as the finest prints in the world, and Ward also engraved sporting subjects after H.B.Chalon, Ben Marshall, George Garrard and John Nost Sartorius.

The colour, vitality and charm of the sporting print is epitomized in the work of Henry Alken Senr. His output was prodigious and biographers attempting to assess the number of prints after his works by his own hand, and by others, had to call a halt in despair when five figures were reached. No phase of sporting life lacked interest for him—hunt scurries, racing, driving, shooting—their appeal was immense. He probably achieved his greatest popular success with his sets of hunting in the Shires, for the most

part engraved by him, which frequently included dashing Quorn thrusters at various meets or galloping with immense enthusiasm across country. There were such subjects as *How to Appear at Cover etc.*, a set of seven plates; another set of *Hunting Accidents* and *On the Road to the Derby*, and many sets of shooting scenes in aquatint. In all his own prints the inimitable Alken touch of caricature and careful portrayal of human features, a relic of his training as a miniaturist, were meticulously reproduced. Other engravers, famous and obscure, all produced prints after his works. Aquatints by Robert Havell after the Alken coaching scenes, so often depicted in a snow storm, delighted a wide public, and engravings by J.Harris after *The First Steeplechase on Record* and other 'chasing scenes have become classics. Alken's masterpiece in this genre were the six plates of *The Quorn Hunt* (pl. 98), line etched by Alken himself and aquatinted by F.C.Lewis, issued by Rudolph Ackermann in 1835 at £4 14s 6d.

Alken's name was understandably much in demand by the leading publishing firms of the day. Several engravers acted in this capacity themselves, but Siltzer lists nearly seventy publishers of the sporting subject. Most important in this sphere was Rudolph Ackermann in the Strand, who specialized in the coloured work of the finest aquatinters. Ackermann himself was a remarkable character. Arriving in London from Saxony in 1779 at the age of fifteen, four years later he established the Repository of Arts which became the fashionable literary and artistic meeting place of the day. There he encouraged the early work of Rowlandson, the Dean Wolstenholmes (father and son), James Pollard and Henry Alken Senr, and became the presiding genius responsible for many of the best prints by the new methods. In addition, he was a designer of coaches, of a mechanical device attached to balloons that during the Napoleonic wars dropped pamphlets on France, and also a considerable philanthropist, raising over £100,000 for relief of the countries devastated by war. Today the same firm, now in Old Bond Street, London, still exerts a major influence in the world of sporting art. Equally influential was S.W.Fores, later to become Messrs Fores. Established in 1785–6 especially for the production of contemporary caricatures, within a year they became publishers and sellers of sporting prints, including many of the more famous hunting and racing series. Today in New Bond Street this firm still holds the dominant position in this field. Other important publishers such as S. and J.Fuller were responsible for Herring's spate of Derby and St Leger winners, the greater number being the work of Charles Hunt in aquatint. Very popular in its day was a set of Herring's racing scenes by John Harris and W.Summers, published in 1856 in *Fores' National Sports*. *Saddling, False Start* (pl. 71), *The Run In* and *Returning to Weigh* give a vivid impression of the Victorian sport of kings and the Thoroughbred of the day.

Although hunting, providing both action, colour and landscape background, always remained the favourite subject, scenes of provincial sport after both Dean Wolstenholmes became popular aquatints by R.G.Reeve, and Dean Wolstenholme Junr also worked assiduously in this medium himself, sometimes using quiet modest shooting scenes as subjects. This less flamboyant sport attracted several engravers, not forgetting, of course, William Woollett and his splendid set of shooting scenes after Stubbs. The work of Samuel Howitt, the self-taught brother-in-law of Rowlandson, for *Orme's Collection of Field Sports*, published in 1807 with twenty plates, included hunting and coursing (pl. 72) among the subjects, but half of the plates show the different facets of shooting, from woodcock to hare, and these were most delicately engraved in aquatint by J.Godby and H.Merke, with the assistance in one case of W.M.Craig. In pristine condition this series makes an important collector's item.

Any mention of the sporting print automatically conjures up the coaching scene. The popularity of the famous mail coaches and the sophisticated private drags emphasizes the powerful glamour the Georgian harness world held for the Englishman, a magic which still endures. The number of engraved works after James Pollard are only surpassed by those of Henry Alken Senr and J.F.Herring Senr. Pollard's coaching scenes alone number nearly seventy; less than a dozen were engraved by his own hand and many delicate, detailed aquatints after his works were by Robert Havell Junr and R.G. Reeve, their finished products more often than not surpassing in delineation and elegance the original picture. Today Pollard is better known by his engravings than by his pictures. The inclusion of famous hostelries and familiar beauty spots in these aquatints also enhanced their public appeal.

The demand for pictures of this competitive, exciting, world of road travel was insatiable. Aquatints by J.Harris after scenes by Charles Cooper Henderson were published by Rudolph Ackermann and by Fores of 41 Piccadilly. The first series, of 1837, *Fores' Coaching Recollections*, shows various road routines with such titles as *Pulling Up to Unskid* and *Changing Horses*. It was followed by *Fores' Coaching Incidents*, a set of six, again aquatinted by J.Harris, where such occurrences as *Stuck Fast, Flooded* and *Late for the Mail*, suggest that the works of Charles Cooper Henderson reflect to a greater degree than any other artist, the rough and tumble as well as the elegance and panache of the coaching era.

The arrival of mechanical processes meant that the effective period of the British sporting print lasted little more than a hundred years; but in an age of realism it provided a form of pictorial journalism for British sporting art which brought enjoyment to a wide public possessed of only modest means.

12 Some sporting illustrators: fact and fiction

'What is the use of a book', thought Alice, 'without pictures . . . ?'

Lewis Carroll, 1832–98
Alice in Wonderland

The English have always possessed a native gift for book illustration, a talent that certain of their animal artists have used with undoubted skill and perception. The early treatises on equitation and sporting pursuits depended for much of their interest on their contemporary illustrations. The collaboration of Hollar and Barlow in works on Stuart field sports is important, and Barlow's own drawings for his *Severall Wayes of Hunting, Hawking and Fishing according to the English Manner*, have already been mentioned. The influence of the Duke of Newcastle's *A New Method and Extraordinary Invention to Dress Horses*, published in this country in 1667, was increased by van Diepenbeck's engravings, which clarified the latest theories of classical equitation and enabled them to be studied at leisure.

Thomas Rowlandson was a born illustrator and, encouraged by Rudolph Ackermann, his aquatints for various books provided constant employment. The artist himself would make the actual drawing, which was then often handed over to a team of professional colourists, many of them French emigrés. Rowlandson's satiric eye and deft hand made his illustrations a delight and, though sometimes coarse in the context of the age, they exhibited far fewer indecencies than many of his rivals. Over a hundred books owed popularity to his unique talent and he provided pictures for works as diverse as the novels of Smollett, Fielding and Goldsmith, all of which gave scope for coaching and sporting scenes; volumes with no letterpress such as *Racing Series* with six aquatint plates; and, most popular of all, *The Three Tours of Dr Syntax* (pl. 99). This last work

with its good-humoured, moralizing, pedant hero, a representation of the Cornish Parson, the Rev. Ralph Baron, Vicar of St Breward Church, and its self-portrait of Rowlandson himself as the lean and hungry artist travelling on an overladen pony, provided the opportunity for some humorous and adroit equestrian scenes. If these illustrations do not represent Rowlandson at his best, they nevertheless excel the lively doggerel verses supplied by William Combe, a journalist and satirical writer; the combination certainly delighted the public, and Syntax hats, wigs and coats became the mode of the moment.

Rowlandson provided illustrations for various editions of that extravaganza, *An Academy for Grown Horsemen* by Geoffrey Gambado, first published in 1787, after the original drawings of Henry William Bunbury (the actual name of the author), and for numerous books in which horses play an important part in the composition. The different types of harness horse and vehicles that he portrays provide in themselves a symposium of Georgian travel habits and customs.

The popularity of angling in the early nineteenth century resulted in a flood of piscatorial literature. Samuel Howitt's *The Angler's Manual or Concise Lessons of Experience*, with twelve plates designed and etched by the author, appeared in 1808, and illustrates, with delicate and perceptive talent, the different procedures from pike to minnow fishing. It was followed, in 1839, by *The British Angler's Manual* by Thomas Christopher Hofland, which contained fourteen steel plates by W.R.Smith after the author's own pictures and thirty-nine woodcuts after various other artists, including Sir Francis Chantrey RA, to whom the book was dedicated.

Outstanding among illustrators was Thomas Bewick, who rescuing the woodcut from oblivion established a school of English wood-engraving that still remains unsurpassed. He was a genius in this medium; his technique enabled varying tones of grey to contrast with pure white, which gave his pictures a three-dimensional quality and colour sense never before achieved in the woodcut. Apprenticed at fourteen to Robert Beilby, a Newcastle engraver, who also fulfilled orders for woodcuts by printers, the pupil soon far excelled the master. He produced illustrations for *Gay's Fables* and *Select Fables*, and received a prize of seven guineas for the latter from the Society for the Encouragement of Arts.

Bewick's art and mind were dominated by the country way of life. His acute perception of animals and rural customs, led him to become, in his own words, 'a silent poet of the waysides and hedges'. Nevertheless his realistic approach to the countryside resulted in him writing and illustrating two practical and important text books, *A General History of Quadrupeds* in 1790, and, at seven-year intervals, his two volumes of *A History of British Birds*. The first work ranges from agoutis to zebras, but some of the most perceptive woodcut illustrations are of the modest hare, the cocker spaniel and the fallow deer. The artist's section on the horse includes nine different types from the racehorse to the packhorse, the woodcuts here being functional rather than decorative. Bewick writes intelligently and, like James Ward, he deplored the custom of docked tails. He held advanced ideas on many subjects, voicing his qualms about the cruelty of hunting wild animals and the unfairness of the Game Laws, and emphasizing that 'to convince the intelligent poor man that the fowls of the air were created only for the rich is impossible and will remain so'.

Each beast and bird illustrated is set with exact fidelity in its typical environment, but the greatest delight of these volumes are the vignettes and tailpieces, often measuring only two by three inches. Here the vagaries of the English weather, of the changing

seasons and varying sports and scenes are lovingly recorded—an angler resting, a partridge shoot, a horse with its dung bag, a chaise with its accompanying Dalmatian. Here is the very essence of rural England depicted with perceptive genius. Over 300 of these *Bewick's Celebrated Vignettes on Indian Paper* were published without letterpress in 1827. Collectors of his prints should look out for his single wood engravings with his thumbmark impression in the top margin, a precaution to stop pilfering workmen selling his work illegally.

Books on the actual science of field sports were also in demand and high in this category is *Rural Sports* by the Rev. Wm.B.Daniel, published in 1801 in two large volumes. It was followed twelve years later by a third, entitled *Fragments with Anecdotes of the different Animals that are the Objects of the Sportsman's Pursuit*. Almost every possible sporting recreation and its exercise receives attention—advice on horses, hounds, fish and wildfowl, legal rights, dog training, guns, rods; all are meticulously described, but particularly interesting is the lavish use of engraved plates after several sporting artists of the day, the greater number being works after Sawrey Gilpin engraved by John Scott.

Mobility and humour were reintroduced by the illustrations of the indefatigable Henry Alken Senr; in his lifetime over sixty works were published with his illustrations. A greater number of these were purely collections of his sporting plates bound in one volume, comic in content and often without any text—such as *Humorous Specimens of Riding* and *Qualified Horses and Unqualified Riders*, and other works in light satiric vein bent on debunking the would-be fashionable sportsman of the day. But his *Sporting Scrap Book*, with fifty plates designed and engraved by himself, is a serious work, emphasizing Alken's brilliant draughtsmanship, whether the subject be hounds, post horses, farriery or cattle. The artist's fifty plates for *The National Sports of Great Britain*, published by M'Lean in 1825, admirably complement the text which was written by Alken himself. Dryly humourous and intelligent, it covers most activities, likely and unlikely, from horseracing, hunting the marten, to poaching and badger baiting, with vivacity and nicety of detail. Touches of humour abound in the lugubrious patience of an angler and the deferential greeting of a groom. Here the dedicated sportsman and gifted sporting artist combine to give us an incomparable record of country pursuits of the day.

During his long working life Alken was immensely prolific and popular, but his later years were handicapped by a review by T.B.Johnson, a Liverpool printer and editor of a minor sporting magazine, who influenced a fickle public when he wrote: 'We have seen many of this gentleman's productions, every one of which might be justly considered an outrage against common sense. Before Mr Alken can produce genuine caricature he must endeavour to acquire some trifling knowledge of the figure and conformation of man, horse and dog; he must also witness the chase of which at present he is woefully ignorant.' This of a man who had a lifelong first hand experience with horses and hounds and of whom a critic in *Blackwood's Magazine* had written a few years previously 'Happily for England and for Art, Henry Alken shines and shines like a star of great magnitude.' Johnson's spiteful words and the onset of ill-health brought a decline in the demand for Alken's work, and in his last years book illustration, though it ranked very low in the artistic hierarchy of the day, provided a welcome source of income.

His spirited pictures for Nimrod's works, *Memoirs of The Life of the late John Mytton* (see p. 90), *The Chace, The Turf and The Road* (1837, plates in black and white),

and *The Life of a Sportsman* (1842), played an important part in their success. His light touch and hint of caricature were to have considerable influence on the work of Hablot K. Browne and John Leech who, with Alken himself, were to illustrate the Surtees novels.

During the last years of his life, Alken's work frequently appeared in the various sporting periodicals—the *Sporting Review*, the *Sportsman* and the *Sporting Magazine*. The *New Sporting Magazine*, founded in 1831, was to have as its editor R.S.Surtees, a tall straightlaced lawyer, second son of a respected Durham county family. Admitted to Chancery in 1822, like many other London citizens he enjoyed sport with hounds meeting at Streatham, Dulwich and the fashionable sporting hub, Croydon. 'Scribbling', as he termed it, occupied his leisure and eventually took over from his legal career: from his hunting diaries he worked up sporting articles for the *Sporting Magazine*, which appointed him successor to Nimrod, its hunting correspondent. It was in the *New Sporting Magazine*, in a series of unillustrated articles that appeared between 1831 and 1834, that Mr Jorrocks first made his debut. He was only a shadow of the character he was to become, but nevertheless here was the grocer from Great Coram Street out with the Surrey hounds, enjoying aquatics at Margate and high life in Paris, dining more well than wisely. In 1838 these disjointed scenes were published in book form as *Jorrocks' Jaunts and Jollities*, with the sub-title *The Hunting, Shooting, Racing, Driving, Sailing, Eating, Eccentric and Extravagant Exploits of that Renowned Sporting Citizen, Mr John Jorrocks of Botolph Lane and Great Coram Street*, with plates by Hablot K. Browne. The young artist was already popular with the reading public as illustrator to Dickens under the pseudonym of Phiz and, like Surtees himself, was a keen follower of sport in Surrey. He produced nine excellent etchings and the very first portrayal of Mr Jorrocks. In making him a bulky untidy fellow, a thoroughly bad horseman and obviously lacking the social graces in all his various predicaments, Hablot Browne captured something of the hero's bucolic zest and more than hinted at the character he was to become in *Handley Cross*. Nine years later Browne illustrated *Hawbuck Grange* for Surtees with eight plates, including a brilliantly descriptive picture of hounds, 'bright coloured, wiry haired and rough mizzled'. John Leech was to say 'I *wish* I could draw horses like Browne' and certainly in *Hawbuck Grange* each horse is an individual, from Tom Scott's 'young 'un' to Dr Podgers's pony; nevertheless there is a lack of artistic punch and vitality, and the novel was not a success.

Hablot Browne illustrated no more books for Surtees for the next eighteen years owing to pressure of work elsewhere, especially from Charles Dickens, who is said to have based Mr Pickwick on the character of Mr Jorrocks. Instead, Henry Alken Senr illustrated the next editions of the *Jaunts and Jollities*. Perhaps Nimrod's opinion that Alken 'drew like a gentleman' explains the touch of respectability in the artist's portrayal of the hero which lacked the real impact of the rollicking grocer who was to become England's greatest sporting character. But Alken's illustrations are colourful and effective.

Alken also illustrated Surtees's *Analysis of the Hunting Field* (Surtees's only book not published anonymously) with some excellent coloured plates that give a very clear pattern of English country life and sport in the first half of the nineteenth century. Outstanding is the superb title page which is divided into several miniature scenes— a typical Alken disaster over a gate, the field swimming a river in flood, and even a dashing lady in a smart green habit.

Three minor artists, Henry Heath, George Tattersall and John Jellicoe, collaborated

to produce the illustrations for *Hillingdon Hall*, another unsuccessful Surtees novel, and though Jorrocks was introduced, it was more or less in a farming capacity, for no actual hunting scene is depicted at all.

Surtees wrote novels for over twenty years without attracting the reading public. *Handley Cross* itself, first published as a serial and as an unillustrated book in 1843, initially aroused no interest. Hablot Browne had turned down the invitation to provide illustrations, and young Leech, then at the beginning of his career, had had the effrontery to ask six guineas for each sketch, a price rejected as quite unreasonable. Surtees insisted on the book being published unadorned and it failed to sell. Perhaps Surtees's malicious joy in making fun of the nobility and county dignitaries and his tactlessness in elevating a vulgar city merchant to the illustrious position of Master of Foxhounds had not endeared him to the Victorian reading public. *Mr Sponge's Sporting Tour* also appeared as a serial with no illustrations in the *New Monthly Magazine* between 1849 and 1851, but the author had learned his lesson and decided to re-publish in 12 parts with pictures. Surtees, impressed by Thackeray's drawings for the immensely popular *Vanity Fair*, wanted his friend to do the illustrations but Thackeray understood his artistic limitations and wrote in a letter 'I have not the slightest idea how to draw a horse or a dog or a sporting scene of any sort. My friend, Leech, I should think, would be your man—he is of a sporting turn and to my mind draws a horse magnificently.' Medicine had been the intended career of 'my friend Leech', but family misfortunes at the age of twenty-one had resulted in him using his considerable talent as an artist to help support his family. Virtually without professional training, apart from a brief instruction in wood engraving from Orrin Smith and in etching from George Cruickshank, John Leech drew direct upon the polished wood with a hard lead pencil, producing work of great delicacy and beauty. Until the end of the nineteenth century, however, the illustrator had no control over the methods of reproduction and depended much on the skill of the copyist, so that Leech's subtle, sensitive qualities were often coarsened in the final result.

Book illustration is always a partnership between author and artist, and in the case of Surtees and Leech it was a perfect fusion of two arts and the start of a friendship that endured until Surtees's death thirteen years later. Rarely has an artist put himself into the skin of a character as Leech did with Mr Sponge—unprincipled, a real bad hat and even in his supreme love of hunting always having an eye for the main chance. Then, of course, there was the delectable Lucy Glitters of equivocal morals. It is said that all Leech's women took on the appearance of Mrs Leech—pretty, dark and neat—a description that applies to Lucy (pl. 104), bewitching in her hunting hat with its bunch of cock feathers at the side. *Mr Sponge's Sporting Tour* is certainly better constructed and easier reading than *Handley Cross*, but it is the thirteen coloured plates and innumerable line drawings that brought it immediate acclaim and gave Surtees his first literary success. He was forty-seven and it had taken twenty-three years. The publishers lost no time, and in the same year a re-issue of *Handley Cross*, in thirteen parts with illustrations by the 'illustrious Leech', was announced. *Handley Cross* will always be seen through the eyes of this artist, for here again Leech underlined every facet of the hero's boisterous character.

The publishers had originally suggested that the rich vulgarity and gusto of Jorrocks should be toned down to appease the snobbish and respectable Victorian reading public, but John Leech's pictures swept all prejudice aside and in the brash, bumptious, eccentric world of Jorrocks which he evoked, nothing is played down. The scene is set

with the most famous drawing of all, '*Come Hup, I say, you Ugly Beast*' (pl. 105), showing Jorrocks perched precariously on top of a bank playing the gaunt Arterxerxes like an elusive fish. The pugnacious, rotund MFH, scarlet in the face with temper and exertion, is the vulgar, lovable, *nouveau riche* turned master of hounds to the life, possessing no social graces and certainly not a gentleman—but oh! what a sportsman!

Mr Sponge was followed first by *Ask Mama*, a novel which even Surtees described as without a plot, and then *Plain or Ringlets*, with its superb study of that most magnificent of riding masters escorting the ladies out on the Rosebery Rocks hired hacks. Although Leech could draw this type of horse, a bit gaunt and over at the knee, to perfection, his Thoroughbreds often lack the Alken quality and look as though they would be more at home between the shafts of a cab. Arterxerxes, of course, is his masterpiece—a great common obstinate brute of a horse with a monstrous Roman nose and ridiculous rat tail. His minor characters are brilliant, and he also excels in sporting costume. Surtees always describes the clothes of his characters with immense care, but completely ignores the scenery. Leech follows the text absolutely, showing Mr Sponge in his short-tailed hunting coat, sleeves carried to the finger tips to be turned back as required, and his whipcord waistcoat. The well-made boots, of course, have the deprecated brown tops. The turnout of the horses provides an accurate record of the saddlery of the day—not a noseband to be seen, double bridles with very long cheeks, and all the hunting whips are held crook end uppermost. But Leech could never resist adding also delightful landscapes of the English countryside.

In 1861 Surtees started his last work, *Mr Facey Romford's Hounds*. It was to contain twenty-four coloured plates, but before these were completed Surtees died, in March 1864. Time was also running out for Leech: worn out by overwork, stricken by insomnia and angina, he lived only six months longer. Between them they had exploited a new aspect of the sporting world, with the uninitiated taking on the sophisticated devotees, and it had proved a great partnership.

It is interesting to find that Hablot Browne completed the final drawings for *Mr Facey Romford's Hounds*, and it says much for his collaboration that it is barely noticeable. But of all the illustrators of Surtees's novels, John Leech reigns supreme.

13 Victoriana: royalty and realism

Go anywhere in England where there are natural, wholesome, contented and really nice English people: and what do you find? That the stables are the real centre of the household.

George Bernard Shaw, 1856–1951
Heartbreak House

Surtees and Leech introduced a certain streak of wholesome vulgarity into England's sporting scene, but most artists of the Victorian period, hedged in by respect for rigid class distinctions and wealth, painted conventional and fashionable subjects using an exact representational style. After the moral licence of the Georgian eras, the pendulum had swung towards a narrow nicety, which was reflected even in the sphere of sporting art.

Both George III and George IV had been lavish benefactors of the animal artist, and Queen Victoria was to continue this role, though in a different vein—not for her commissions of racehorses and hunters. As patron of the newly formed Agricultural Society, she and the Prince Consort took every opportunity at the royal farms to further the enlightened progress of British agriculture. Portraits of their livestock were encouraged, in the style of T.Sidney Cooper's picture of the Queen's favourite, 'Buffie', *The Victoria Jersey Cow* (pl. 101), with its pleasing vista of the Solent. Exception was taken, however, to a bunch of dock leaves in the foreground, in case it was thought to reflect on the efficiency of the royal farming methods.

From childhood the young Princess had been an animal lover, with almost a twentieth-century teenage enthusiasm for riding and ponies, and her diaries abound with such entries as: '13 April 1833. At 12 we went out riding in the park with Victoire,

Lehzen and Sir John; it was a *delightful* ride, we cantered a good deal. SWEET little Rosy WENT BEAUTIFULLY!!' (Esher (ed) *The Girlhood of Queen Victoria*, London, 1912, Vol 1, p. 66.) Thomas Creevey was to remark soon after the accession that 'I was quite delighted with Vicky in every way. She looks infinitely better on horseback than in any other way; she was dressed so nicely too, and her manner quite perfect.' Artists were not slow to appreciate these facts and she became a favourite equestrian subject. Landseer was to paint her on horseback on numerous occasions ranging from the informal study on a little grey, blind in one eye, for which he had no sittings, to the scintillating oil sketch, *Queen Victoria and The Duke of Wellington reviewing the Life Guards* (pl. 109). In this second work the central figures stand between serried lines of guardsmen, the Queen on her favourite grey Arab, composed and girlish in dark blue habit faced with scarlet. Interesting details are the over-large noseband, too big for the typical 'pint-pot' muzzle of the true Arabian, the high pommel and decoratively stitched saddle flap of the early Victorian sidesaddle. Landseer also painted the widowed Queen at Osborne in 1867, clad in sombre black, with dour John Brown holding the head of the dark brown pony on which Her Majesty sits, reading her correspondence. A typical saccharine touch is the begging terrier, Prince.

No Victorian home was complete without a reproduction of an animal painting by the prolific, prosperous Sir Edwin Landseer RA. Acclaimed as an infant prodigy, success came too early in the artist's career, and his outstanding talent for animal painting was gradually submerged in a glossy sentimentality that often ignored the inherent dignity of animal form and character. In this weakness, unfortunately, he was encouraged by many commissions from Queen Victoria for pictures of her large variety of pets, ranging from Pekinese to parrots. But he also painted fine studies of her children and of sport in the Highlands, the latter in the grand romantic style. At his death in 1873, the Queen, in addition to chalk drawings, sketches and frescoes, owned thirty-nine of Landseer's oil paintings, and the artist left a fortune of over £200,000.

Landseer used paint with brilliant expertise but with exaggerated detail; however, in such spectacular works as *The Hunting of Chevy Chase*, savagery takes over from sentimentality to prove the artist's true stature and his mastery of the big occasion.

Only Richard Ansdell RA, born in Liverpool in 1815 and a student at the Liverpool Academy School, appears to have challenged the reputation of Landseer. His diploma work for the Liverpool Academy, measuring 84 × 144 in., was *A Stag at Bay*, and he first exhibited at the Royal Academy in 1840. He painted animals with verve and effect, excelling in such scenes as *Returning Home after a Day's Sport* (pl. 113). The affluent Victorian sportsman's predilection for pictures of huge dimensions, allied to the demand for detailed realism, created almost insurmountable problems for the artists of the day. It speaks much for their ability that so often the results were acceptable and even pleasing. As late as 1884 Richard Ansdell showed undeniable ingenuity in composition in *The Caledonian Coursing Meeting*, relating different groups of spectators and participants on this popular sporting occasion.

Nothing suggests Landseer's true fluency as an artist more than his line sketches in pen and wash. The drawing of Lady Harriet Hamilton cantering, confident and happy, on her pony, seems to epitomize Browning's 'Sing, riding's a joy!' (pl. 108). It was the Queen's own love of this form of exercise that resulted in feminine equitation becoming very much *à la mode*, with equestrian portraits frequently commissioned. Sir Francis Grant also excelled in this subject and, unlike most artists, his likeness of the horse was always executed as ably as that of the rider, a legacy of John Ferneley's teaching. Grant,

fashionable and successful, fulfilled many important commissions—a picture of the Queen riding with Lord Melbourne, and an elegant and stylish picture at Badminton, presented by the 'Gentlemen and Farmers and Other Friends of the Hunt' to the Duke and Duchess in June 1864. It shows Henry, Eighth Duke of Beaufort, standing by his grey hunter and his wife with her bay. Though the Duchess wears a habit of the Beaufort blue and buff, in actual fact she never hunted.

Feminine infiltration into the hunting field, nevertheless, was on the horizon: side-saddles had now been fitted on the near side with the third pommel or leaping head, an English innovation to give improved security. Suitable riding clothes and riding technique became important topics, and the best seller on the subjects was *The Habit and the Horse, a Treatise on Female Equitation* by Mrs J.Stirling Clarke, published in 1860, which actually mentioned (p. 23), 'All superfluity of under-clothing should be dispensed with, both for convenience in riding as well as for personal experience, a large "tournure" on horseback is preposterous. . . . At the same time the error of extremes into which some ladies run by the absence of petticoats altogether must be carefully avoided.' But the great attractions of this volume are the delicate engravings by J.Burkill after J.Morin, which depict the Victorian *equestrienne* as both provocative and attractive.

Henry Barraud captures the same felicity and charm of the period in *Their Royal Highnesses, Edward and Alexandra, Prince and Princess of Wales, Riding in Windsor Park*, a picture painted, by permission, from life in 1868 for Baron Grant, one of the Prince's many rich financial friends, five years after the royal marriage (pl. 123). The Prince's poise is confident, a fact borne out by a remark of Payne, the Pytchley huntsman, to Lord Spencer after one of His Highness's days out with hounds, 'Make a capital king, my lord, sits so well.'

Far removed from his energetic hunting scenes, John Ferneley Senr produced several attractively composed conversation pieces during his long career. Of particular interest is *The Ferneley Family*, painted about 1855, showing the elderly artist, always a devoted *pater familias*, standing with members of his family; his son Claude and three married daughters are all on horseback and a couple of grandchildren play with a delightful donkey. But his picture, *Miss Heyrick with the Palmer Children*, painted almost thirty years earlier, emphasizes even more strongly the feeling for the family circle which became such a feature of Victorian life (pl. 107).

Ferneley also presented the less spectacular sporting activities of Victorian England. There had been a great revival of interest in archery, and Ferneley captures the delightful informality of one occasion in his *Archery Meeting at Bradgate Park*, painted in 1850. Bradgate Park, once the home of the ill-fated Jane Grey, was only a few miles from Melton Mowbray (pl. 111).

Such a picture as *Horses and Dogs at Wynnstay* (pl. 110), painted in 1864 by the minor Shropshire sporting artist Edward Lloyd, admirably reflects the pleasant tempo of the life of the Victorian country gentry, with its waiting phaeton and pair, saddled riding horses, child's pony and attentive grooms against the portico and park background of an obvious stately home. The coaching picture also made a come-back, for coaching clubs were again active, and 1856 saw the establishment of a Four-in-Hand Club of thirty members headed by the Duke of Beaufort, followed in 1870 by the Coaching Club, also under the Duke's presidency. J.C.Maggs, a Bath specialist in the subject, continued the stage-coach scene with verve and expert knowledge long after the railways had become an accepted form of travel; and nostalgia for the old days encouraged many important patrons, including the Queen herself.

In general, however, by the mid-nineteenth century the splendid robust qualities of British sporting art had been diluted by a demand for trivial prettiness. J.F.Herring Senr, for instance, abandoning the racing scene, painted with some sentiment such pictures as *Shoeing the Bay Mare* and *The Halt*, both of which reflect the insatiable Victorian interest in domestic animal life. He used as willing model in many scenes his near-white Arab, Imaum, originally owned by the Queen; and for Her Majesty he painted a splendid direct picture of her two saddle horses, Tajar and Hammon, which she always kept hanging in her dressing room at Osborne. The great exception to the conventional approach appeared in the work of William Huggins. Born in Liverpool in 1820, Huggins possessed an instinctive genius for painting animals. *Tried Friends* (pl. 112), a portrait of Mr Case, a Birkenhead magistrate, illustrates his imaginative use of sunlight and shadow. His pictures, acutely observed and painted with transparent effect, especially his numerous studies of lions, tigers and farmyard birds, anticipate the French Impressionists to a greater degree than the work of the French sporting artists of the day. John Lewis Brown, a contemporary of Huggins who worked all his life in France, relied on absolute realism for his informative racing and hunting scenes; while Victor Gerusez, known as 'Crafty', produced his humorous French racecourse groups and drawings of the horse in the style of a Gallic Rowlandson.

It was left to John Leech in his woodcuts for *Punch* to make the point that field sports were being enjoyed by tradesmen as well as the socially established, with the misadventures of his plebeian hero, Mr Briggs, who featured in a series of ridiculous hunting, shooting and fishing mishaps. The artist's humour, nevertheless, was always kind, laughing with his victims and never against them. In many drawings he suggests the growing emancipation of the Victorian young woman, for as well as showing discreet Dianas titupping along The Row, he also depicts the more daring beginning to follow hounds. To enjoy the foibles of feminine costume, the hunting and riding scenes of the quiet whimsical artist, Randolph Caldecott, demand study, especially as seen in his contrasting *Facts and Fancies* of 1884 (pl. 106), which shows both the neat and tailored as well as the frilled and feathered.

Hunting for women really came to be considered as the fashionable introduction to high society with the arrival in the Shires of the beautiful Empress of Austria, a brilliant horsewoman, in the 1870s. Her portrait by Emil Adam in an elegant tight-fitting black habit, leaping an enormous fence on a blood bay horse, seems to corroborate her famous remark to her pilot, Captain Bay Middleton, 'Remember—I do not mind the falls, but I will not scratch my face.' By the end of the century even Florence Nightingale was writing in a letter, 'So, drat hockey and long live the horse! Them's my sentiments.' Hunting in fact increased threefold during this period and by 1900 it was estimated 200,000 hunters were used in the sport. Subscription packs had taken over in great degree from privately owned hounds and there was no lack of rich men to subsidize the position of Master of Foxhounds. Many London sportsmen travelled by rail to Melton Mowbray to swell the fields of the Shires to almost unmanageable numbers.

By the mid-century racing had become a recreation to be enjoyed by the sporting world *en masse* at such meetings as Epsom, where the Downs were common land. William Powell Frith, arch-portrayer of the popular Victorian scene, in pictures smooth, photographic and packed with detail, exhibited his *Derby Day* at the Royal Academy in 1858. Nothing perhaps emphasizes more the difference from those select matches on Newmarket Heath of a hundred years earlier recorded by Seymour and Sartorius, with their sparcity of spectators, than this huge polyglot gathering. Acrobats, coach parties,

roués and cockney traders, not horses, play the major rôles, and the actual distant glimpse of racehorses was painted for Frith by John Herring Senr. No wonder one of the little royal Princes remarked, 'Oh Mamma, I never saw so many people together before.' 'Nonsense,' said the Queen. 'You have often seen many more.' 'But not in a picture, Mamma.' (W.R.Frith *My Biography and Reminiscences* Vol. I, pp. 286–7.)

In spite of the inferences of *Derby Day*, bloodstock breeding was still the prerogative of the nobility and the wealthy. It was men such as the Prince of Wales, the Dukes of Westminster and Portland, Lords Rosebery and Falmouth, and the Rothschilds, who owned the big studs. They commissioned, almost with complete accord, portraits of their classic winners from the most fashionable artist of the day, German-born Emil Adam; he was also the most gifted. Third generation of a distinguished family of Bavarian painters, Emil Adam, born in 1843, was described as the first horse artist in Europe, and continental as well as British owners demanded his services. The Duke of Westminster considered him the only animal painter who could put a Thoroughbred on canvas, and undeniably quality pervades his portraits of such royal Derby winners as Persimmon (pl. 119) in 1896 and Diamond Jubilee in 1900. The Jockey Club possesses an admirable collection of Adam's pictures of classic horses, and here students of the Thoroughbred can find interesting pointers on the evolution of the breed. Meticulous in his detail and producing a telling if photographic likeness, Emil Adam unfortunately rarely varied the static pose of the horse with jockey up, always set against delicate cloud effects but lacking any real distinctive or attractive landscape background. After two hundred years the wheel had turned full circle: once again it was a continental artist who came to fulfil the commissions of wealthy English sportsmen.

When discussing sporting art of the latter half of the nineteenth century it is necessary to take into account the influence of photography. In 1841 William Henry Fox Talbot received his patent for Talbotype or Colotype prints on paper; forty years later E.J.Muybridge's instantaneous photographs of animals at speed appeared. By imposing new standards of realism, photography stifled the naivety, vitality and humour characteristic of sporting art for the last two hundred years. This may account in some part for the overall lack of distinction in the works of such men as John Charlton, John and Alfred Wheeler, Thomas Blinks, Heywood Hardy, Charles Lutyens and several others of the period; but though collectively uninspired, each could produce a competent and pleasing painting of horse and hound on occasion.

There were many ramifications of the Wheeler family, all artists, but John Wheeler, born *c.* 1811, who lived into his eighties, and a son, Alfred, established a considerable reputation with the sporting fraternity. The former painted *The Fox*, a good likeness of the Duke of Portland's pony, and *St Simon with Fred Archer Up*, in which the long lanky form of 'The Tinman' dwarfs the invincible two-year-old colt.

In the 1870s John Charlton brought a breath of fresh air into his foxhunting scenes, especially those painted for Earl Spencer's collection at Althorp. Hounds appear as individuals, reminiscent of Francis Barlow's studies two hundred years earlier. John Emms, who died in 1912, could paint foxhounds with uncanny skill, often portraying the more modern type with the rich markings of the Belvoir strain. Heywood Hardy, who also lived into the next century, worked in both oils and watercolours, often using fictional sporting themes with a period touch of sentiment. Stephen Pearce specialized in equestrian portraits; his *tour de force, Coursing at Ashdown Park*, exhibited in the Royal Academy in 1875, measured 120 in. in length and involved sixty portrait studies. It was presented to the Earl of Craven by the Coursers of the United Kingdom.

Thomas Blinks, born in 1860, is perhaps best known for his painting *The York and Ainsty Hounds on the Ferry at Newby* (pl. 114), exhibited in the Royal Academy in 1898. He was later to introduce a plethora of scarlet coats into his pictures, but usually painted hunting and steeplechasing scenes with practical knowledge and verve. Women play an important part and it is surprising he never introduced Mrs Sam Garnett, who came from Ireland and electrified the Shires by appearing in a red jacket which fitted her admirable figure like wax. However, the fashion met with no approval from conventional husbands and was not copied. George Wright also painted hunting scenes in the same style, with as good an eye for a country as for a horse. Noticeable in all these compositions is the lack of individual incident which features so largely in Henry Alken's and, in a lesser degree, John Ferneley's pictures; very rarely do we see a rider upside down in a ditch or a horse immersed in the Whissendine.

Queen Victoria's own fondness for the Scottish way of life, ranging from Highland ponies to tartans, encouraged a fashionable sporting exodus northwards for the shooting and stalking season. Archibald Thorburn's studies of grouse and blackcock among the heather, painted with exquisite detail and also a proper understanding of ornithology and trajectory, were regularly exhibited at the end of the century at the Royal Academy. Today this less ostentatious Victoriana of considerable charm is again much in demand.

British sporting art over the years had made small impact on the continent, but in the Victorian era its influence in the United States in establishing a national school became apparent. Early English settlers in the New World, countrymen and sportsmen at heart, had inevitably created opportunities for hunting and racing, and a tradition of contemporary pictures of these sports was gradually established.

American sporting art owed its inspiration to the British school and, repeating past history, to an artist of continental background, for it was Edward de Troye, born in Lausanne in 1808, who became the supreme portrayer of the Thoroughbred in the United States. Educated in England and working at an early age in Windsor Castle, after a short spell in Jamaica the artist arrived in Philadelphia, became known as Edward Troye, and travelling extensively between 1830 and 1870 became a prolific painter of horses and cattle. Regarded as the Landseer of America, his style derived in marked degree from such earlier British artists as James Ward and Ben Marshall, being quite devoid of Victorian sentiment and excess. Owing to a total lack of money sense, he had often to paint too much, too quickly, but at his best his portraits of the American Thoroughbred, especially of greys and brood mares, were outstanding, and were to influence the work of every American painter of horses that came after him.

The National Museum of Racing at Saratoga Springs houses a splendid collection of sporting pictures and sculpture from the eighteenth century to contemporary Smithson Broadhead, which includes more than a score of Troye's pictures. The merit of such a fine work as *American Eclipse* (pl. 117), a portrait of the great racehorse and sire, is not diminished by the proximity of Ferneley's *Priam*. The mellow maternal picture of *Roxanna and her Colt* (1866–7) in the Jockey Club (NY), must also be considered one of the artist's most notable contributions to sporting art. In 1867 Troye wrote and illustrated *The Race Horses of America*, in which he hoped 'to transmit to posterity the circumstances and characteristics which gave them fame', but his oil paintings provide the most important and outstanding record of the American Thoroughbred, and must ultimately be considered responsible for introducing the traditional style of British sporting art into the United States.

Such American artists as Henry Stull, William Van Sandt and T.J.Scott were also painting the American Thoroughbred racehorse before the end of the century, and if their portraits lack the flair and quality of a Marshall or a Herring, a competent likeness was generally achieved, as in T.J.Scott's *Parole*. Parole, the winner of fifty-nine races, came to England in 1878 as a five-year-old to win the Newmarket Handicap, the City and Suburban Handicap, and the following day the Great Metropolitan. He was known as 'The Hero of Two Continents'.

Arthur Fitzwilliam Tait, born in Liverpool in 1819, after training at The Royal Institute, Manchester, also emigrated to the States where over the years he gained a reputation as a skilful animal and sporting artist in the late style of J.F.Herring Senr. Tait, with the help of his patron, Mr Osborne, became a full Academician of the National Museum Academy of Design in 1858, and many of his works were lithographed by Currier and Ives. Frederic Remington, born in Canton, New York, in 1861, as much at home with a horse and a lariat as a paint brush and easel, brought a flavour of the Wild West into American sporting art, but at the same time occasionally painted the more conventional equestrian scene, when he presents practical sporting facts with illuminating detail. In *Steeplechase at Cedarhurst* (pl. 118), the imperturbable seat of the moustachioed gentleman jockey, undismayed by the disastrous effects on his horse of an over-tight running martingale, bears the strong imprint of Henry Alken Senr.

American sporting art in the twentieth century was enriched by artists of such first-class calibre as Smithson Broadhead and Milton Monasco, and many others who brought a new approach to the subject, but much of their vitality and sureness of eye springs from the earlier traditions of the British school of sporting art.

14 Towards the twentieth century

The lot has fallen unto me in a fair ground; yea, I have a goodly heritage.

Psalm xv

The custom and etiquette of field sports, established by centuries of tradition, adapt only slowly to new social and economic conditions and, comparably, innovations in sporting art receive only reluctant acceptance. In France by the end of the nineteenth century, Toulouse-Lautrec in such equestrian works as *Riding in the Suburbs of Paris* and *The Paddock*; Renoir in his luscious *L'Amazone*; Manet in *Courses au Bois de Boulogne* and, above all, Degas in such sporting scenes as *At the Races, Jockeys* and *The Start*, had brought a new dimension to the pictorial representation of the horse, but contemporary English artists were slow to relinquish the Victorian convention of orthodox realism. However several sporting painters born in the latter half of the nineteenth century, though ignoring this new trend, inherited in diluted form something of the clear untrammelled vision of such earlier masters as Ben Marshall and John Ferneley Senr.

Among these can be numbered Godfrey Douglas Giles, born in 1857, an Indian Army Major who initially painted military and battle pieces but later turned to hunting scenes which were presented with knowledge and perception. Many of these showed the sport from a new pictorial angle with the field scattered directly ahead over a wide landscape, and credit is given to him as the originator of series of pictures of hunting countries which were to be brilliantly continued by Lionel Edwards.

This latter artist, born in 1878, was to become the Grand Old Man of sporting art of his day. He was already beginning to produce promising work before the end of the century and for the next sixty years he became ever more expert in his sensitive portrayal of the English sporting scene; his watercolours in particular show a fluent vitality

and freshness. Lionel Edwards, himself an ardent foxhunter, allied his practical know-ledge to his own good draughtsmanship and exquisite colour sense, bringing a touch of magic to the traditional sporting scene. He was an artist who appreciated the fact that English field sports took place, more often than not, in grey autumnal and winter weather, misty and subdued in tone, with scudding rain and fleeting clouds. The 'pink' coats rarely appear bright scarlet, horses and riders gallop through deep going, and hounds splash through pools of rainwater and mud.

Also bridging the centuries was Lynwood Palmer, born in 1868, who became something of a modern John F.Herring Senr with portraits of such leading classic race-horses of the day as St Simon, Minoru, the Tetrarch and Captain Cuttle. Son of a Lincolnshire clergyman, Palmer ran away as a youth to Canada to escape a professional career as lawyer or diplomat. Completely without proper training, with the help of General Field of the United States Army, he earned a living for some time as an artist in New York. Returning to England in 1899, the patronage of the wealthy Countess of Warwick, a famous figure in the hunting fields of the Shires, quickly resulted in commissions to paint all the Duke of Portland's stallions; he never looked back. This was an era when racing was the fashionable sport and important owners, many from the wealthy world of commerce, were competing in breeding classic bloodstock.

Lynwood Palmer, a man of great personal charm, with a practical and uncanny under-standing of a horse—in fact he acted as adviser to Lord Derby's stud—brought an immensely diligent and professional approach to his work, and his pictures of the Thoroughbred make a valuable and important record. A satisfying portrait, however, had also to be allied to an attractive and suitable background, a legacy he inherited from Stubbs, and this influence shows strongly in his painting *Jean's Folly, Cherry Lass and Black Cherry* (pl. 115) of classic brood mares bred at the turn of the century. It is reminis-cent in more mundane form of Stubbs's own memorable studies of mares and foals; but cannon bones now appear definitely shorter and quarters finer, for the modern Tho-roughbred in the nineteenth century had been produced primarily for speed over short distances and the breed had already acquired a definite stamp.

It is remarkable that despite the shackles of native insularity and narrow artistic convention two English artists of the late Victorian era were to be strongly influenced by the new Impressionist vision of handling colour and form. For Robert Bevan and Joseph Crawhall, both born in the 1860s, Impressionism opened new horizons. These two brilliant animal artists possessed a flair for the sporting aspect, and here at last was the breakaway from the monotony of the galloping Shires and the posed classic winners of the turf. Nevertheless, with the exception of these two painters and later, Munnings, few artists born in the latter half of the nineteenth century were to exploit this new vision in the field of sporting art.

Joseph Crawhall, artistically talented from early childhood and encouraged by a sympathetic father, studied in 1882 at the Paris studio of Aimé-Morot, a painter of animal subjects, portraits and battle pieces. The experience only lasted for a couple of months, Crawhall finding little benefit in working from models or in adapting his style to painting in oils; nevertheless the experience was of the greatest importance in his career. Though he was to recognize that his real affinity lay with the brush drawings of the Chinese and Japanese schools, and most of his serious work was in watercolours or gouache, often on brown holland, this brief contact with artistic life in France left its mark on his imaginative use of colour and form. Everything he painted was the result of long and concentrated observation without the aid of a sketch book, and Sir William

Burrell considered Crawhall one of the greatest animal and bird painters that ever lived—certainly his understanding of anatomy and insight into the animal mind was unique. The watercolour, *The Greyhound* (pl. 102) suggests something of this imaginative quality, contrasting forcibly with the more functional studies of greyhounds by Sawrey Gilpin and Ben Marshall of a hundred years earlier.

As a young man Crawhall lived in Tangiers where with the Old Etonian and Spanish nobleman, the Duke of Frias, Hereditary Grand Constable of Castile, G.D.Armour, later to become a clever and humorous sporting artist, and John Lavery, he hunted fox and pig with a pack of mongrel hounds. Sport was unconventional but highly enjoyable, and in 1893 Crawhall, a splendid horseman, won the Tangier Hunt Cup for the fourth time in succession; all of which provided plenty of subject material. Returning to Yorkshire he spent his time breeding horses and hunting on his Arabian stallion, Beck, with the York and Ainsty, the Sinnington and the Middleton Hunts. Financially independent, he was also unsociable and reserved, being nicknamed 'The Great Silence' by Lavery. Eccentric but pleasant, he always wore riding clothes except on Sundays and his artistic output was spasmodic, for he would intermittently work at fever pitch for a few days and then destroy in self-criticism most of the result.

His studies of the hunting scene are presented with a brilliant economy of line. In the poise of a rider and the contour of a horse's quarters, character, temperament and the inherent thrill of the occasion are suggested with an intuition that amounts to genius. Such pictures as *The Meet* (pl. 122) record a moment of truth—subtly indicating the real relationship between rider, horse and hound.

Robert Bevan's originality of approach and mastery in handling of crayon and colour washes broke away completely from contemporary convention. Born in 1865 in Sussex, he studied at the Westminster School of Art and Julian's in Paris. In 1893 he worked in Pont-Aven where he met Gauguin, an influence which led to his becoming, with Walter Sickert, an important member of the Camden Town Group which introduced Post-Impressionism into England. Horses strongly dominated his imagination. Like Crawhall, in early youth he had hunted in North Africa and for one glorious season had been Master of the Tangier Hunt, but lack of cash and the demands of his career made the auction sales at Tatt's and Aldridges and the cab-yards of Islington his hunting fields in the future.

It is these backgrounds which inspired some of his most brilliant work and Bevan's extraordinary gift for characterization is pinpointed in such typical paintings as *Showing at Tattersall's* (pl. 120). There is a wealth of information in the urgency of the running leader and the dour, bowler-hatted individuals appraising the catalogues. The artist's studies of cab-yards seen in the evening light, with tired, lean animals, seedy drivers, and growlers and hansoms looming through the gloom, in muted tones of blue and grey, possess an evocative dreamlike quality suggesting a forgotten world, before the overwhelming impact of the motor car (pl. 121). Crawhall and Bevan together made possible a new and imaginative approach to the twentieth-century world of horses, but later British artists in the equestrian field were slow to appreciate this fact.

Sir Alfred Munnings, born in 1878, perhaps alone of his contemporaries was to use colour and form with something of the same verve and imagination. Even in such a juvenile work as the black and white drawing, *A Southerly Wind and a Cloudy Sky Proclaim it a Hunting Morn*, dated 1903, there is more than a hint of his future fine paintings of horse and hound (pl. 116). Criticism of the artist's talent as facile and slight has not been lacking, but his splendid studies of rough cobs and gypsy lads, the

superlative expertise of *The Return from Ascot* with the Windsor greys, his studies of heavy weight-carriers with robust foxhunters and racing two-year-olds, were to bring to equestrian art of the twentieth century a brilliance of achievement not seen since the epoch of George Stubbs.

Sporting art in England, even within its narrow traditional confines, possesses an infinite variety in which not only field sports but travel, agriculture and domesticity also play their part. Above everything else it illustrates the quiet, even tenor of country life, enjoyed for generations and now rapidly disappearing under the pressures of modern industrialism and over-population. Never, therefore, have the pictures of the British school of sporting art been so precious, for they have become not only artistically valuable but a unique and vital record of a world that is ceasing to exist. They are a priceless heritage that should be protected by every means possible for the enjoyment and enlightenment of posterity.

Selected bibliography

Alken, H. *The National Sports of Great Britain* Methuen & Co., London, 1903. Based on edition
published by M'Lean, 1825

Apperley, C.J. (Nimrod) *Nimrod's Hunting Reminiscences* John Lane, The Bodley Head,
London, 1926 (reprint)
Memoirs of the Life of the late John Mytton Esq. Rudolph Ackermann, London, 1837

Apsley, Lady *Bridleways Through History* Hutchinson & Co. Ltd, London, 1936

Ash, E.C. *The Book of the Greyhound* Hutchinson & Co. Ltd, London, 1933 (2nd ed.)

Ashley, M. *Life in Stuart England* B.T.Batsford Ltd, London, 1964; G.P.Putnam and Sons,
N.Y., 1969

Baillie-Grohman, W.A. *Sport in Art from the Fifteenth Century to the Eighteenth Century* Ballan-
tyne & Co. Ltd, London, n.d. 1914; Blom, Benjamin Inc., N.Y., n.d.

Barrow, C. (Sabretache) *Monarchy and the Chase* Eyre and Spottiswoode, London, 1948

Beckford, P. *Thoughts on Hunting* Henry G.Bohn, London, 1847

Bewick, T. *Memoirs Written by Himself 1822–1828* John Lane, The Bodley Head Ltd, London,
1924; reprinted by Southern Illinoi's University Press, Carbondale, Illinois, 1962
A General History of Quadrupeds Longman & Co., London; Wilson & Sons, York, 1824
(8th ed.)

Blome, R. *The Gentleman's Recreation* Vol. 2, London, 1686

Boalch, D.H. *Prints and Paintings of British Farm Livestock 1780–1910* Rothamsted Experimen-
tal Station Library, Harpenden, 1958

Bovill, E.W. *The England of Nimrod and Surtees 1815–1854* Oxford University Press, London
and New York, 1959

Bowlker, R. *The Art of Angling* Richard Jones, Ludlow, 1839

Brailsford, D. *Sport and Society* Routledge & Kegan Paul, London, 1969; University of
Toronto Press, 1969

Cook, Sir T.A. *A History of the English Turf* H.Virtue & Co. Ltd, London, 1901

Cunnington, P. and Mansfield, A. *English Costume for Sports and Outdoor Recreation* A.&C.Black,
London, 1969; Barnes and Noble, N.Y., 1970

Daniel, The Rev. Wm.B. *Rural Sports* Longman, Hurst, Rees and Orme, London, 1807

Dixon, Henry Hall (The Druid) *The Post and The Paddock* Vinton & Co. Ltd, London, 1856

Eliot, E. *Portrait of a Sport* Longmans Green & Co., London and New York, 1957

Ellis, C.D.B. *Leicestershire and The Quorn Hunt* Edgar Backus, Leicester, 1951

Falk, B. *Thomas Rowlandson, His Life and Work* Hutchinson & Co. Ltd, London, 1949

Gilbey, Sir W. and Cuming, E.D. *George Morland, His Life and Works* A.&C.Black, London, 1907

Gilbey, Sir Walter *Animal Painters of England. From the Year 1650* Vinton & Co. Ltd, London, 1900; reprinted by Franklin, Burt, Publishers, *N.Y.*, 1969

Grundy, C.R. *James Ward RA* Otto Limited, London, 1909

Higginson, A.H. *Peter Beckford Esq., Sportsman, Traveller, Man of Letters* Collins, London, 1937

Kendall, George E. 'Notes on the Life of John Wootton, with a list of engravings after his pictures' *The Walpole Society* Vol. XXI, Oxford, 1933

Laver, James *English Sporting Prints* W.Ward Lock Ltd, London, 1970; Drake Publishers, *N.Y.*, 1971

Macausland, H. *The English Carriage* The Batsford Press, London, 1948

Mayer, J. *Memoirs of Thomas Dodd, William Upcott and George Stubbs, RA* David Marples & Co. Ltd, Liverpool, 1879

Mingay, G. *English Landed Society in the Eighteenth Century* Routledge & Kegan Paul, London, 1963; University of Toronto Press, 1963

Mortimer, R. *The Jockey Club* Cassell, London, 1958
 The Derby Stakes Cassell, London, 1962; Fernhill House Ltd, *N.Y.*, 1962

Nevill, R. *Old Sporting Prints* The Connoisseur Magazine, London, 1908

Orchard, V. *Tattersalls* Hutchinson & Co. Ltd, London, 1953; Coward-McCann and Geoghton Inc., *N.Y.*, 1954
 The British Thoroughbred The Ariel Press, London, 1966

Paget, Major G.D.L. *The Melton Mowbray of John Ferneley 1782–1860* Edward Backus, Leicester, 1938; Charles Scribner & Sons, New York, 1938

Parker, C.-A. *Mr Stubbs the Horse Painter* J.A.Allen & Co., Ltd, London, 1971

Pavière, S.H. *A Dictionary of Sporting British Painters* F.Lewis Publisher Ltd, Leigh-on-Sea, 1965

Plumb, J.H. *England in the Eighteenth Century* Penguin Books, London, 1950

Rothenstein, J. *Nineteenth-century Painting* John Lane, The Bodley Head, London, 1932; Books for Libraries Inc., *N.Y.*, 1932

Selway, N.C. *The Regency Road* Faber & Faber Ltd, London, 1957

Siltzer, Captain F. *The Story of British Sporting Prints* Hutchinson & Co. Ltd, London, 1925

Sparrow, W.S. *Angling in British Art* John Lane, The Bodley Head, London, 1923
 'British Farm Animals in Prints and Paintings' *Walker's Quarterly* Vols. 33–34, London, 1932
 British Sporting Artists John Lane, The Bodley Head, London, 1922
 British Sporting Painters John Lane, The Bodley Head, London, 1931
 George Stubbs and Ben Marshall Cassell & Co. Ltd, London, 1939; Charles Scribner & Sons, New York, 1939
 Henry Alken Williams & Norgate Ltd, London, 1927; Charles Scribner, New York, 1927

Taylor, B. *Animal Painting in England from Barlow to Landseer* Penguin Books, London, 1958
 Stubbs Phaidon Press Ltd, London, 1971; Harper and Row Publishers Inc., *N.Y.*, 1971

Thomas, Sir W.B. *Hunting England* B.T.Batsford Ltd, London, 1936

Thompson, F.M.L. *English Landed Society in the Nineteenth Century* Routledge & Kegan Paul, London, 1963

Trevelyan, G.M. *English Social History* Longmans Green and Co., London, 1946 (2nd ed.); Barnes and Noble, Inc. *N.Y.*

Vale, E. *The Mail-Coach Men of the Eighteenth Century* Cassell, London, 1960

Wentworth, Lady *The Authentic Arabian Horse* George Allen & Unwin, London, 1962 (2nd ed.)

Willett, P. *The Thoroughbred* Weidenfeld & Nicolson, London, 1970

Wymer, N. *Sport in England* George G.Harrap & Co. Ltd, London, 1949

Young, G.M. (ed.) *Early Victorian England 1830–1865* Oxford University Press, London, 1934

List of illustrations

Figures in bold refer to plate numbers

193

Index